TALKING FASHION

SARAJANE HOARE

BY SARAJANE HOARE
DESIGNED BY
FABIEN BARON
POWERHOUSE BOOKS
NEW YORK, NY

For my much loved and much missed mother, Elizabeth Jane Lloyd

WHAT DO YOU DO?

Why does the response 'I'm a fashion editor' induce rolling eyeballs in immigration people, scanning looks from fellow women, and smiles of patronage from chauvinistic business men? Oh, of course: aren't we meant to be a bunch of hysterics screeching Think Pink, and lugging trunks of frocks across exotic landscapes? Sure...but seriously, the fact is that we form part of a global business which generates a multibillion dollar annual turnover—which happens to be called Fashion.

So, what *is* Fashion? In plain English, it is clothing which lives in the moment. Fashion is a highly transitory and volatile thing, whose very elusiveness depends on change. Sometimes this change can occur gradually; sometimes it happens at the speed of light. But this is not change for its own sake: it is change which will hopefully inspire a new trend, or a more modern twist on something old. Because—let's face it—it's all been done before.

Like the designers who obsess about finding new ways of making clothes, and the packs of retailers and businessmen who find new means of selling and advertising them, so, too, the fashion editor must find new images that show fashion-obsessed women how to wear them.

What's the vehicle? It is a fashion magazine, driven by a variety of editors—all exploring, defining, and predicting fashion's news in its myriad cultural and social guises. If the essence of fashion lies in its novelty through change, then its existence is clinched when a consumer wants to buy it, and this is where a fashion editor comes in. He/she must have the right 'hunches' about which key looks to pick each season, and how best to portray them in photographic form, so that quick imprints spark a reader into wanting to buy before tossing the magazine aside. This compulsion is what keeps fashion alive and fuels its acceleration. So, how do you become a fashion editor in the first place?

You must love *everything* about clothes, and do so with a passion. It's not just about adoring to dress up for parties, or about shopping—sorry—it's to do with writing about clothes, fighting for them, ironing, pinning, and counting them, weighing, carrying, and analysing them, dreaming of them, even sleeping with the damn things—without ever being able to get away.

I've been there. Believe me. I've even tried to escape by running to the barren bushland of East Africa, where fashion is immaterial. But no matter how far I've gone, it's always crept back. Despite living in Tanzania among Masai warriors, whose rubber tyre shoes are works of art, I've still found myself fussing over my Hermès riding boots and jodhpurs. Only after I managed to track down a fax machine in a remote coffee-farm, and hastily write to my assistant in New York 'Please order size 38 black leather Chanel thigh boots' did I realise that fashion was in my blood. I love it, it's my vocation.

I suppose you are born with it. I know I was. I mean, aged three, I used to insist on wearing red t-bar Startrite shoes *in bed*. But let's not fall prey to the Fashion Victim thing here. It's only to drive home a point: you have to live, eat, and breathe clothes in order to work with them.

Now, given that you have the right hunches, how do you begin, how is it all done? There are no schools for this training. If I had told my University professor that Fashion was what I wanted to do, he would have spluttered. So, like plenty before me, I stumbled into fashion editing by trial and error. Trial—through a chance meeting with Mario Testino, then newly arrived from Peru, fresh-faced and armed with an automatic pocket camera; Error—by improvising shoots for a weekly free-bie, using Mario's home as studio, my sister as model, my father as set painter, and various friends for hair and makeup.

The safest way to start, though, is by assisting a proper fashion editor. But how to track down someone whose very existence seems cloaked in mystery? The answer tends to be this: through a friend of a friend who knows of a hairdresser who might just know of a third assistant to a fashion photographer who might know Someone...

When interviewing for an assistant, the following credentials matter more than educational ones. Does she have a strong head? Can she carry a trunk on it? Can she work with bossy agents, nurse models through tantrums, organize food in the middle of nowhere, drive trucks, flirt with customs men—all the while main-taining an aura of calm and professionalism? Plus, of course, does she love frocks?

Where do all these frocks come from anyway? Here's the 'simplest' way to explain it. Twice a year, an editor-in-chief will send her fashion editors scouting London, Milan, Paris, and New York—on month long road trips to fashion shows. The Collections are a conveyor belt of catwalk presentations where models strut designer stuff in all its diversity—bohemian princesses trailing along snow covered rooftops; revolutionaries striding in deconstructivist garb; utilitarian girl guides; half naked sex goddesses; and the frosty queens of cool. Whatever—it's hard enough keeping your own cool and making sense of seasonal chaos, never mind when you're so jet lagged that you can hardly keep track of time.

But it's here that ideas for fashion shoots are engendered. From here they grow, thick and fast, awakening a collective memory bank: certain elements from child-hood; something you saw; something you once wore. All sorts of things can trigger you: *broderie anglaise* which takes you back to your first bridesmaid's dress; the crimson velvet of a gown, evoking Ingres; a low slung hip belt that makes you think of a cowboy's swagger; muslin smocks reminiscent of priests; draping, suggestive of a Roman toga...However the inspiration is stoked, it is this underlying consciousness that informs the taste and personal selection of an editor, and fires her longing for expression through a fashion story.

If all this sounds a bit pretentious, it isn't meant to. But we are, after all, talk-ing fashion, and nowhere is fashion more hotly discussed than at meetings where an editor, once back from the shows, must deliver ideas to her editor-in-chief and col-leagues. At *British Vogue*, a 'fashion meeting' was a rather cordial affair, lasting just minutes, during which themes were quickly translated into key trends, broken down to shooting assignments, and allocated to the editors most suited to styling them.

Jack the experience up by fifty, and still nothing has prepared you for the length and gravity of similar meetings in New York, where magazines sell to a country fifty times larger, and the pressure upon editors is fifty times greater. Maximum readership equals maximum dollars and minimum risk; so the very nature of a fashion shoot changes from something ethereal to something accessible.

Anyhow, what does all this 'Talking Fashion' entail? You might well ask. To be quite honest, I don't really know myself; but like in any other business—banking or computers say—it's done with terminology. Yes, businessman, you're home! Or maybe not—to an outsider, such insider terminology can sound quite odd...

'I'll do random edits and use up the heavies!' shouts one editor. 'I'd *kill* to do wild warrior-women in tweeds on a hilltop,' says another. 'I'd like to show it off, but, oh, you know, on, old but new', adds another. 'That Helmut coat—I mean, I was: Oh My God, the arms, I'm like *wow*, this is cool, I mean really cool.' 'What about those massive Bombers, should we blow them up?' 'You've got to show the Chunkies.' Excuse me: *Chunkies*? Are we talking some kind of dog food here or something? I don't think so.

Don't think till you know how to. It's no good having a whimsical idea which you can't follow through: your editor-in-chief wants credibility. From boardroom to storyboard, a fashion editor compiles her proposal by making Polaroids from slides of the shows, depicting looks which provide the backbone for her story. Knowing which, out of thousands of outfits, are the key looks is the skill of editing—hence the term 'Fashion Editor.' The storyboard is handed over to a team of marketing editors whose job—through days of telephone calls and faxes to various designer PR houses—is to ensure prompt delivery of the clothes. But Look 43 on Maggie Rizer from Prada in Milan may not even materialize...

Most PR and magazine offices, in order to ensure some sort of professional fairness, are run on a first-come-first-served basis. But, as with any other business, there are exceptions to the rule, to do with hierarchies. As a result, the tension in fashion departments is palpable. Whatever—it's all healthy. This kind of competition keeps a fashion editor on her Manolo Blahnik toes, and probably differs little from the lives of guys pitching stock on Wall Street—except that in Fashion, instead of yelling, it's all done smiling.

Once a storyboard has been pitched, mergers and acquisitions take over. Casting a shoot depends on which photographer should frame it. More meetings with the editor-in-chief, creative directors, and art directors help to ensure the right choice, for, like fashion trends themselves, a photographer wears a coat of many colours.

Apart from being able to shoot models wearing clothes, what makes one photographer more favourable, more fashionable than another is his or her ability to inject current social and artistic awareness into pictures, which often makes for great 'fashion moments.'

For example, when Grunge evolved during the early-'90s recession, and clothes spoke of low-key styles, it was considered old-fashioned for photographers to shoot

in exotic, decorative locations. Instead, they drenched their subjects in reality by using everyday streets and lifestyles. Sometimes this attitude was pushed to its limit, with lanky looking models who played down any semblance of striving and were shot staring cooly off-camera with nothing more than a blue sky behind them. In the late '80s, on the other hand, when power-dressing had reached excessive heights, photographers chose proportionately opulent settings, in which Amazonian models drove fast cars or lounged about in luxurious hotel rooms.

Nowadays, the preference seems to be for a juxtaposition of both. It might also be that the 'right choice' lies with a young amateur photographer whose naiveté will inevitably lead to the use of shock tactics, which, in turn, might produce a more striking and subjective take on clothes that could otherwise look a tad boring. Or, equally, it might involve a more experienced photographer whose finely tuned eye and exquisite lighting can tame and capture an unruly wild subject and show it off in its full glory.

As vital as the photographer is, so, too, his team. A brilliant hair or makeup artist can add a crucial new dimension to the way in which a model and the clothes look. Likewise, a model (who must possess more than beauty) can, with her contribution or lack of it, make or break a fashion shoot. Her skill lies as much in her ability to act with casual disregard for what she is modelling as in her rapport with the photographer—fleetingly seducing him with her movement, poise, and attitude. A beautiful girl shot in a beautiful way on a beautiful page is not always beautiful; a really great photograph will stir something more—the spell of a fleeting instant trapped in an image that will remain in the mind long after it's been seen.

But let's not delude ourselves here with too much high-and-mightiness. We are, after all, talking fashion shoots. After many more discussions about which team, model, and setting is needed to orchestrate the reality of a story, it's time to get booking.

Hairdressers, makeup artists, and models are all juggled—often being flown in. Sets are designed and built, studios hired, locations scouted, hotel rooms and flights allocated, catering and location vans reserved, shoe sizes noted, prop kits, travelers' checks, and carnets prepared, all of which involve loads of wheeler-dealing to keep a soaring budget grounded. Apart from all this production work, hours are spent pulling and editing the newly arrived samples in a Fashion Cupboard—a room full of samples, shoes, and accessories. Rifling though racks of clothes, an editor must pull looks together in a new and exciting way that will justify their being photographed. 'Where are those Dr. Martens? I need a bite of colour here. The bra on that dummy isn't working. Can you find me a rodeo rope? We don't have any size 42 shoes!'

A great deal of scurrying and fetching is involved in tweaking the look for a run-through, which is shown to the editor-in-chief for her final approval. And, at long last, it's time to get packing. Three large trunks are the norm, but people have been known to use up to fourteen! But this is only the beginning. Now we are finally ready to shoot. It's goodbye Manolos; hello Boot Camp!

Aside from the business of keeping everyone happy, and setting the scene for a great shoot, it's important to be psychologically attuned to how much or how little guidance a photographer may need in order to create the Look. It's also crucial to use the right jargon. As Kate Moss once corrected me on a David Sims shoot: 'You don't say it's Modern anymore—that's old. You say it's Edgy or Off.'

Everything is done with an aura of nonchalance. Nothing must betray the pressure of a haemorrhaging budget, or the frustration of scavenging for that critical, nude G-string in a prop kit stowed at the back of some location van. A two day shoot, whether in a studio or on location, can be subject to all sorts of taxing mental conditions, not dissimilar to the unpredictability of weather—from heat waves to blizzards. The experience can be likened to manning a plane. At the start, it's a good idea to log the route with a photographer. Too many head shots, or too many static full length pictures, can sometimes make for a boring trip. With a beginning and an end in sight, a variety of images enables an art director to produce a more interesting layout. After hours of lengthy preparations with styling, hair, makeup, lighting, and location plots—all to get a model looking right for a particular shot—it's time for takeoff. At its best, great teamwork allows you to cruise on autopilot; and with the right collaboration, amazing moments can unfold before the camera. At its worst, even for the most agile of fashion editors, a shoot can be like assimilating complicated orders through headsets and flying through a twister.

And as I flick through a decade of photographs, memories of those experiences come flooding back: On which active volcano did I lose a bag with thousands of dollars' worth of clothes and Tina Chow jewellry, and resort to shooting with one piece of silver fabric? Which supermodel thought it a great fashion statement to wear her 'Che' Guevara beret to a café in Cuba? For which photographer did I go on a hovercraft from Dover to Calais, accompanied by three stuffed falcons, to avoid customs? Which hairdresser hurled a turban at me through a cloud of smoke-bombs during a nomadic shoot in the middle of the Sahara? Which photographer left me stuck in the mud on a wild Hebridean beach, stranded in a Land Rover with a bunch of priceless Jean Paul Gaultier couture, while he ran for that vital London-New York Concorde? At which deserted airport did I hear the sickly snap of my ribcage as I heaved great trunks of medieval props onto a trolley? And where was it that I was reduced to performing a belly dance in an attempt to persuade a background crowd to laugh?

A homecoming from one of these shoots feels as if it should have all the relief and finesse of Michael Douglas in 'The Game,' but it doesn't. It's back on with the Manolos and into the office without a murmur—mission accomplished. The pictures are handed over to the art department, who print and paste them up, so that an editor-in-chief, depending on the balance of designer credits and the mood of the issue, decides to run them or can them.

Why do we do it? I'm certain that this thought has crossed the mind of many a fashion editor. But I know, sure enough, that at the next fashion meeting my hand will go shooting up, and the whole story begins again.

—Sarajane Hoare

Plates

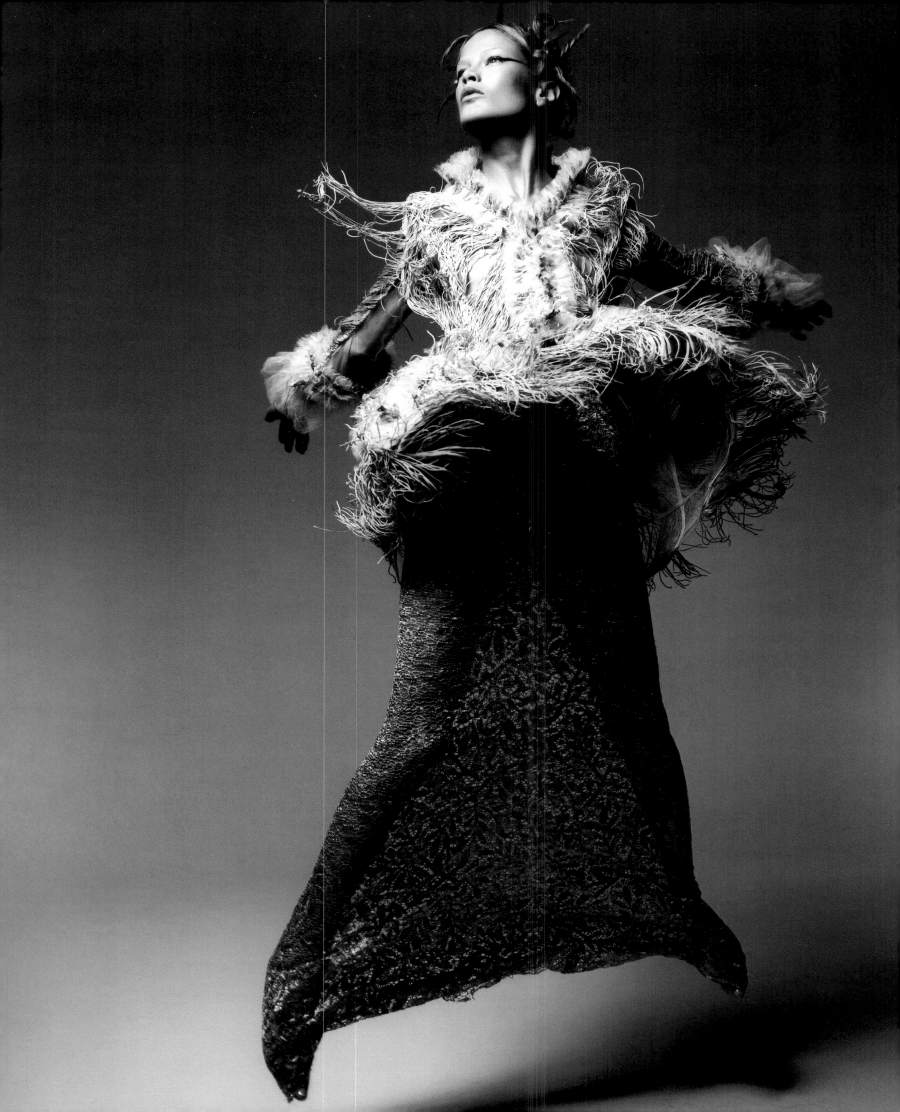

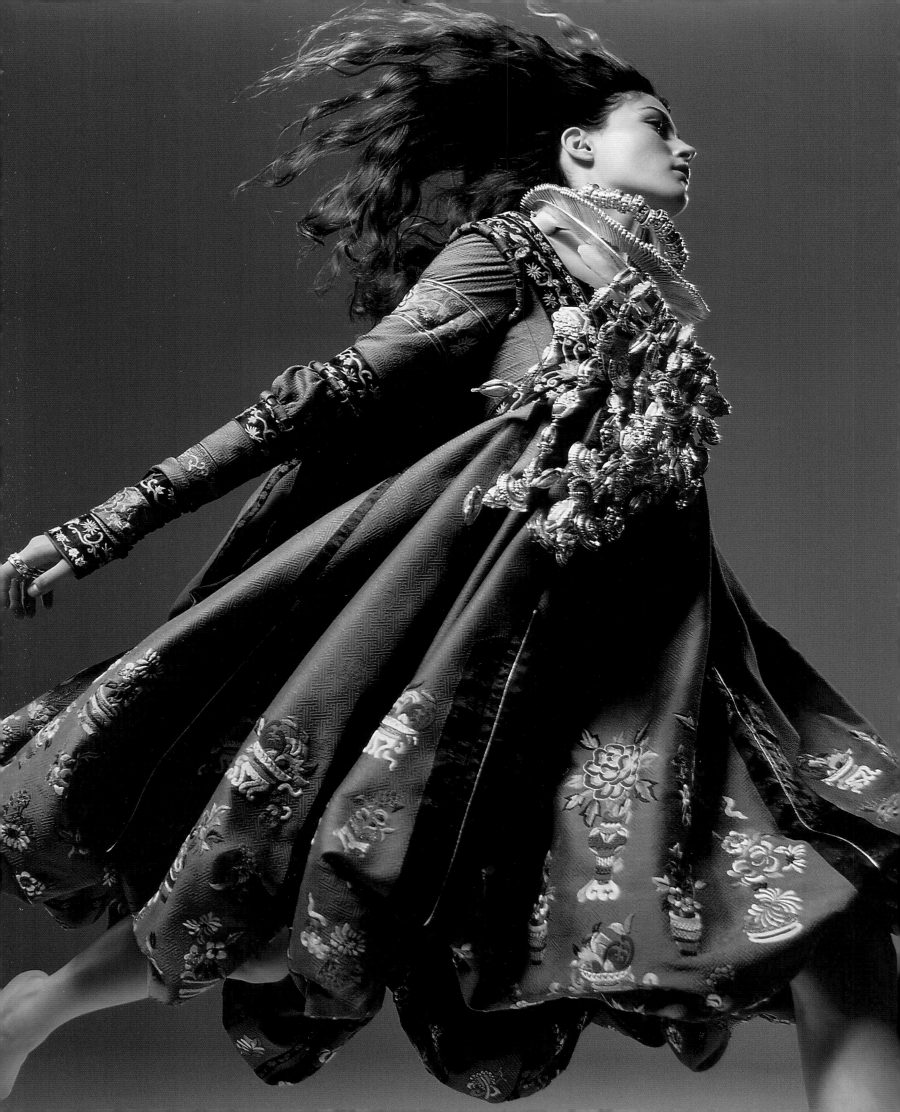

'Shooting couture clothes is about dressing up in all its excessive glory.'

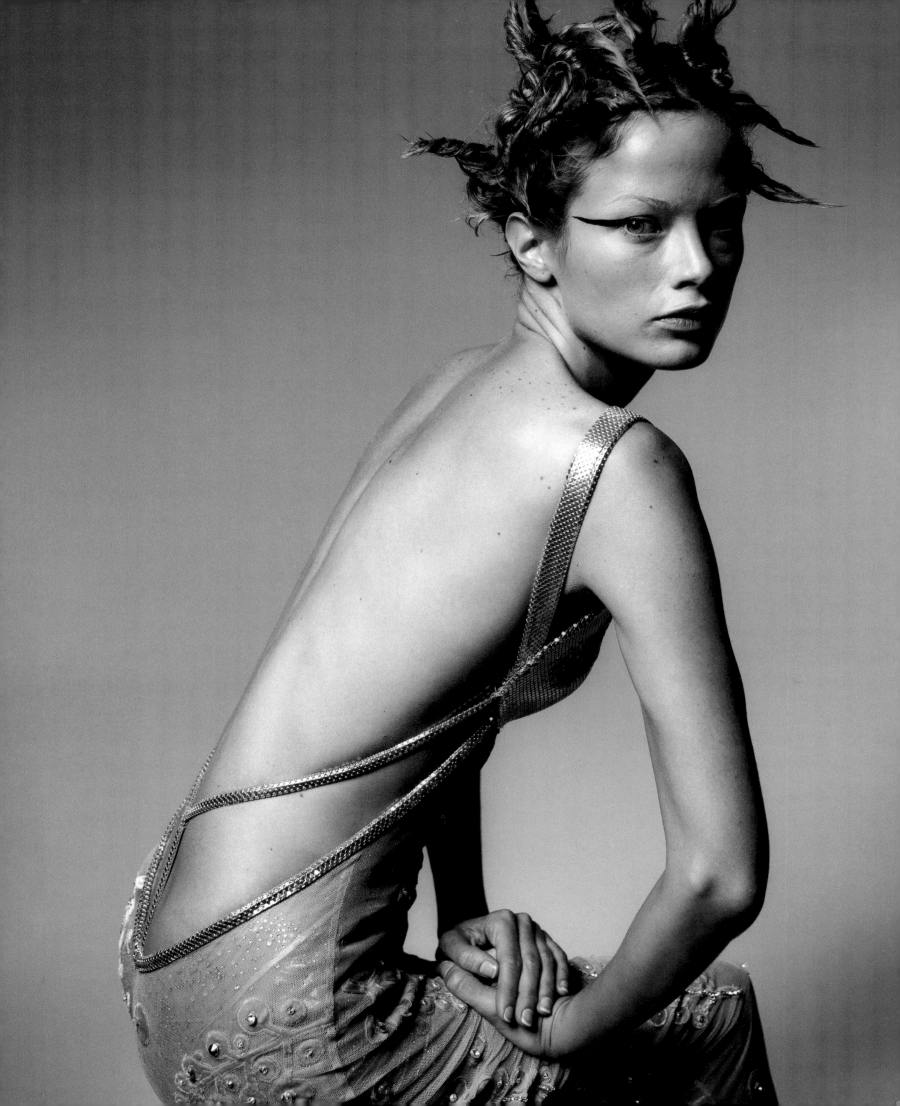

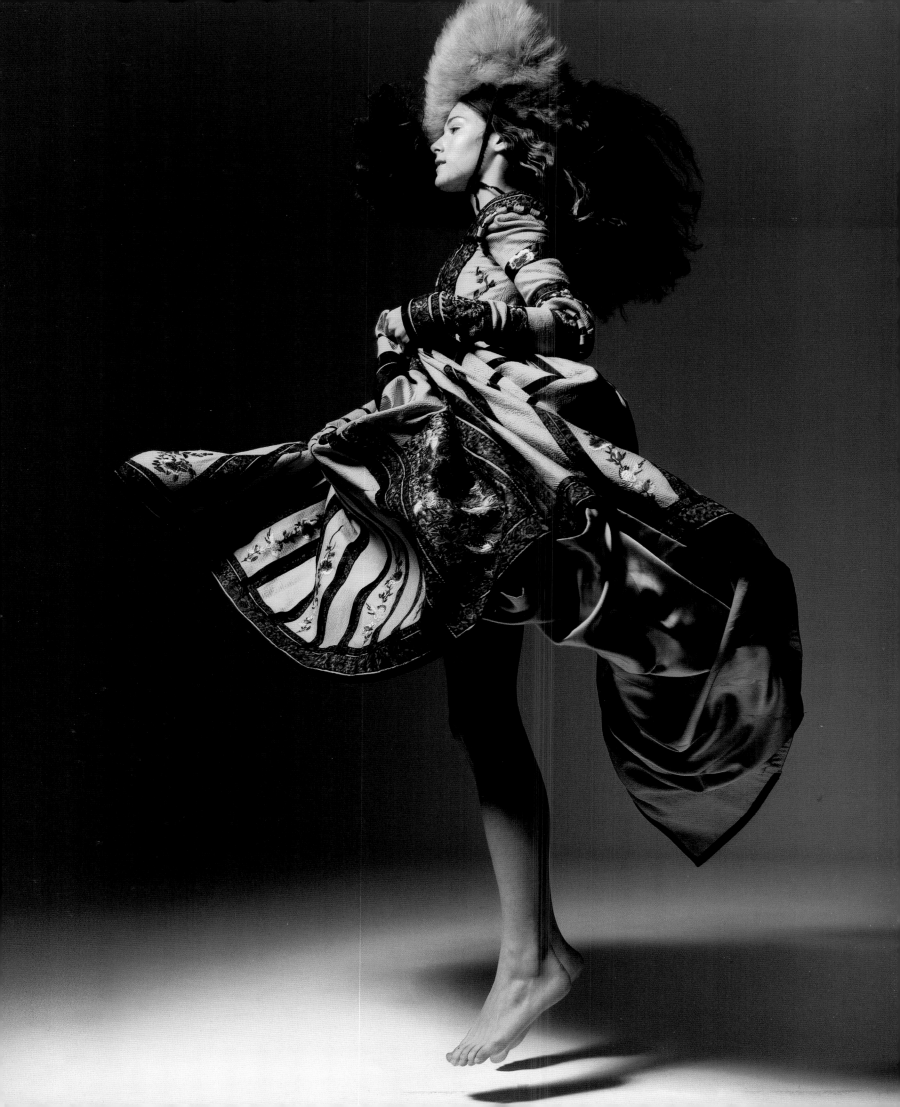

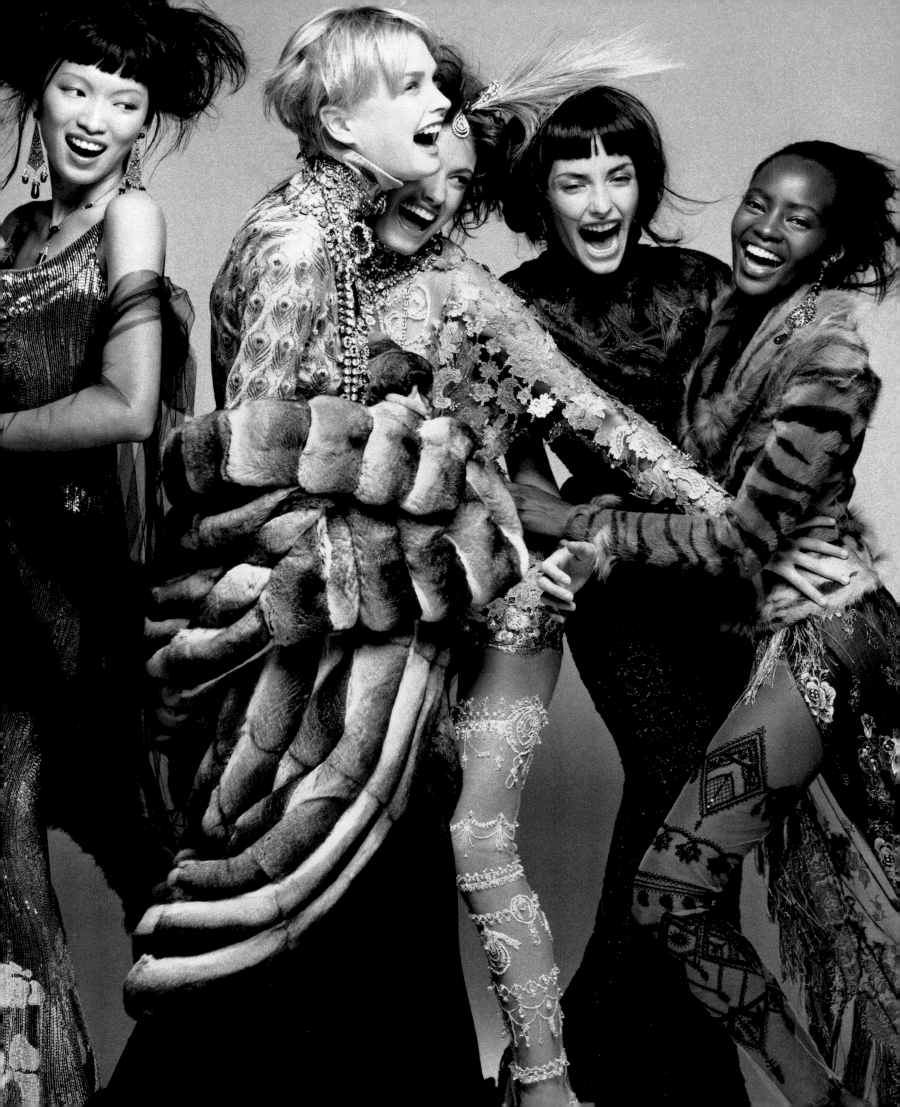

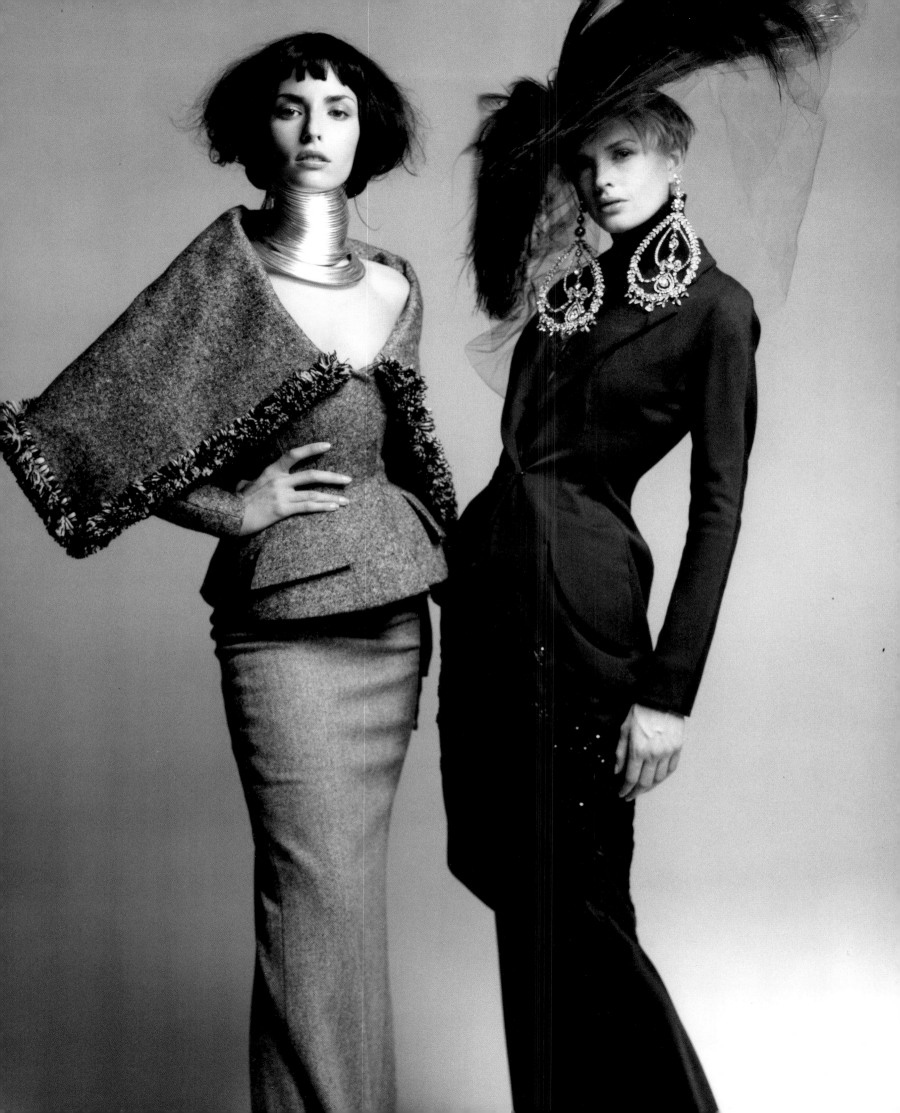

'After
this shot
Danielle
fainted,
thanks
to the
Somali
collar.'

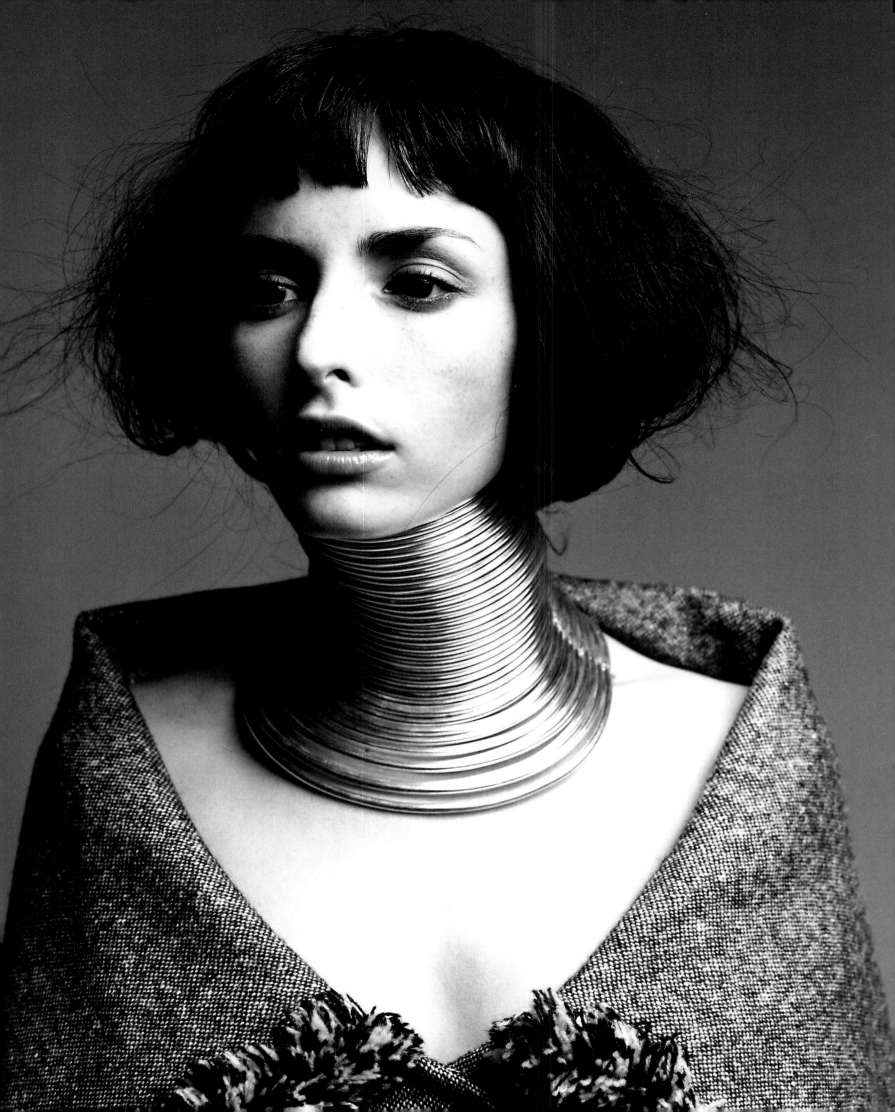

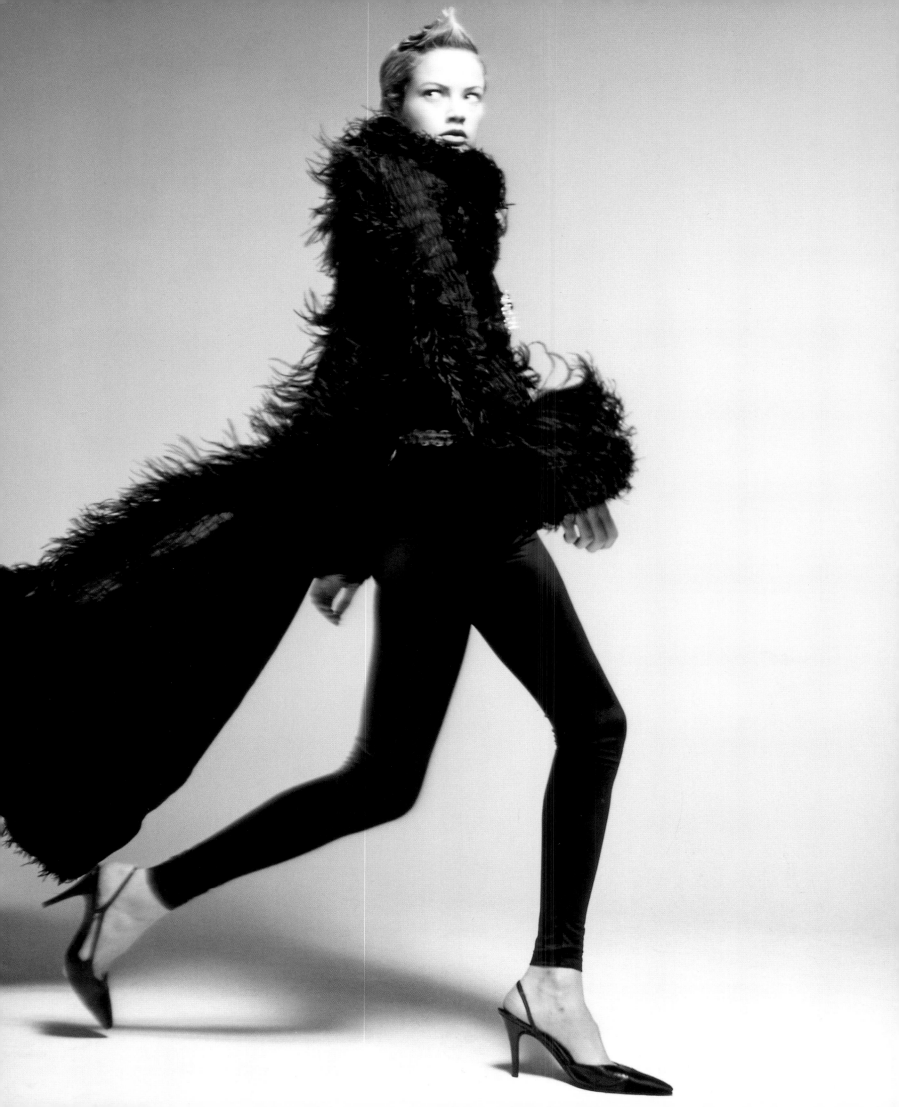

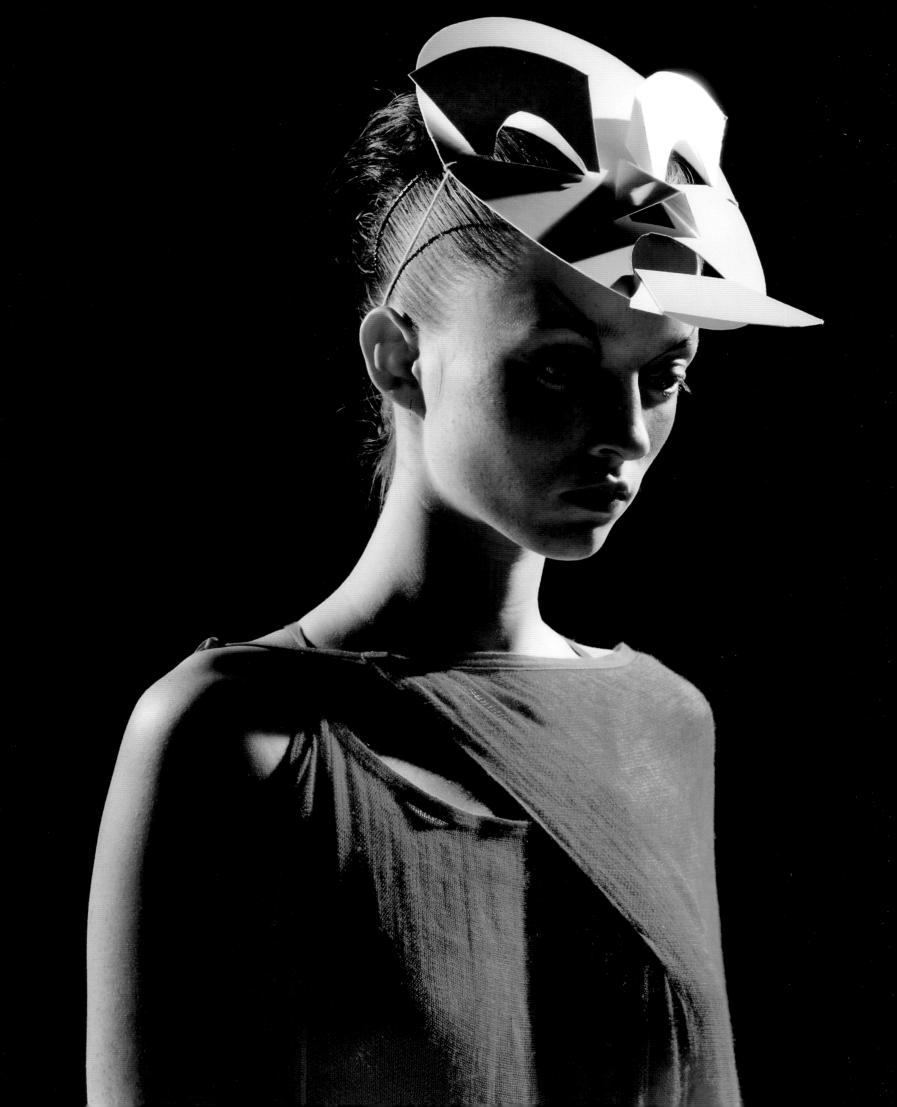

'A really great fashion photograph will stir something more; something intangible that will remain in the mind long after, it has been seen.

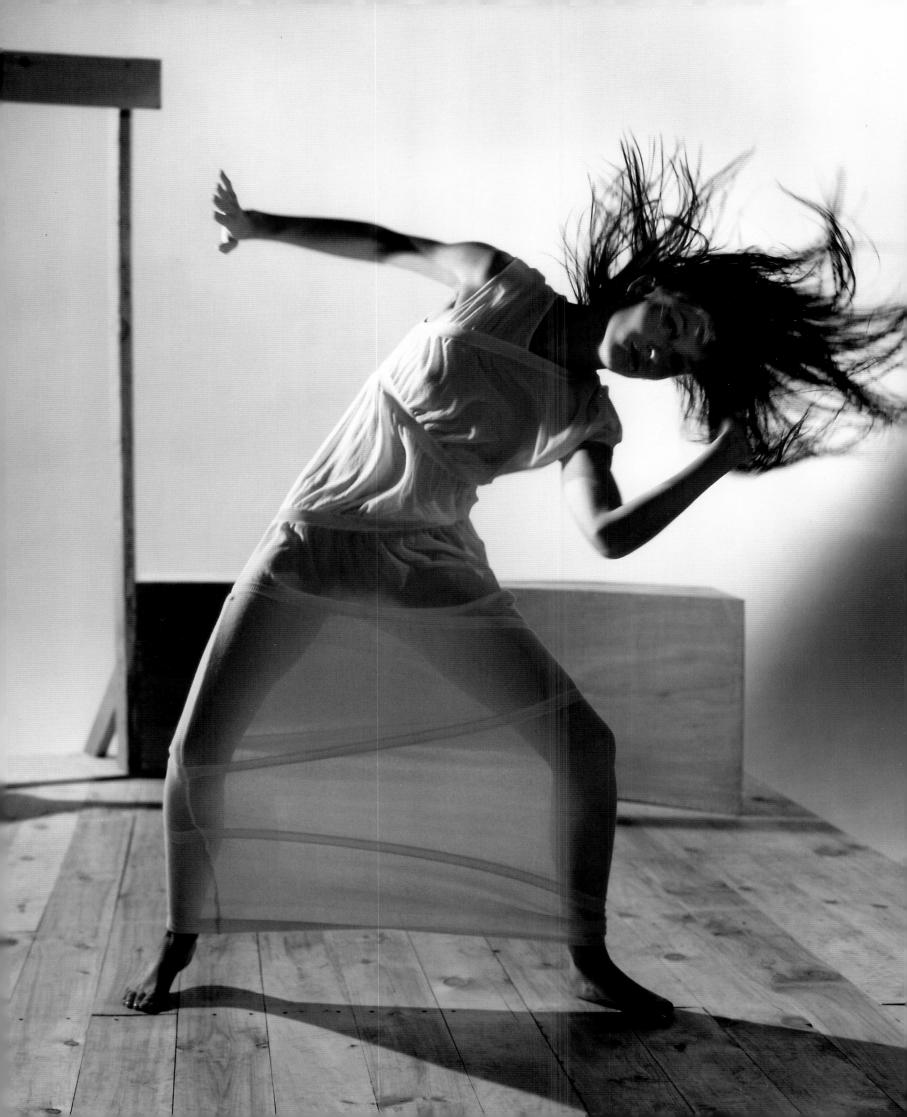

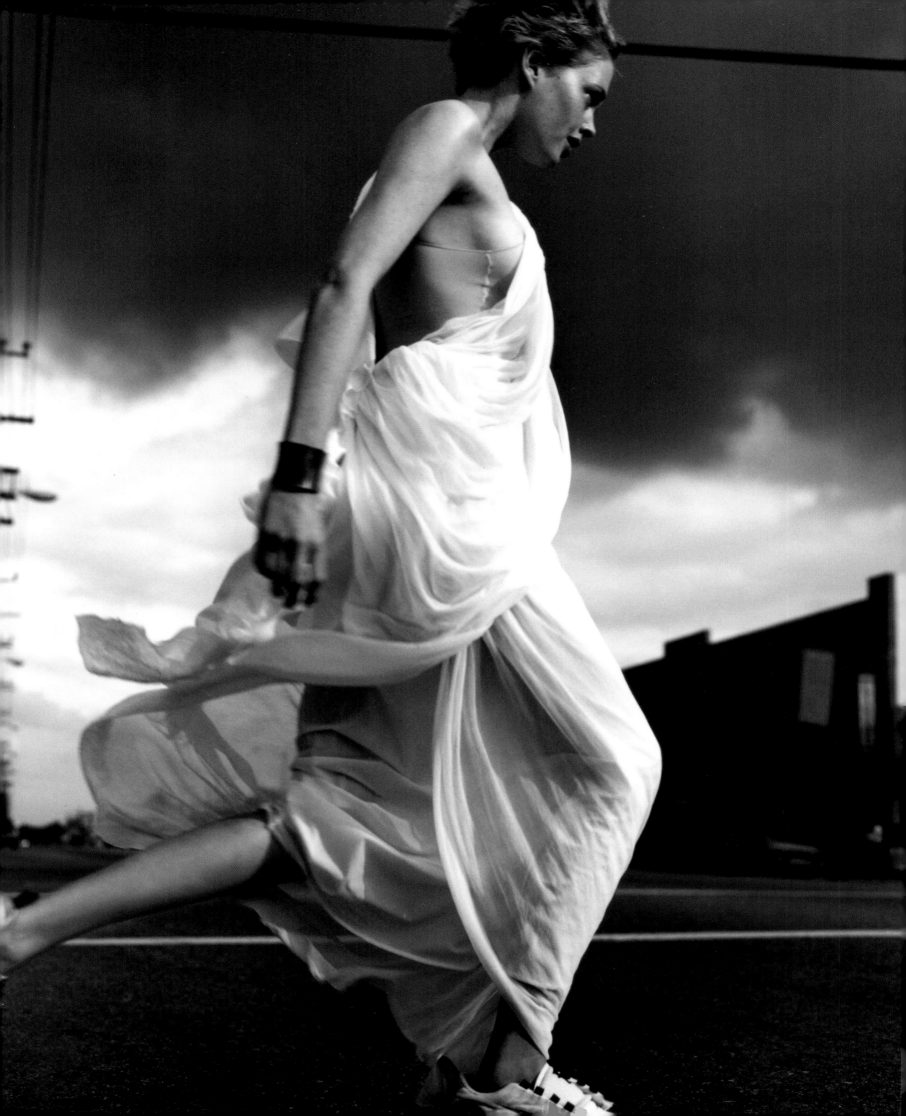

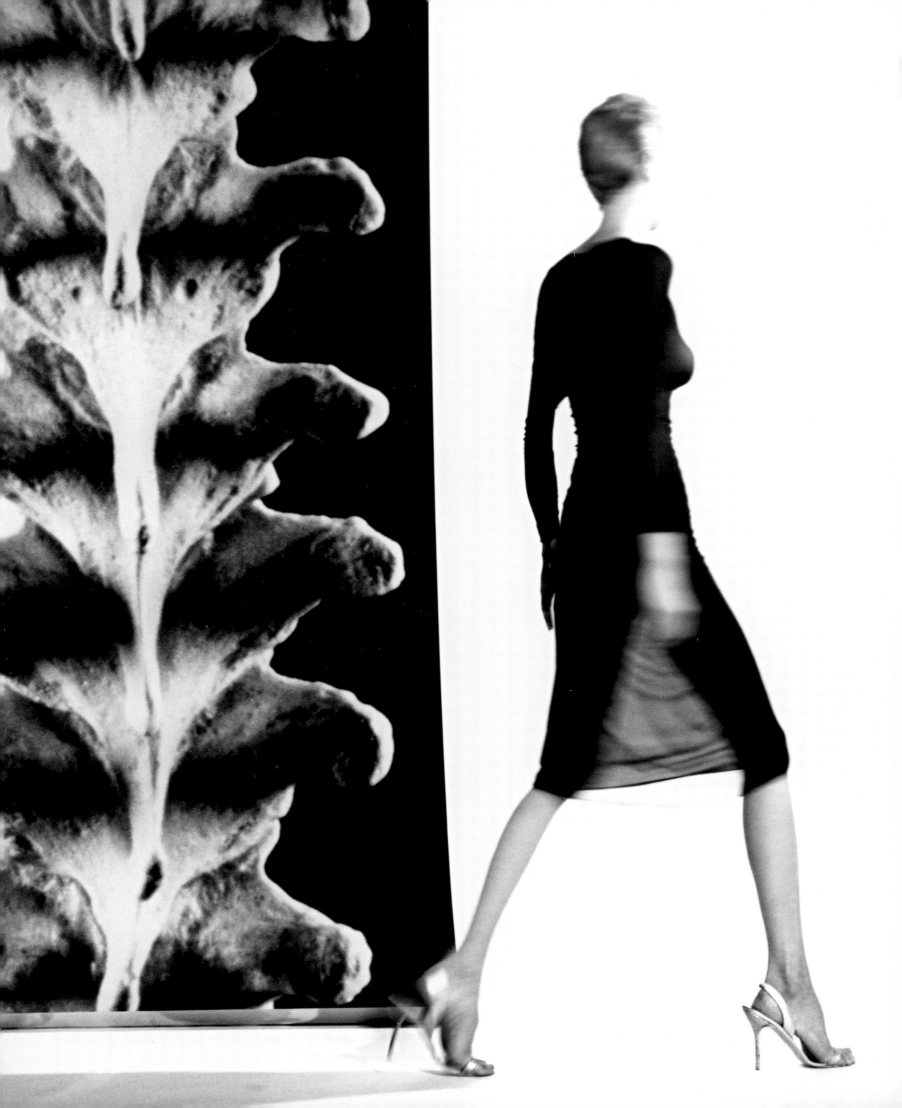

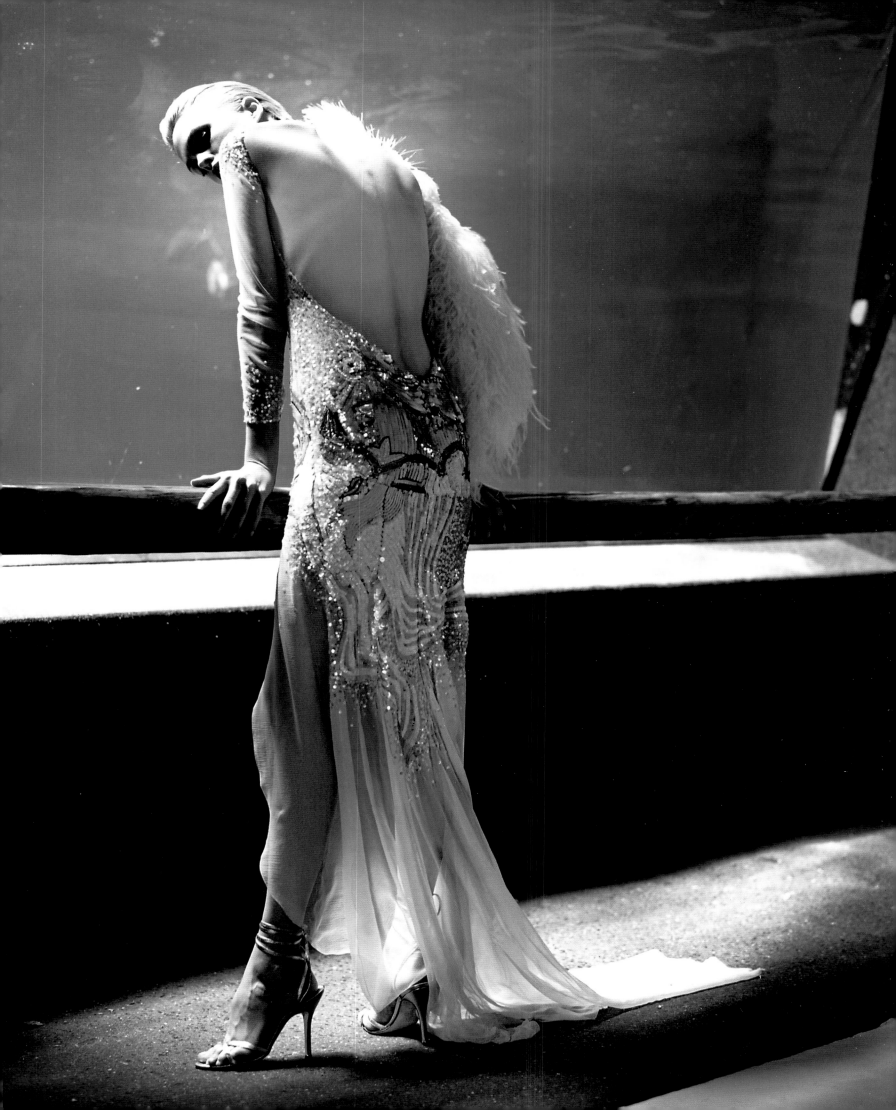

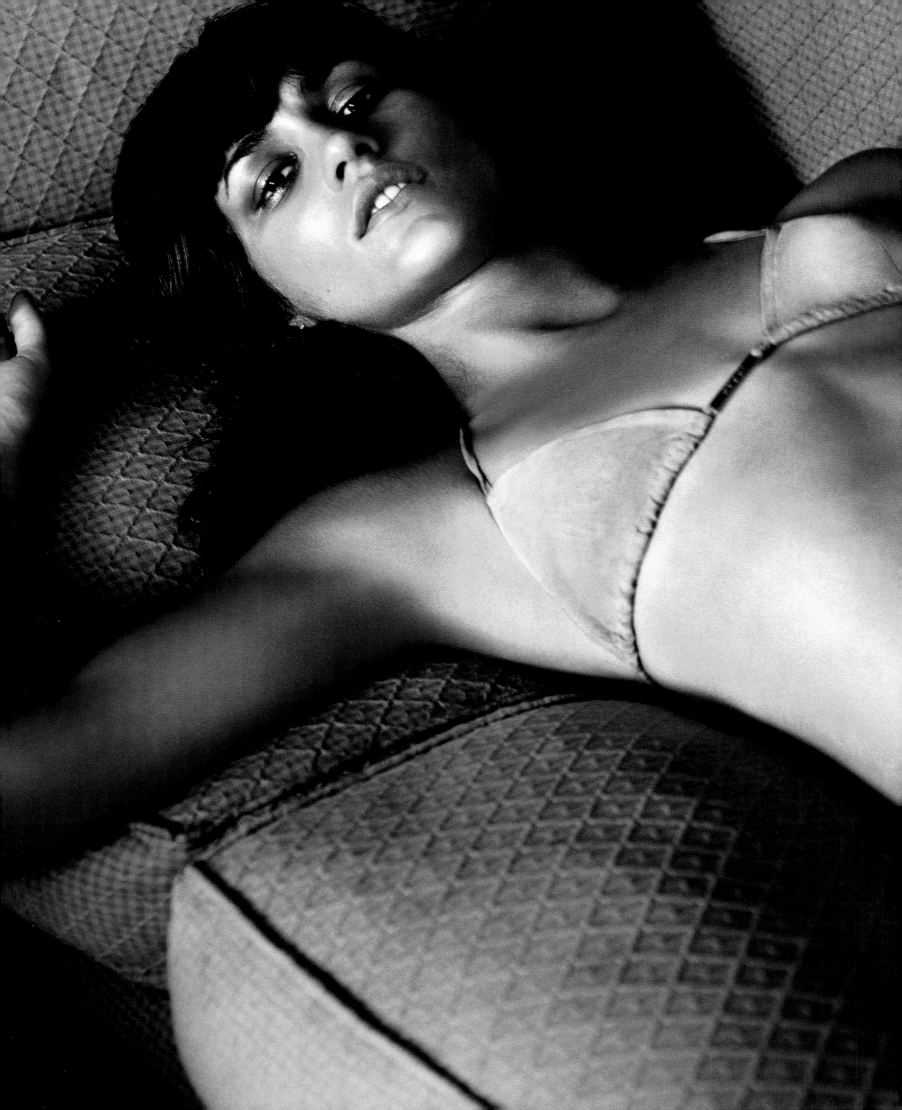

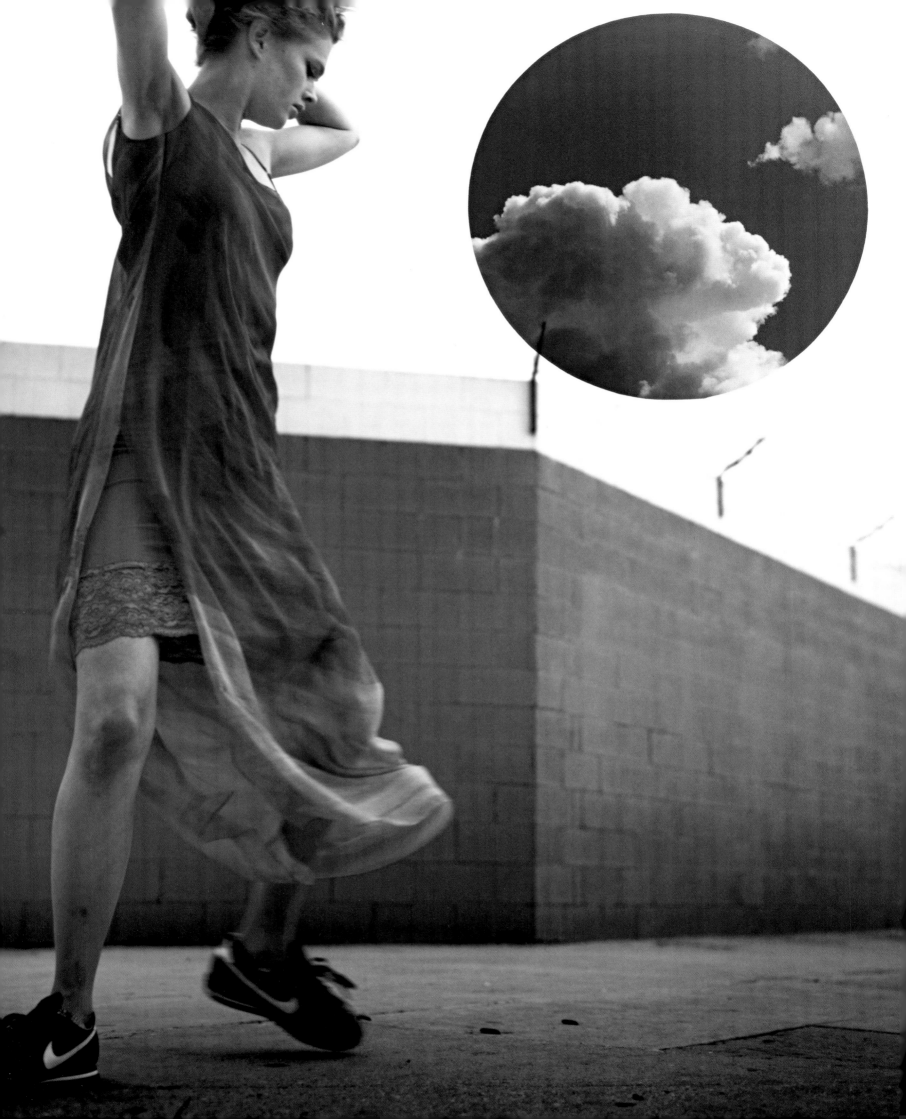

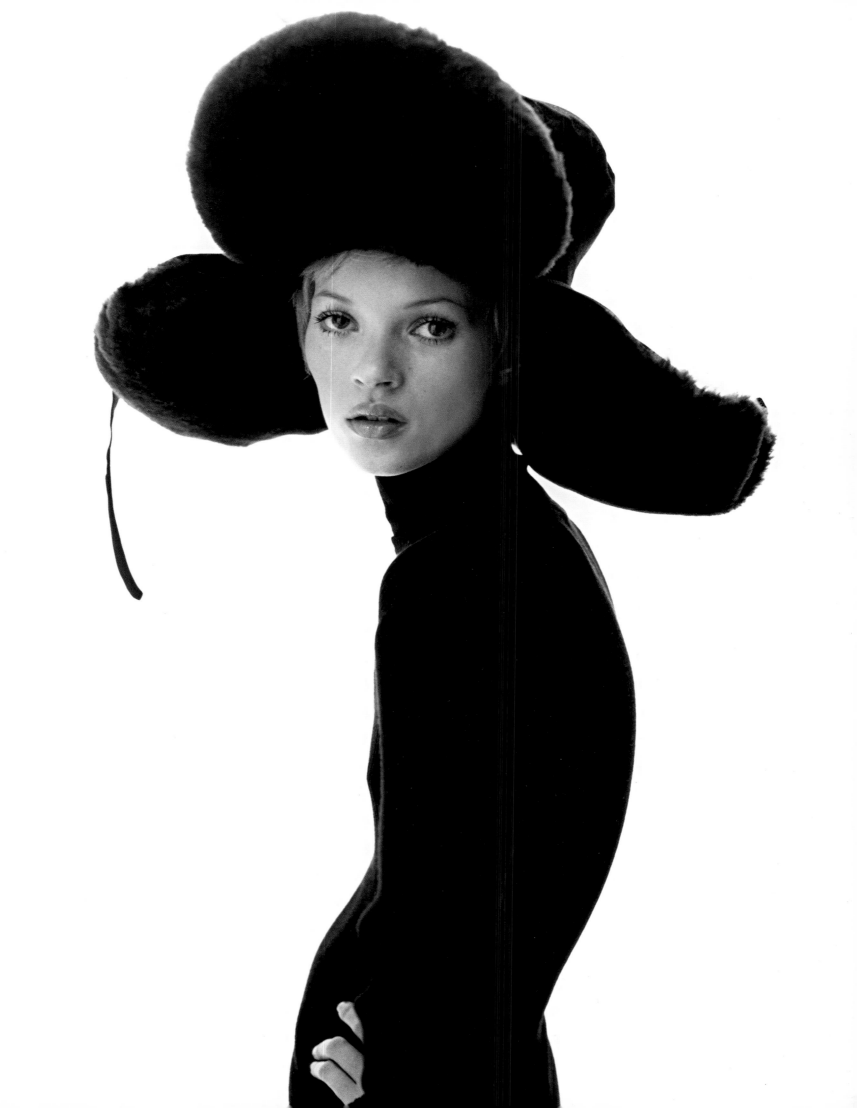

'Bad taste can be good.'

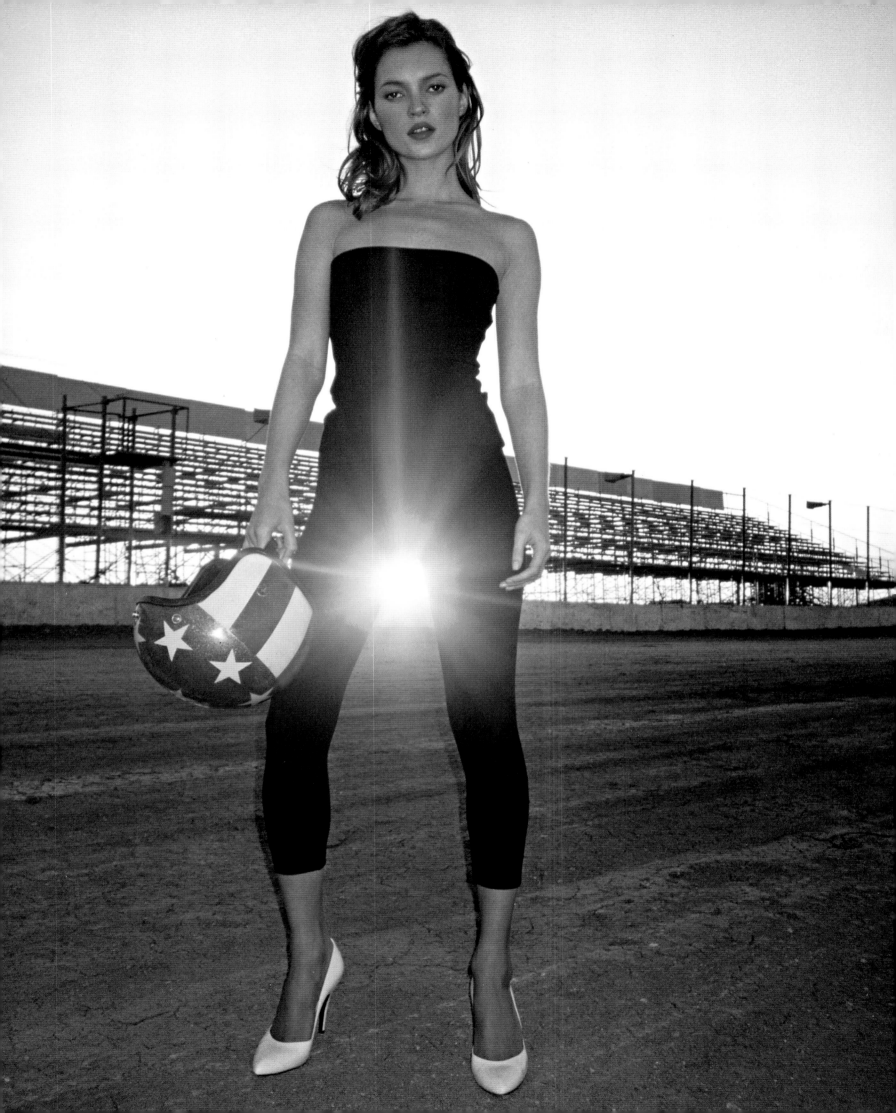

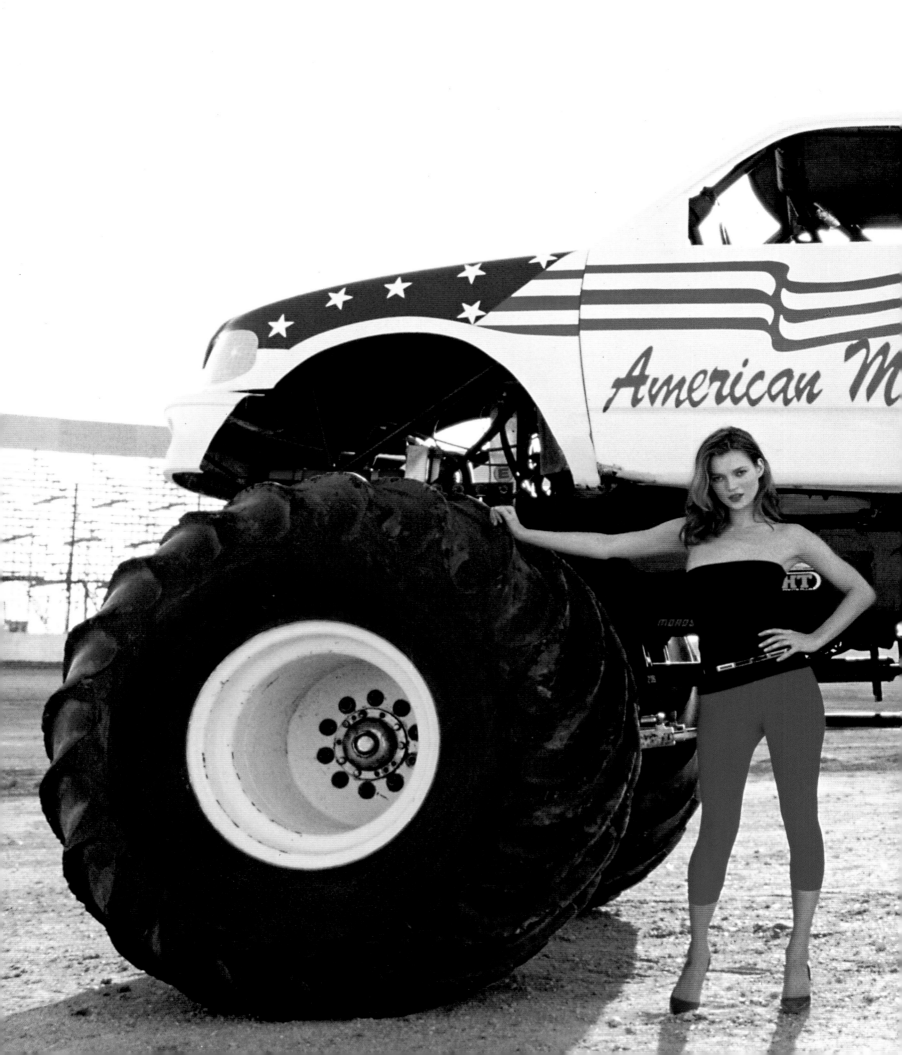

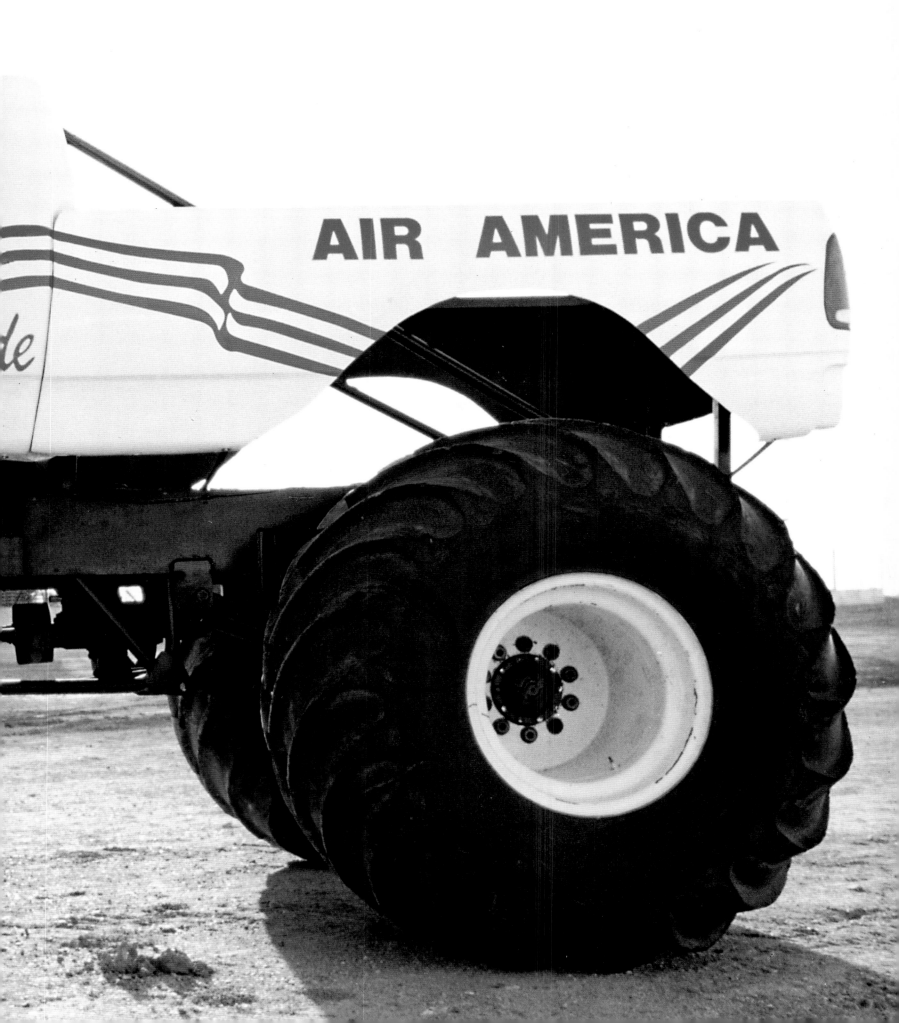

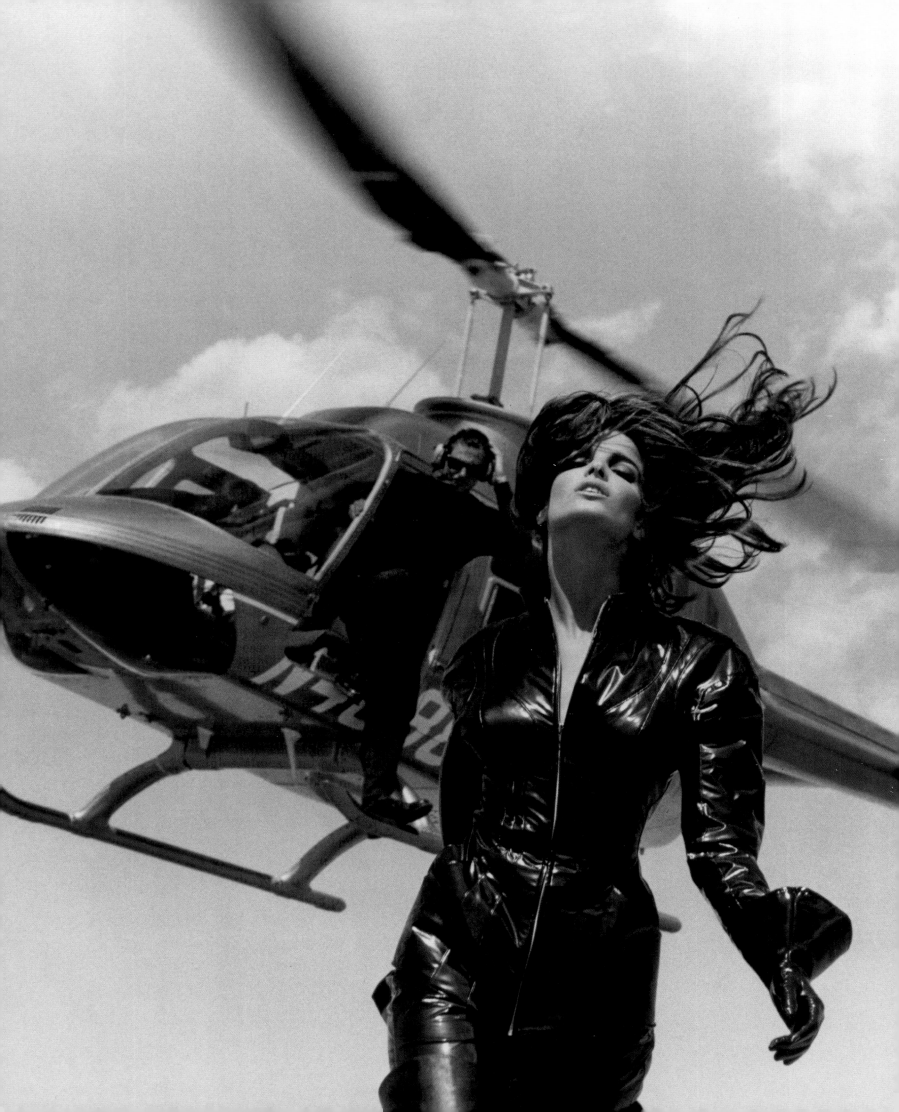

'This helicopter bill was to haunt me for the rest of my days at British Vogue. I don't think Lilly Davies in Accounts ever got over it.'

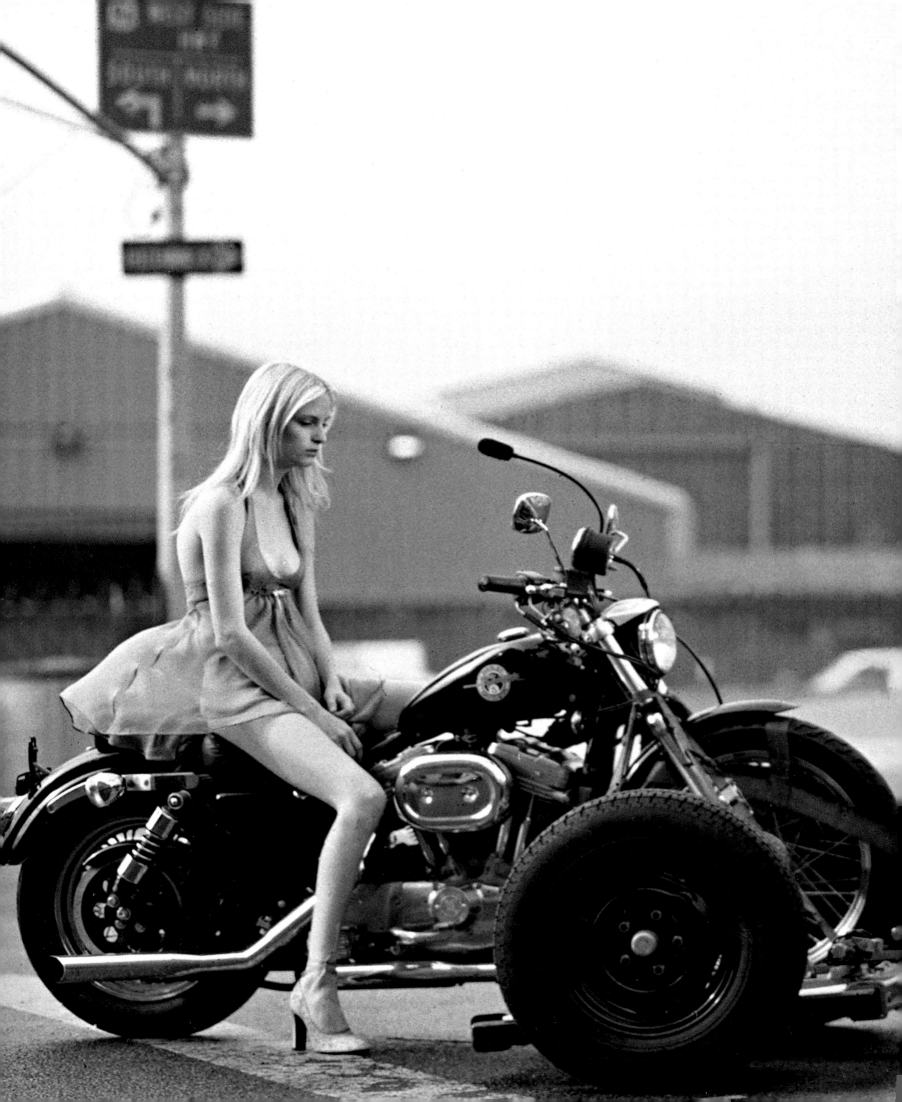

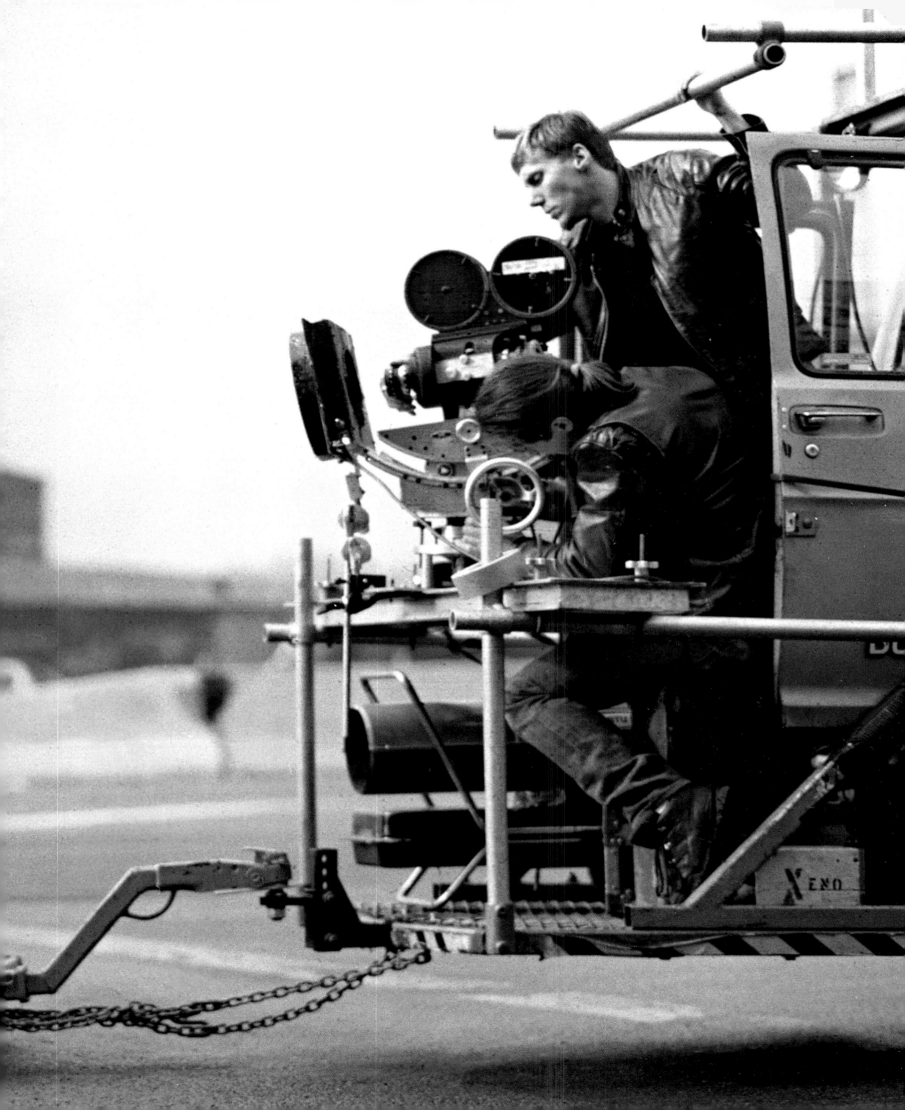

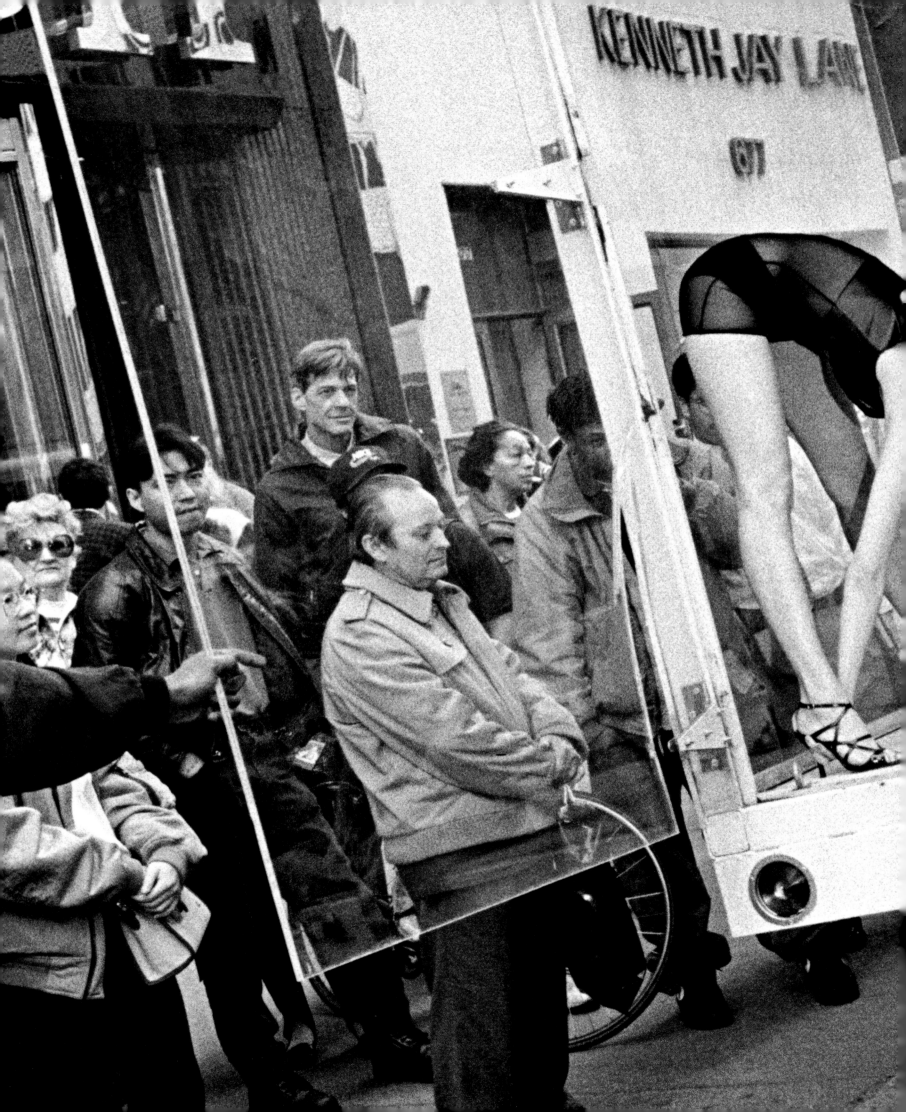

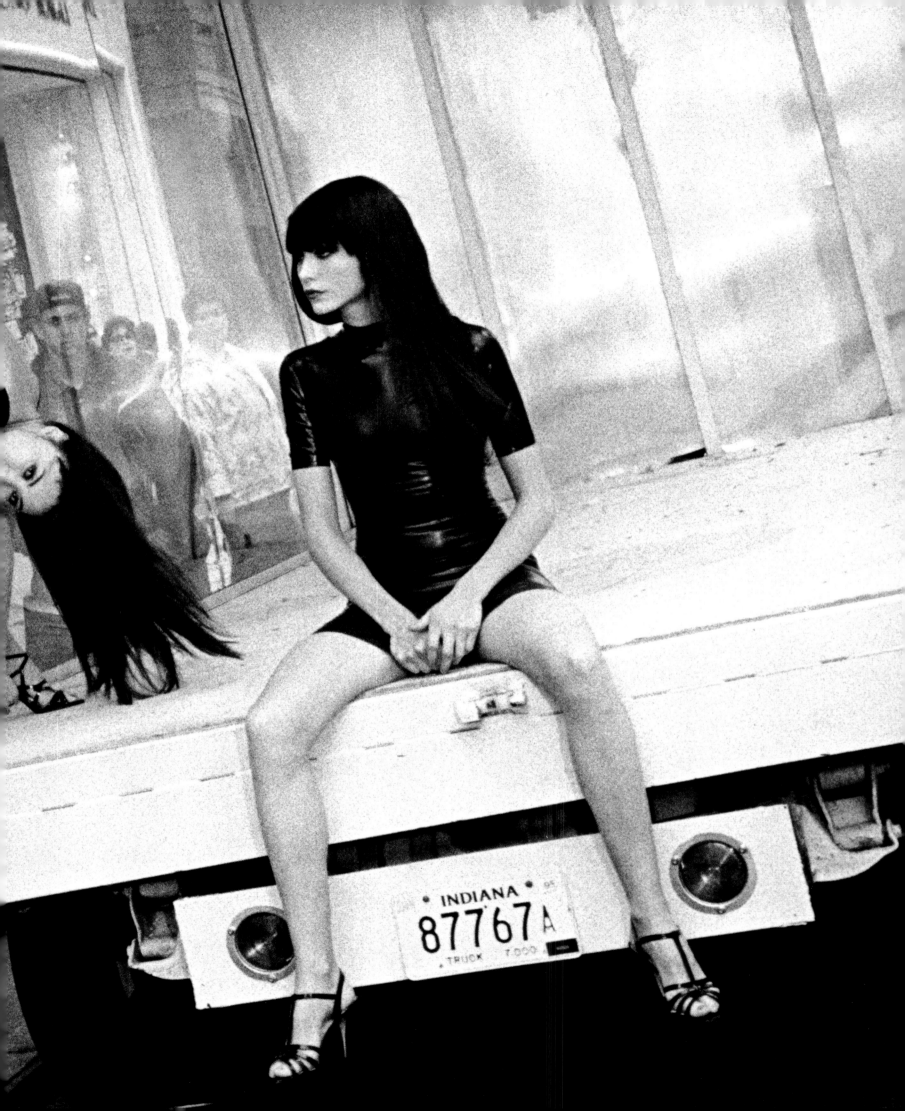

"Looking for a baby?" yelled a builder from high up on a construction site, as Cindy Crawford pushed an empty pram. "Yeah," shouted Cindy. "Whoa! I can give you one!" he yelled back.'

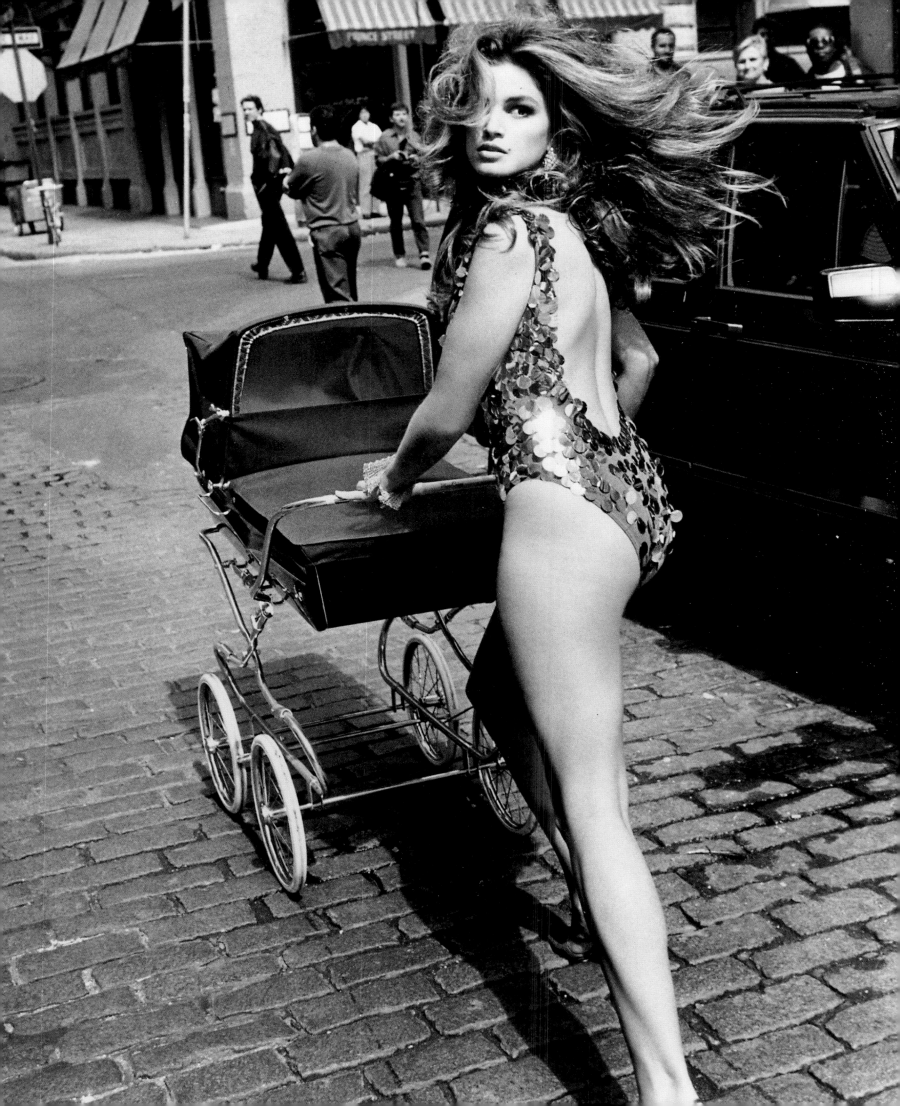

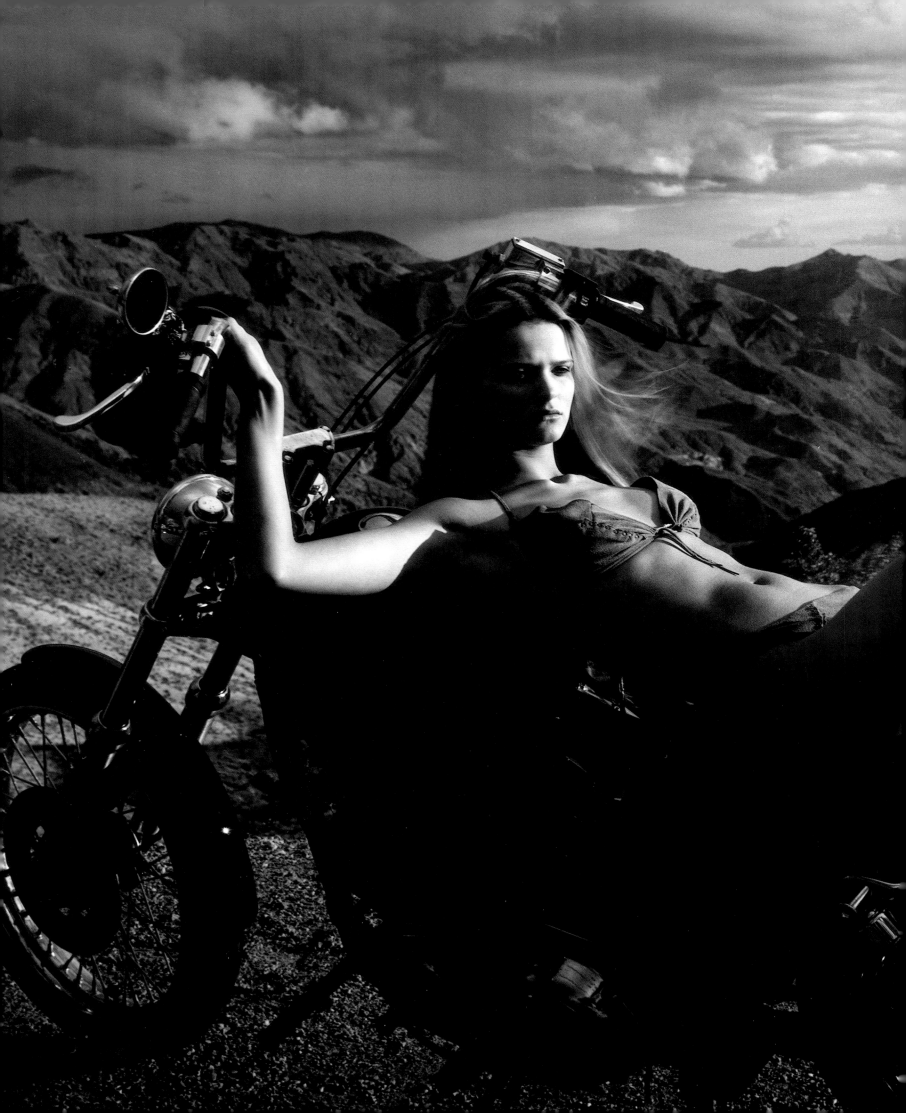

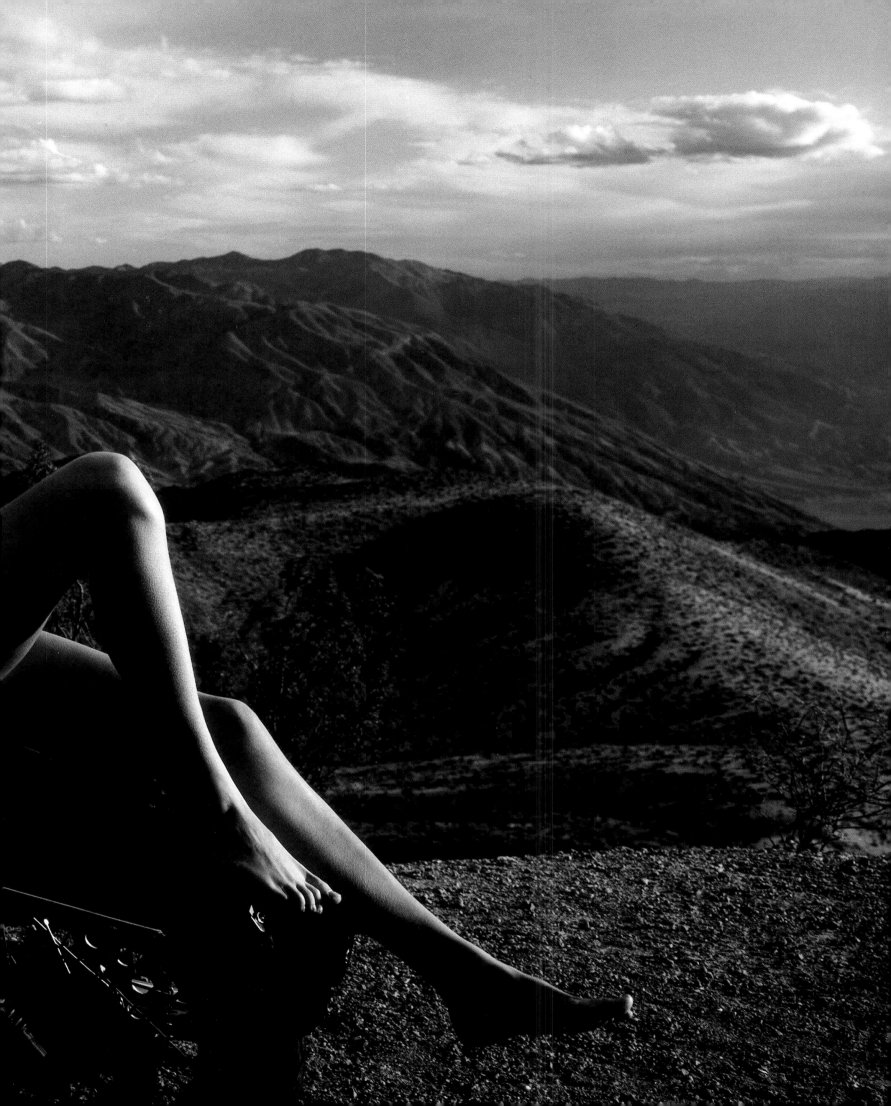

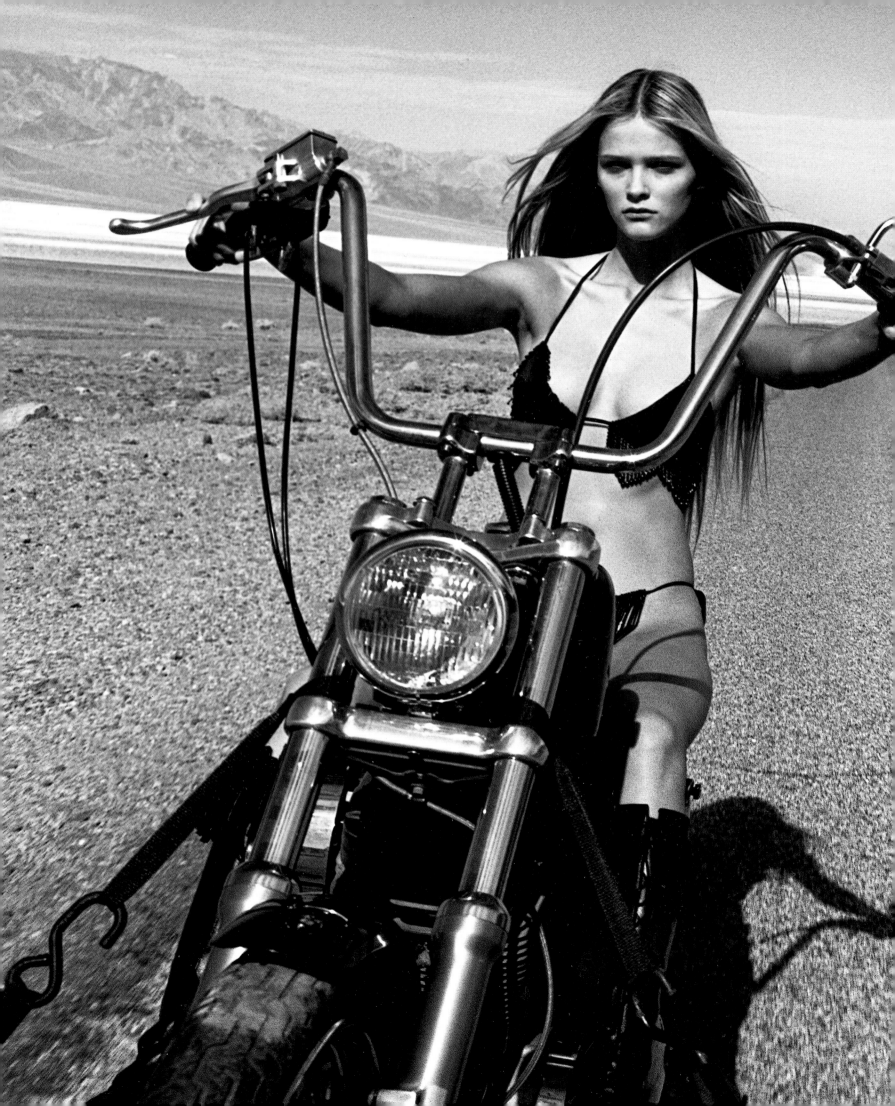

'All fashion editors have a special affinity with a particular style. Mine probably stems from a desire to recreate my grandmother's elegance and my mother's bohemian chic.'

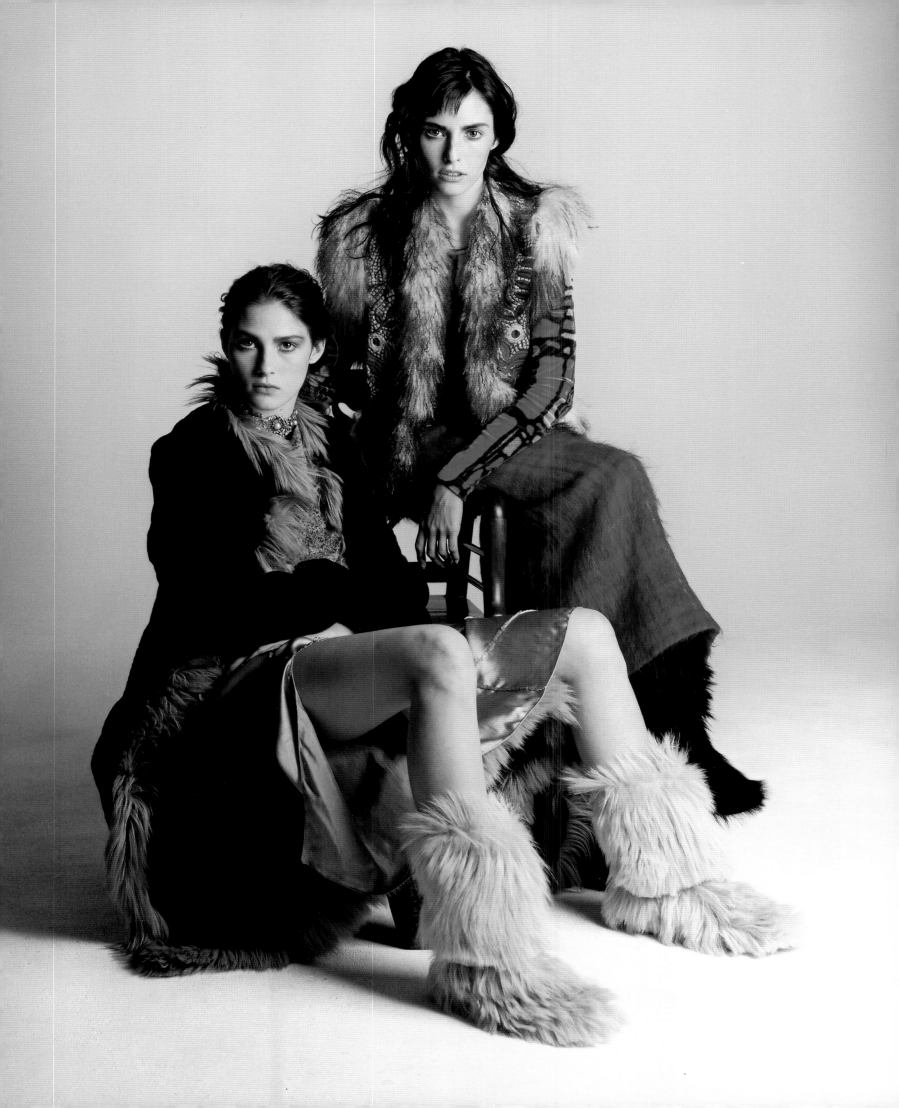

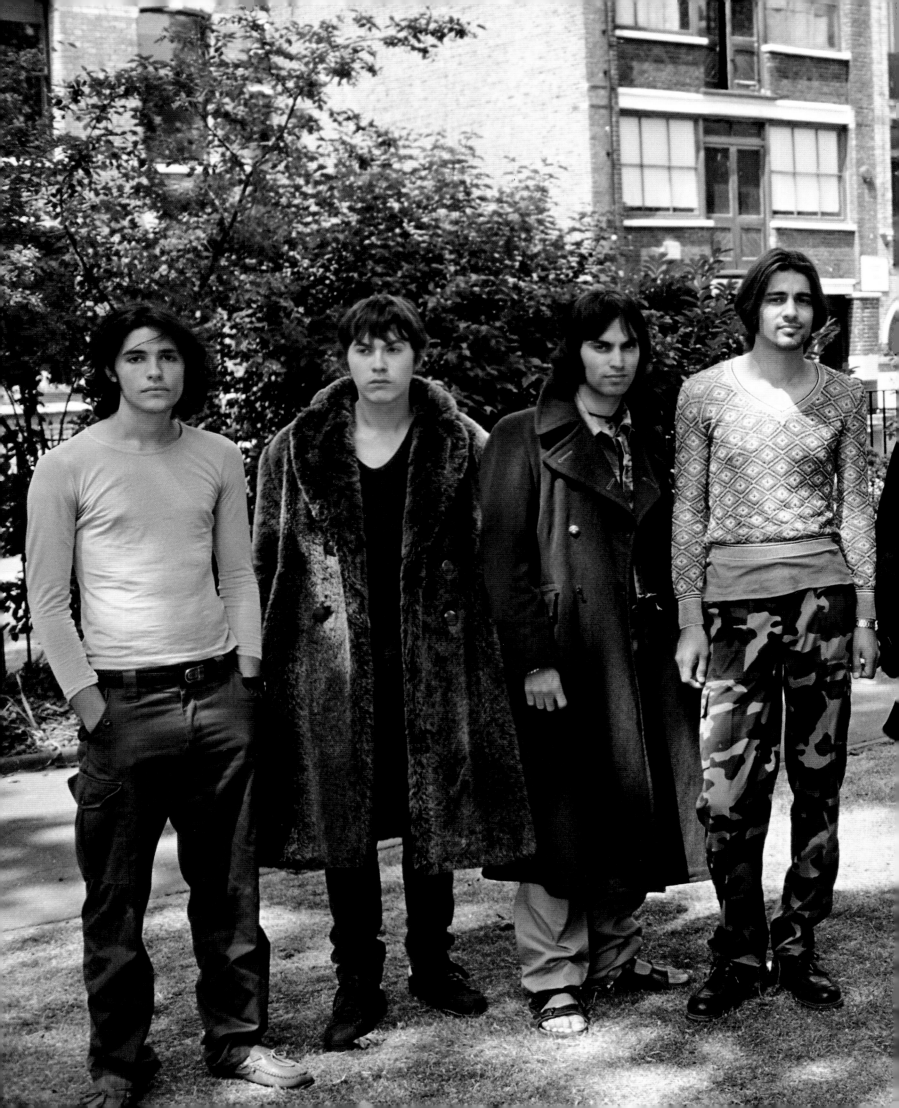

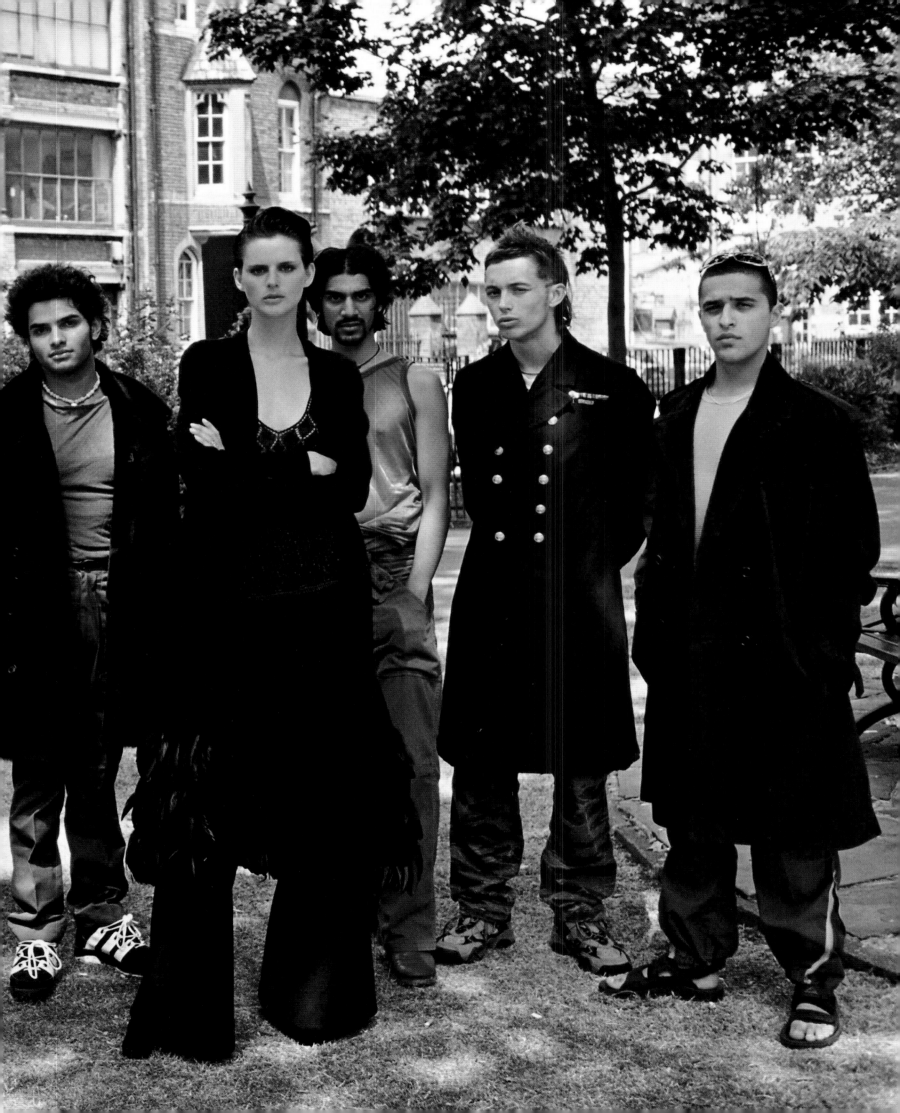

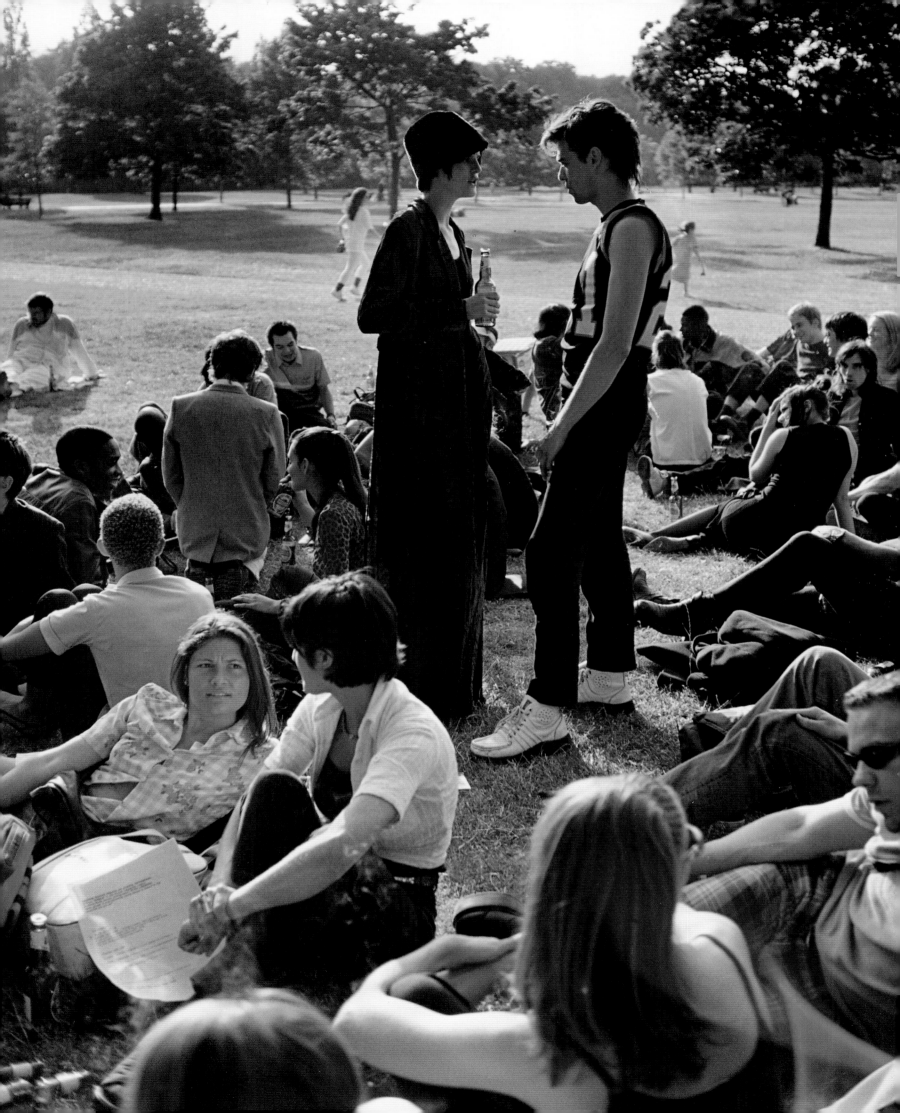

'To round up groovy-looking London kids, we stuck notices on every lamp-post down Kensington High Street, saying: "For free beer and photographs by world-famous Peter Lindbergh, meet at Palace Gate, Kensington Gardens, at 1:00 p.m."'

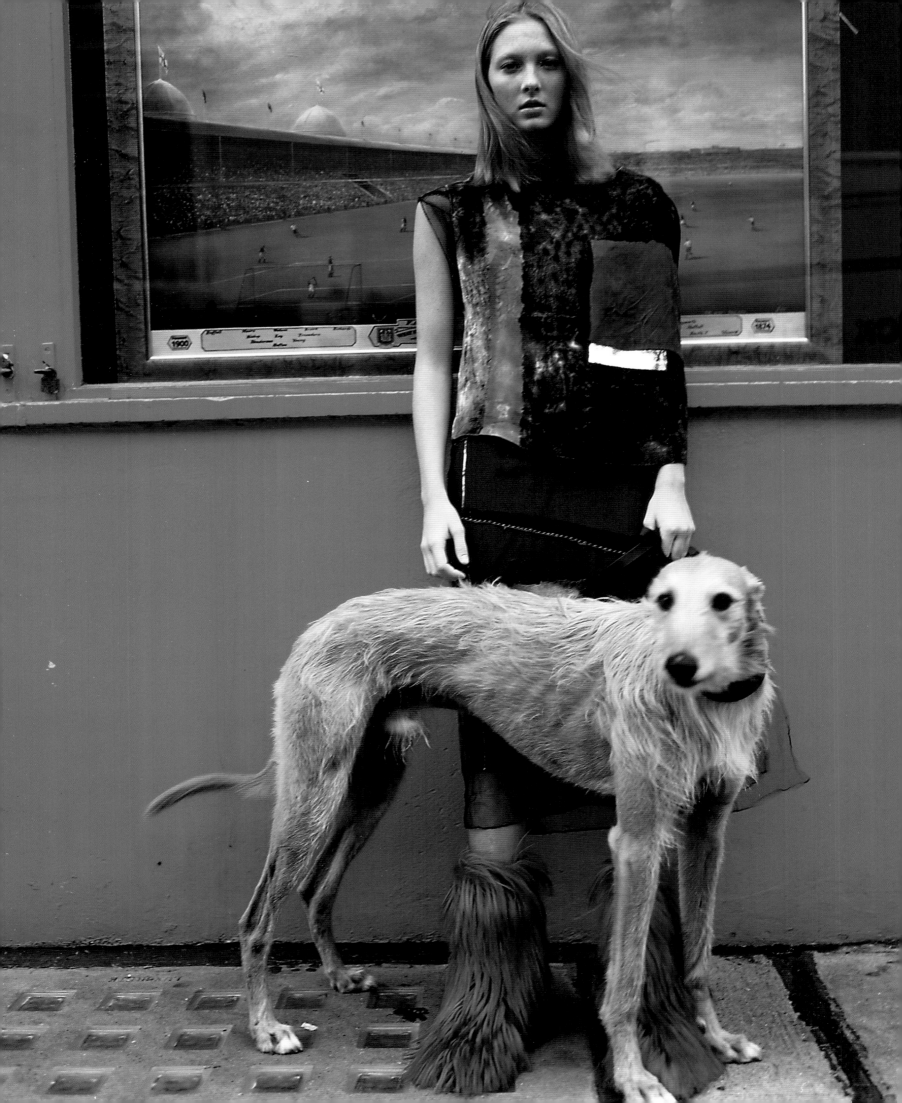

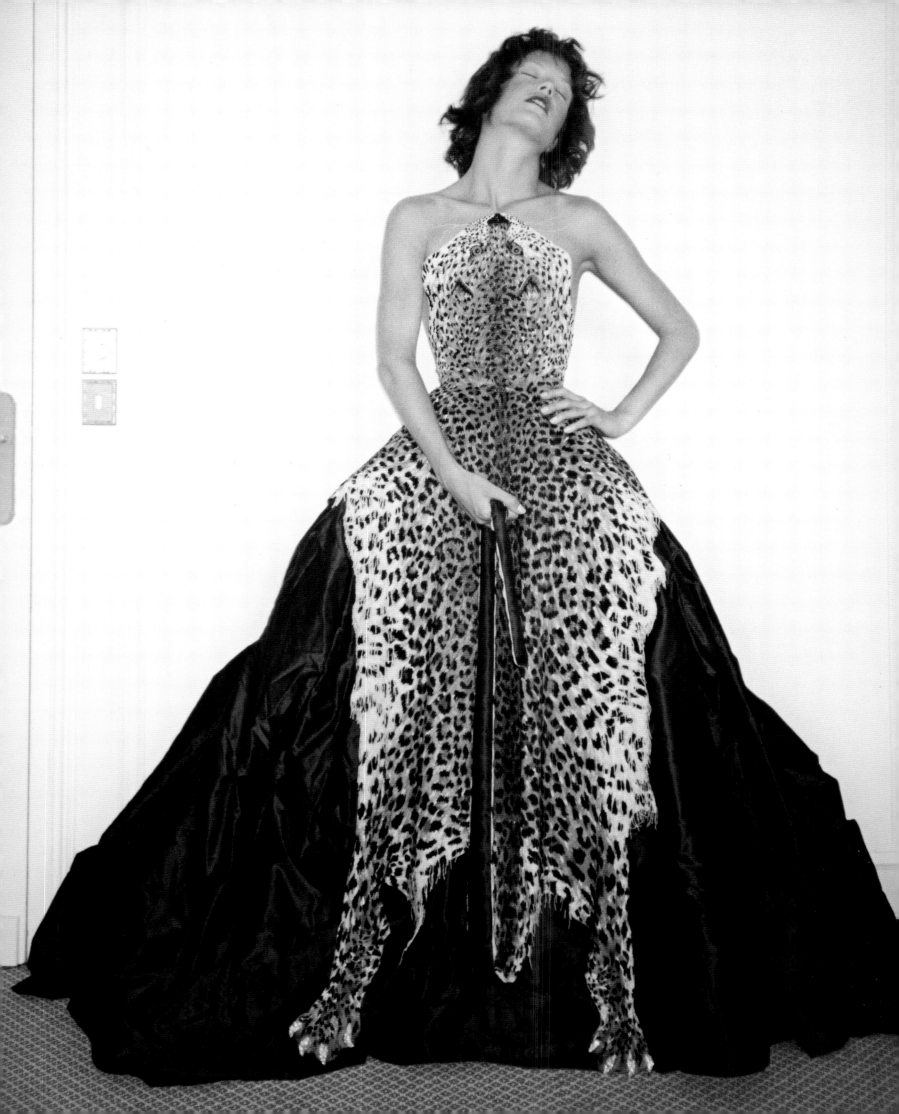

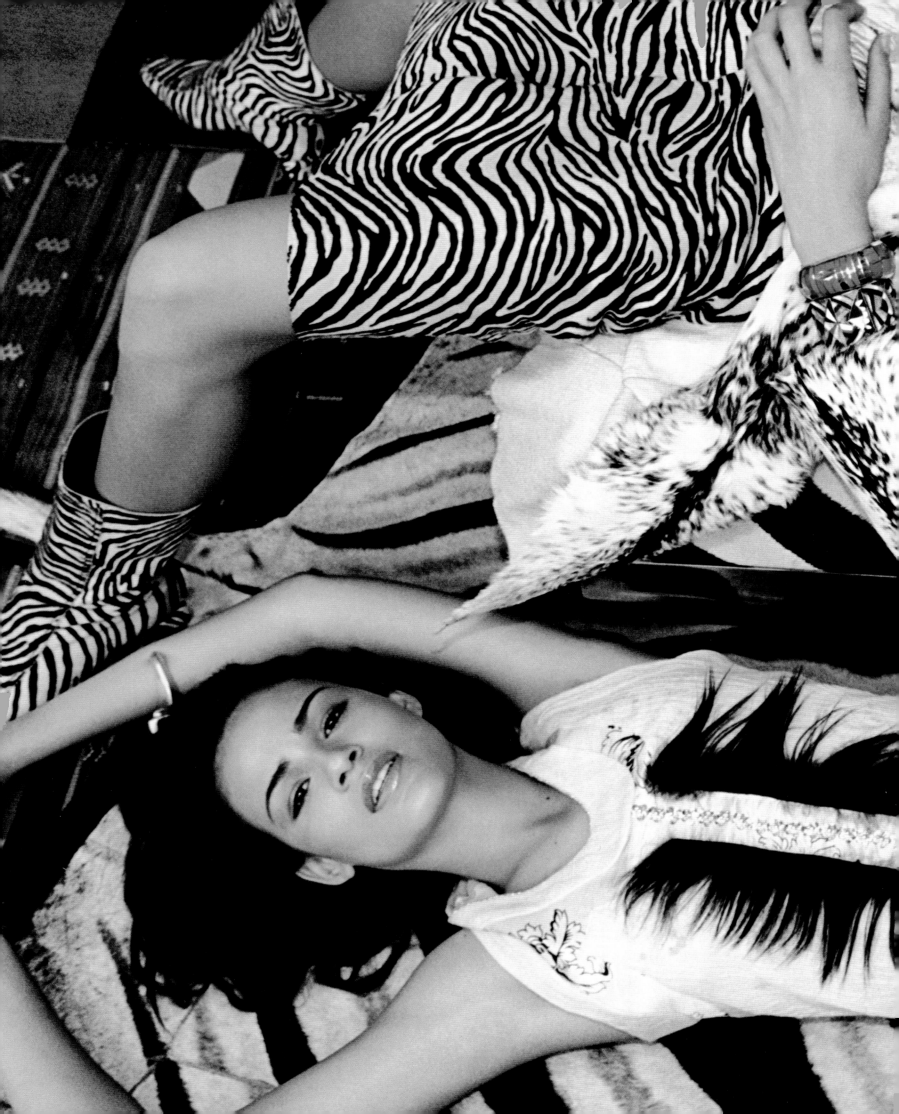

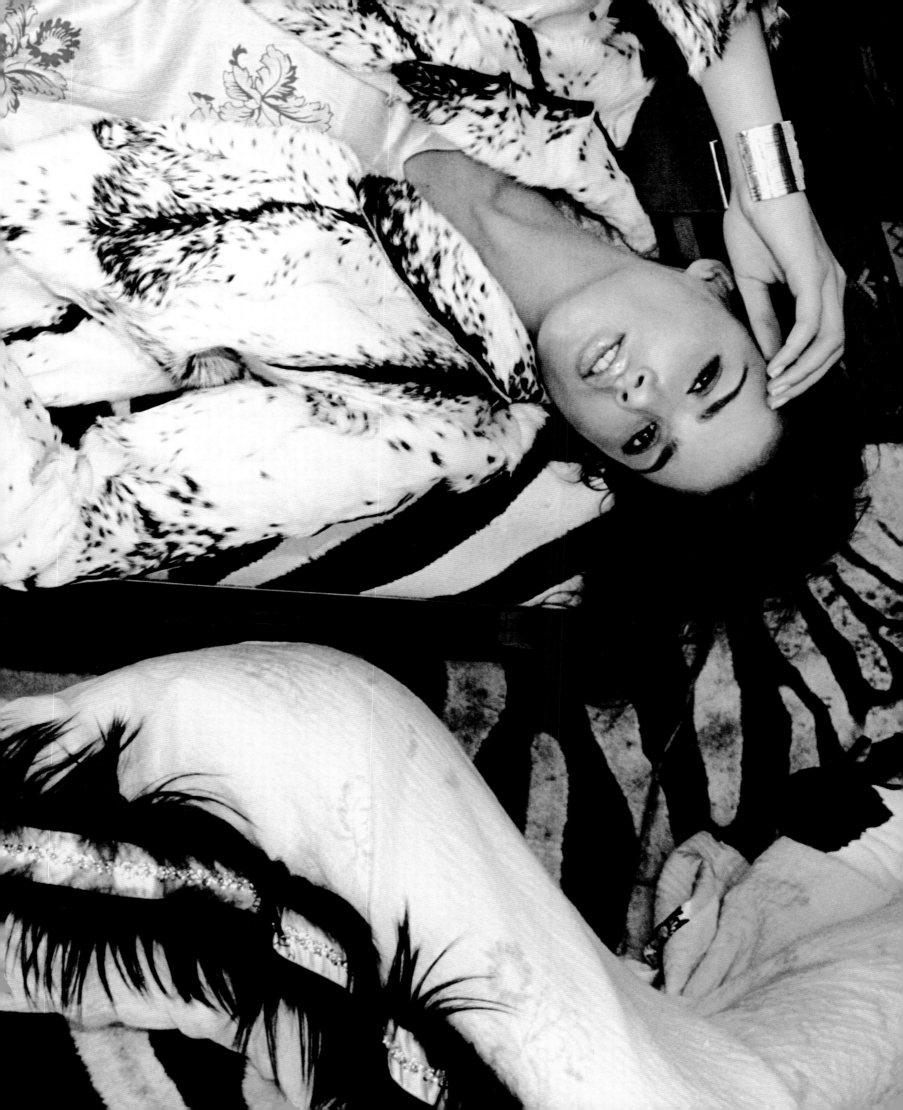

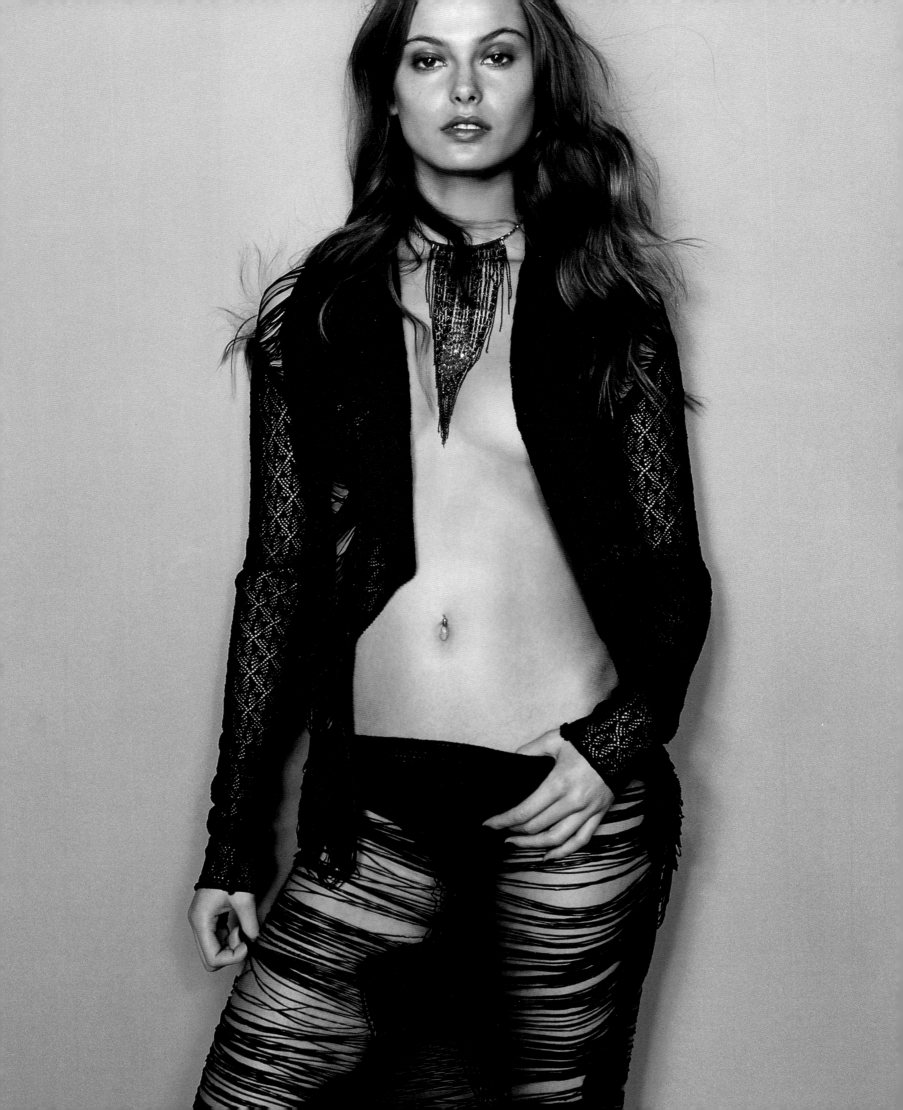

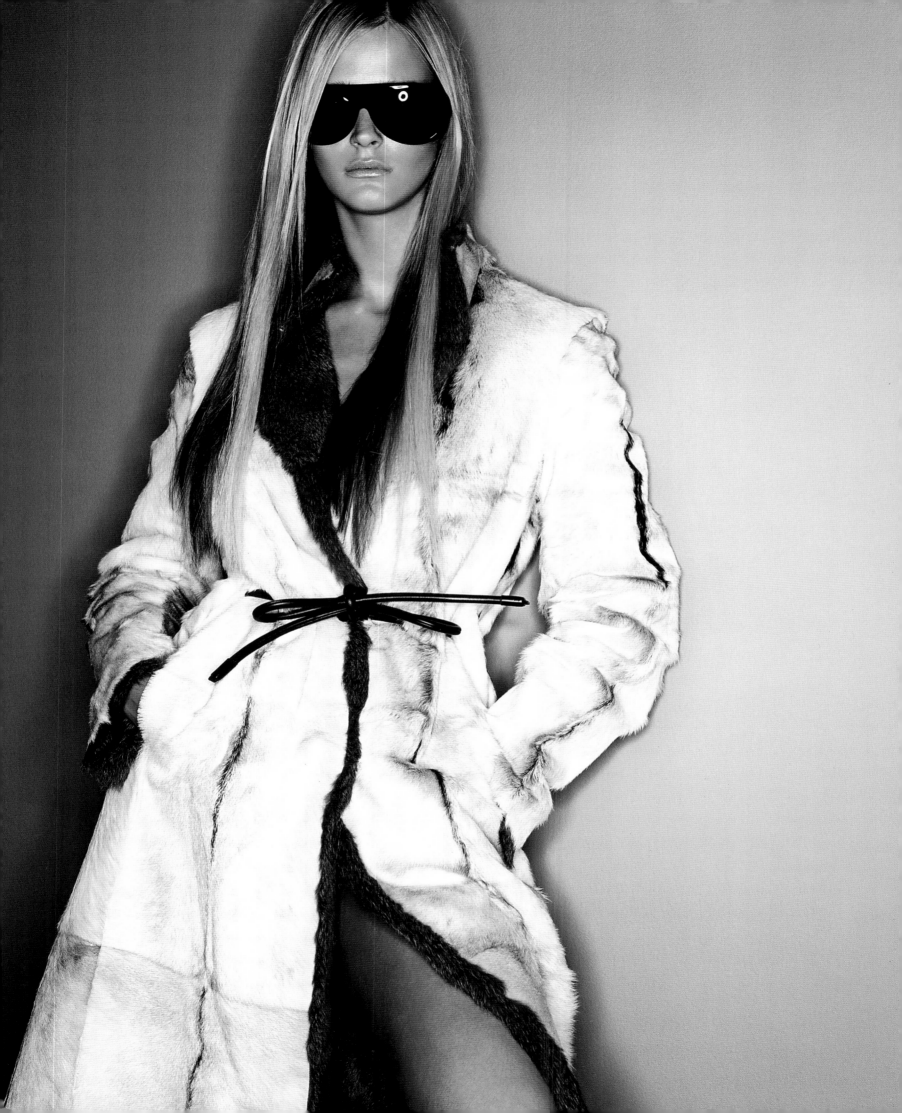

'Classic chic is timeless.'

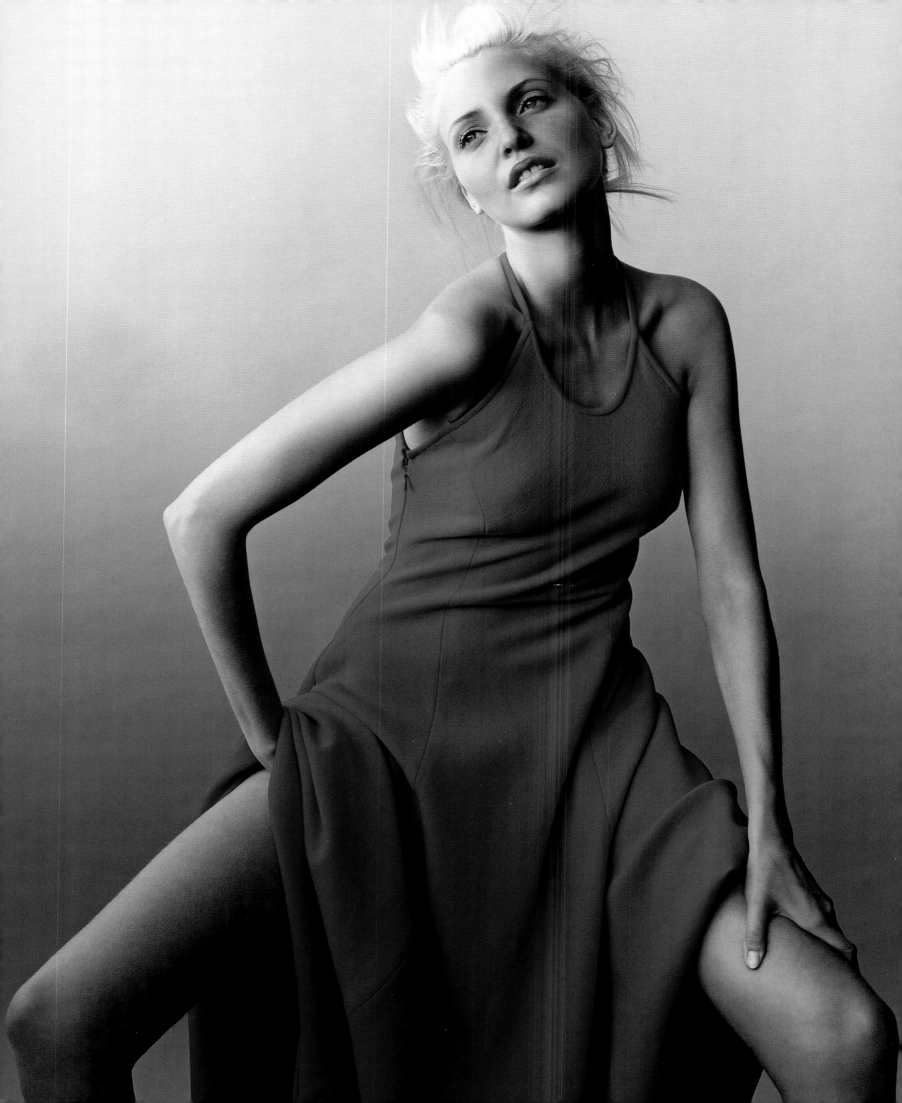

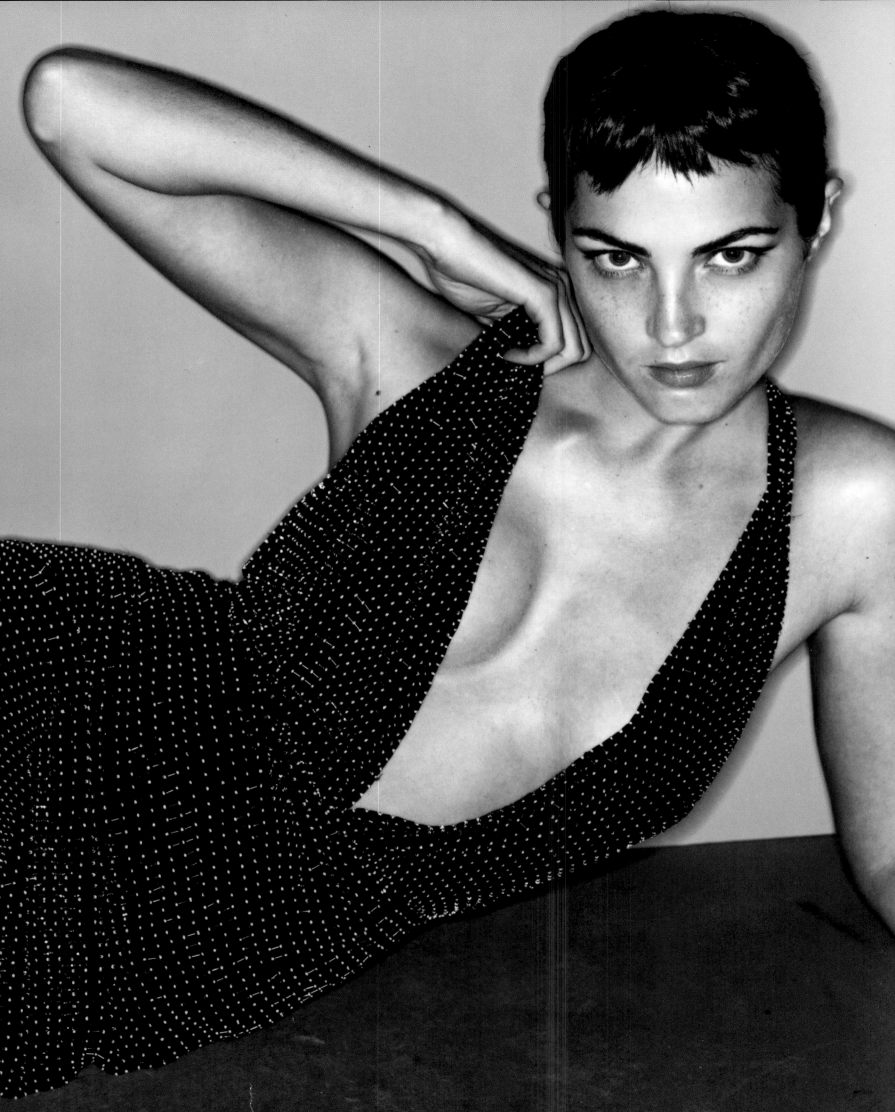

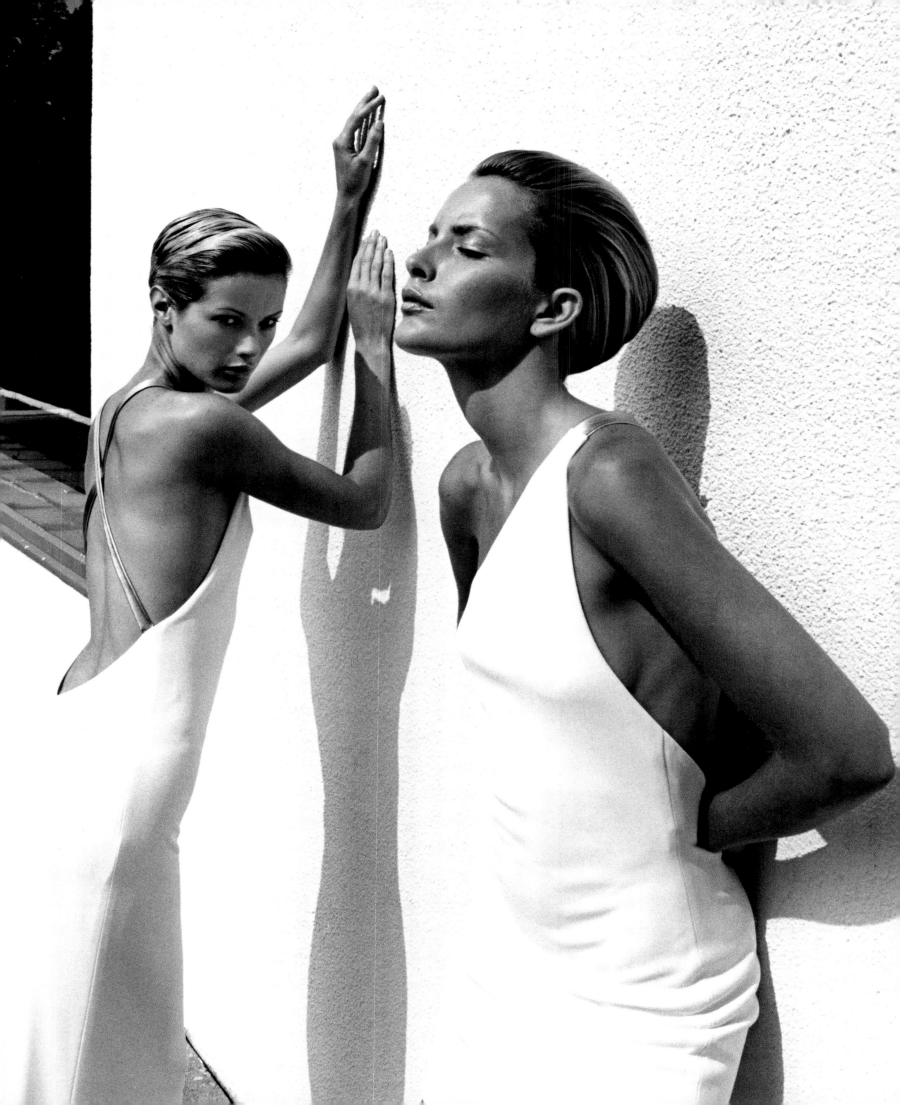

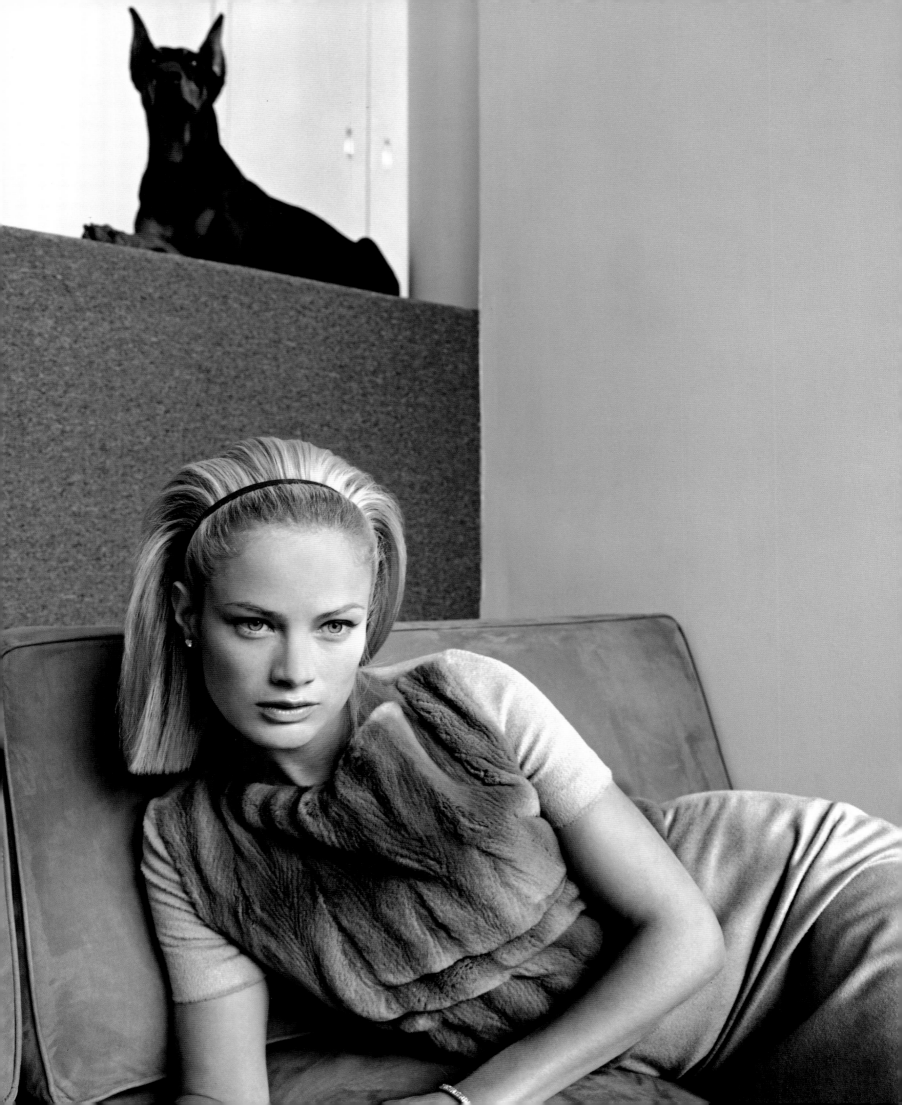

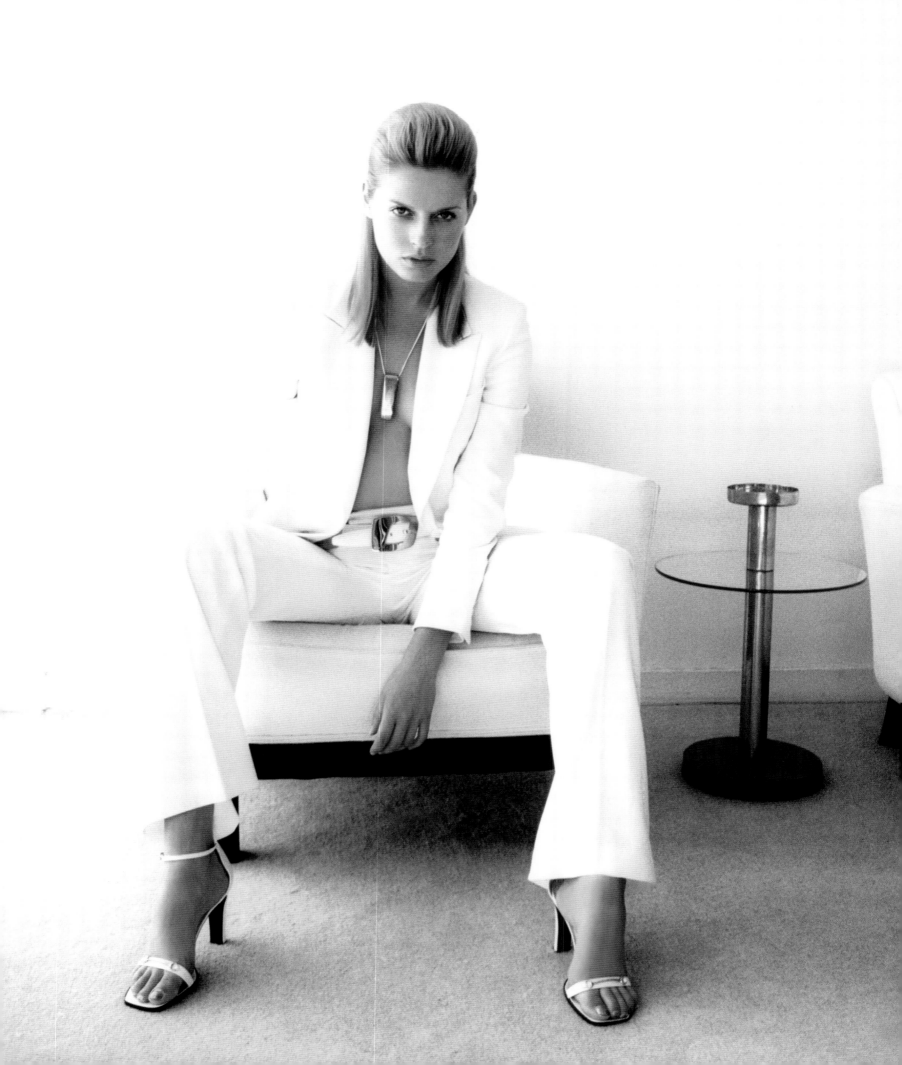

"Who are these for?" asked a big bossy customs man at L.A. airport, as he inspected trunks of gold and silver breastplates. "Madonna," I replied. He rolled his eyes and slammed the cases shut.'

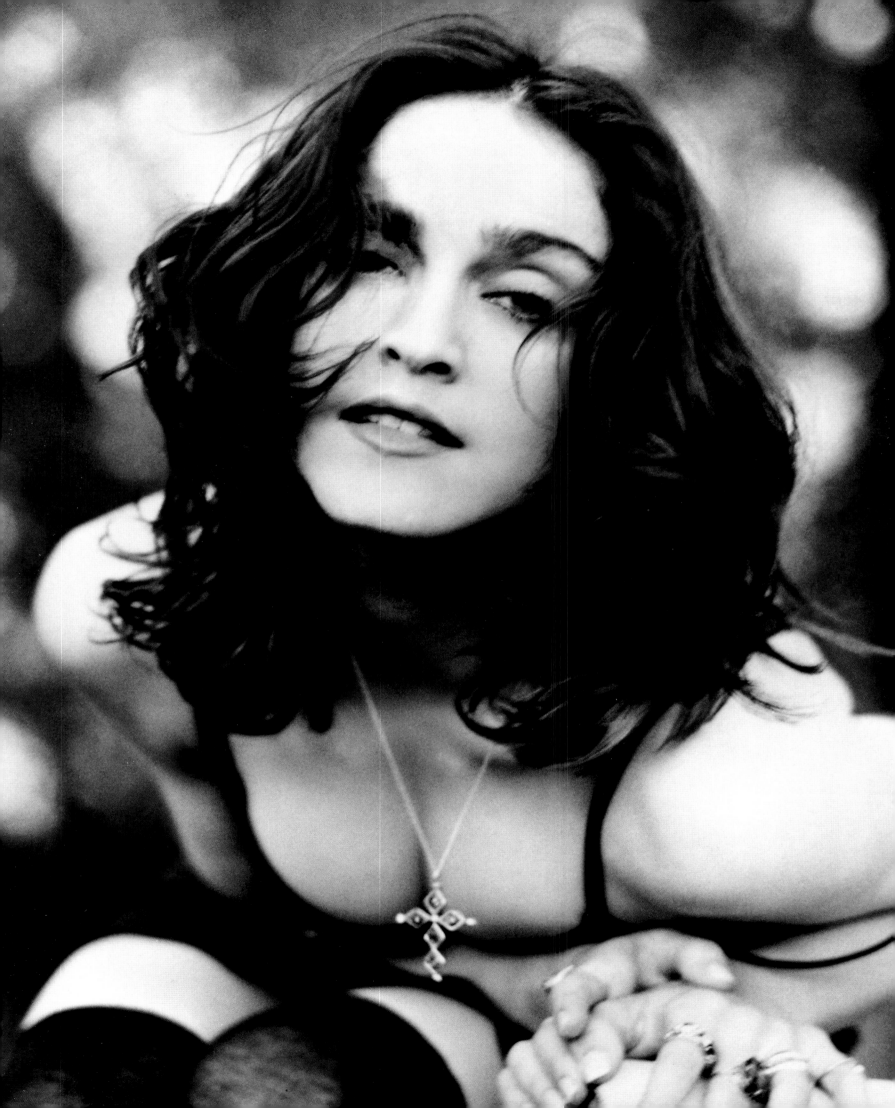

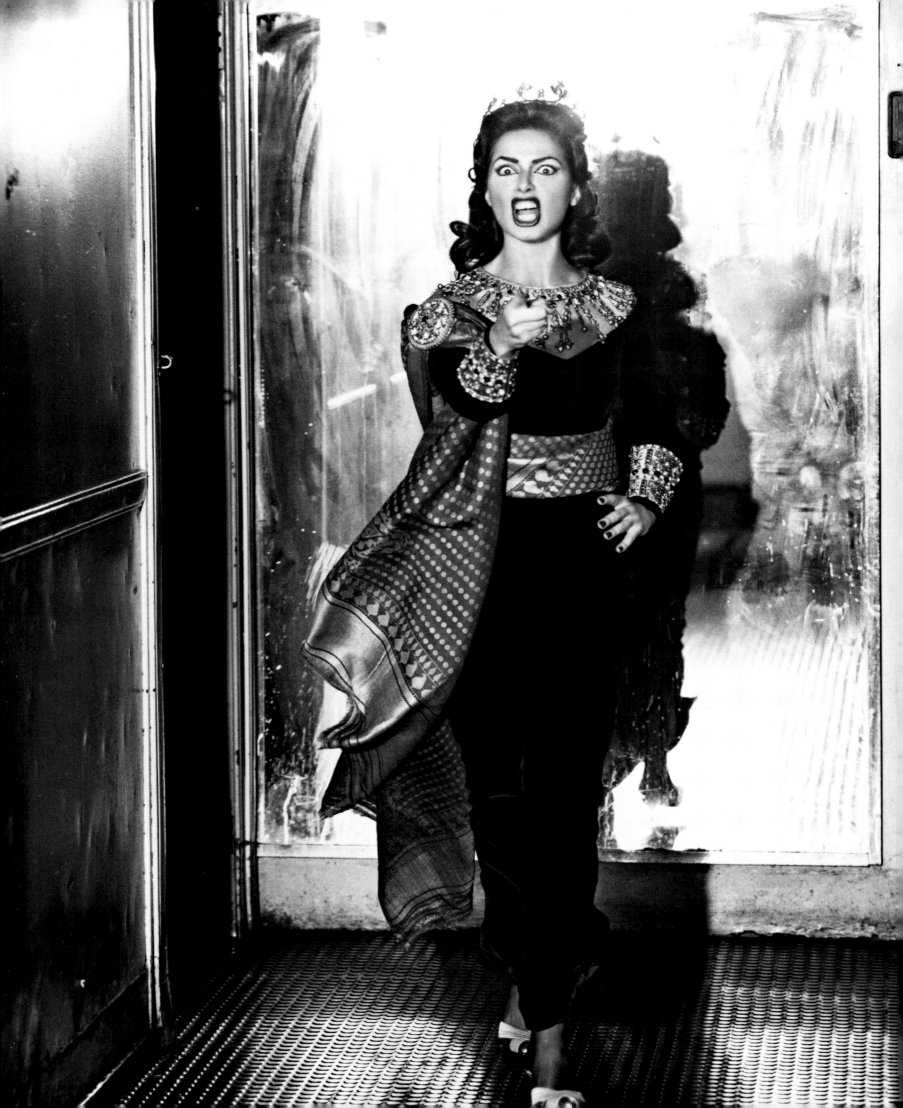

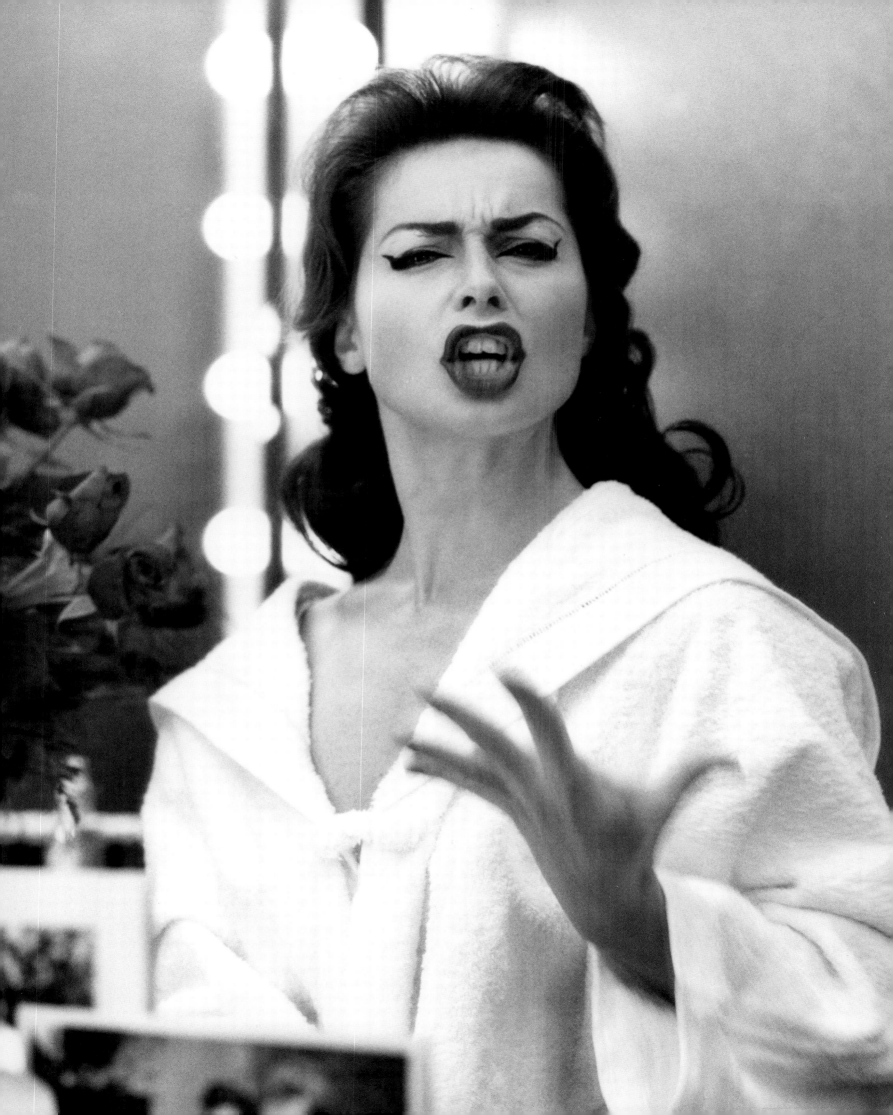

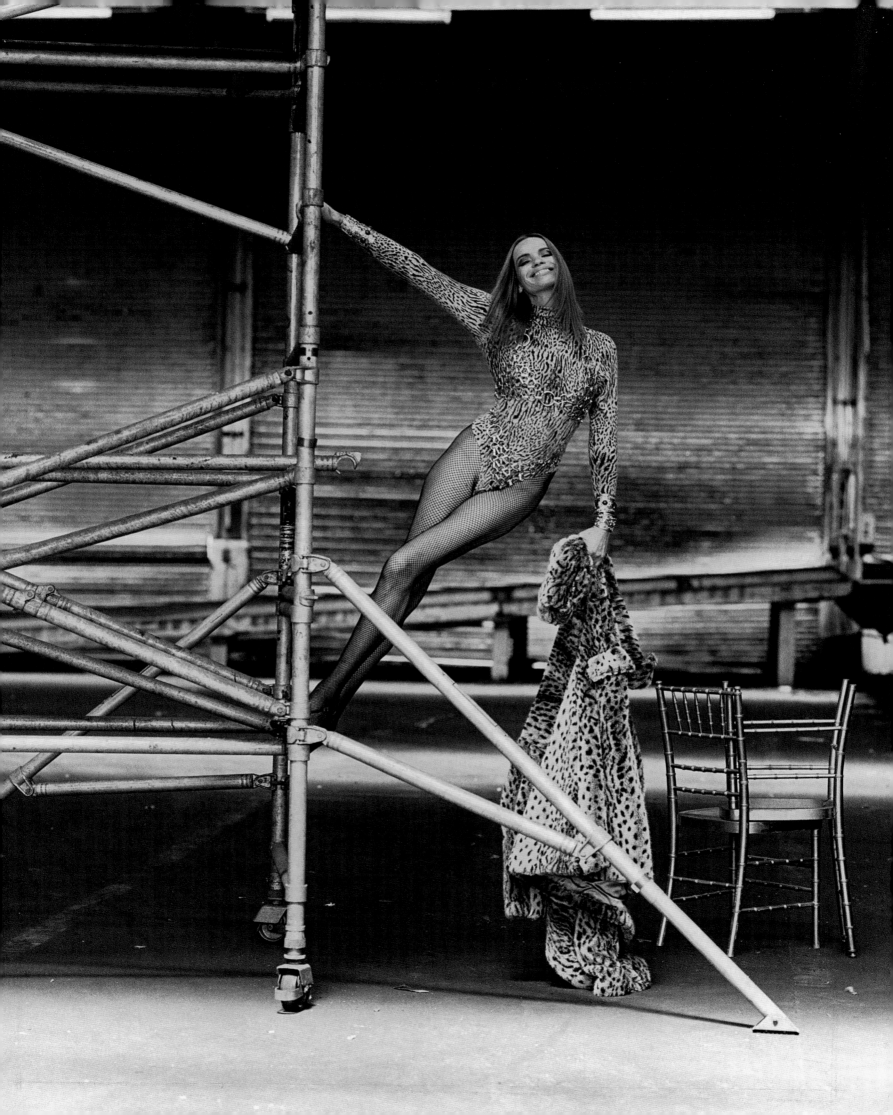

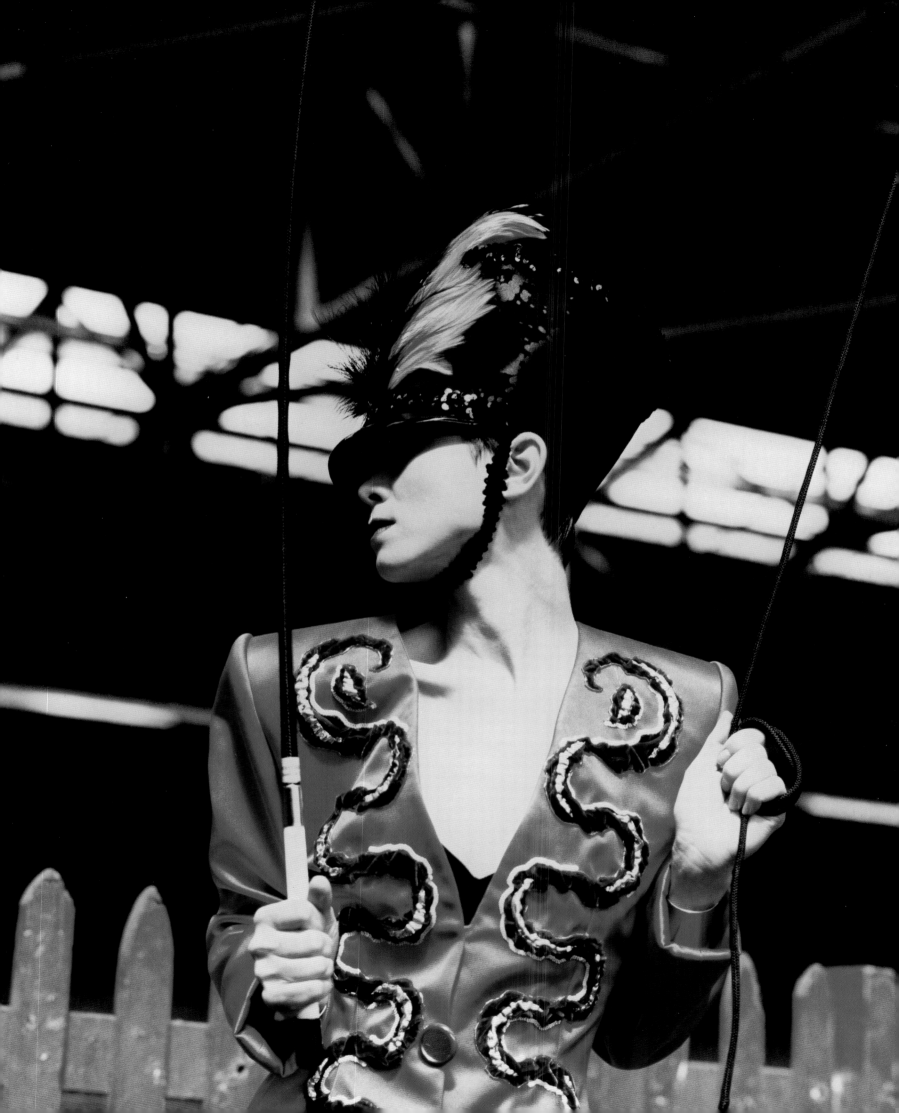

'You have to be extreeeeemely careful when shooting celebrities; I mistook Janet Jackson's boyfriend for my hotel porter...yikes'

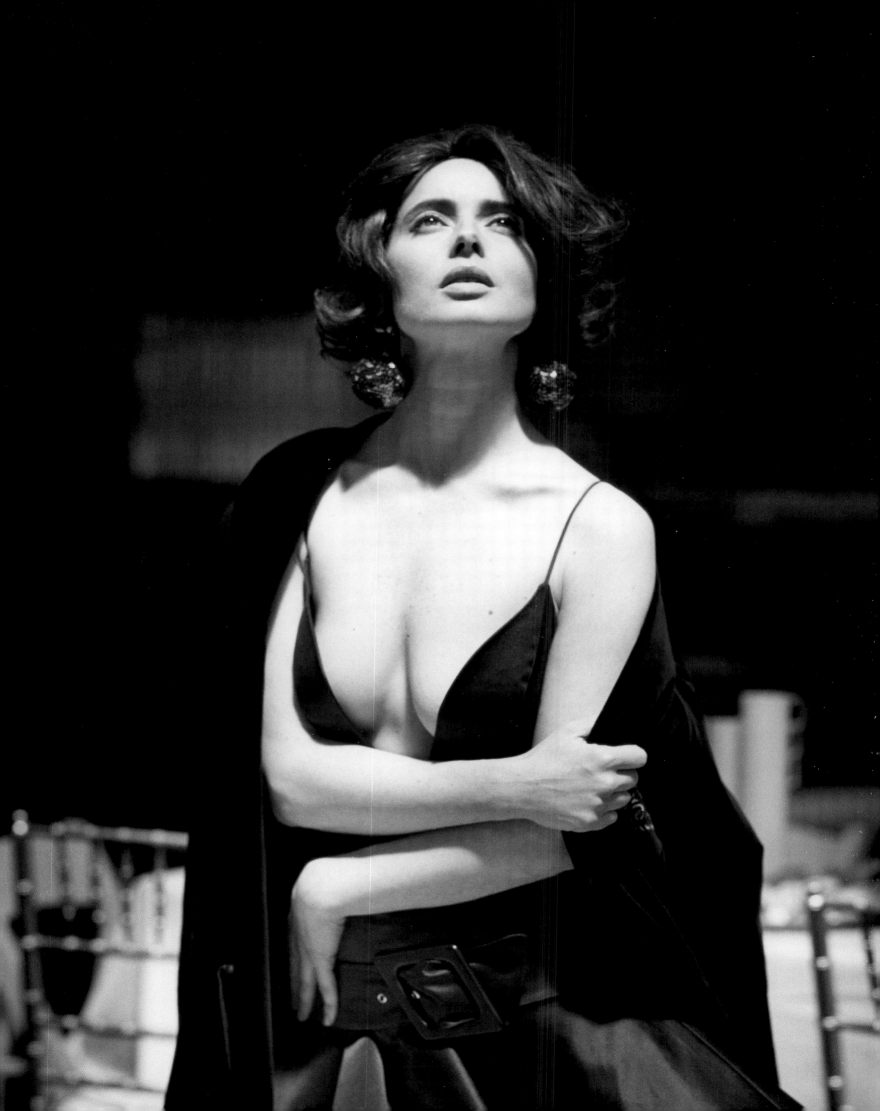

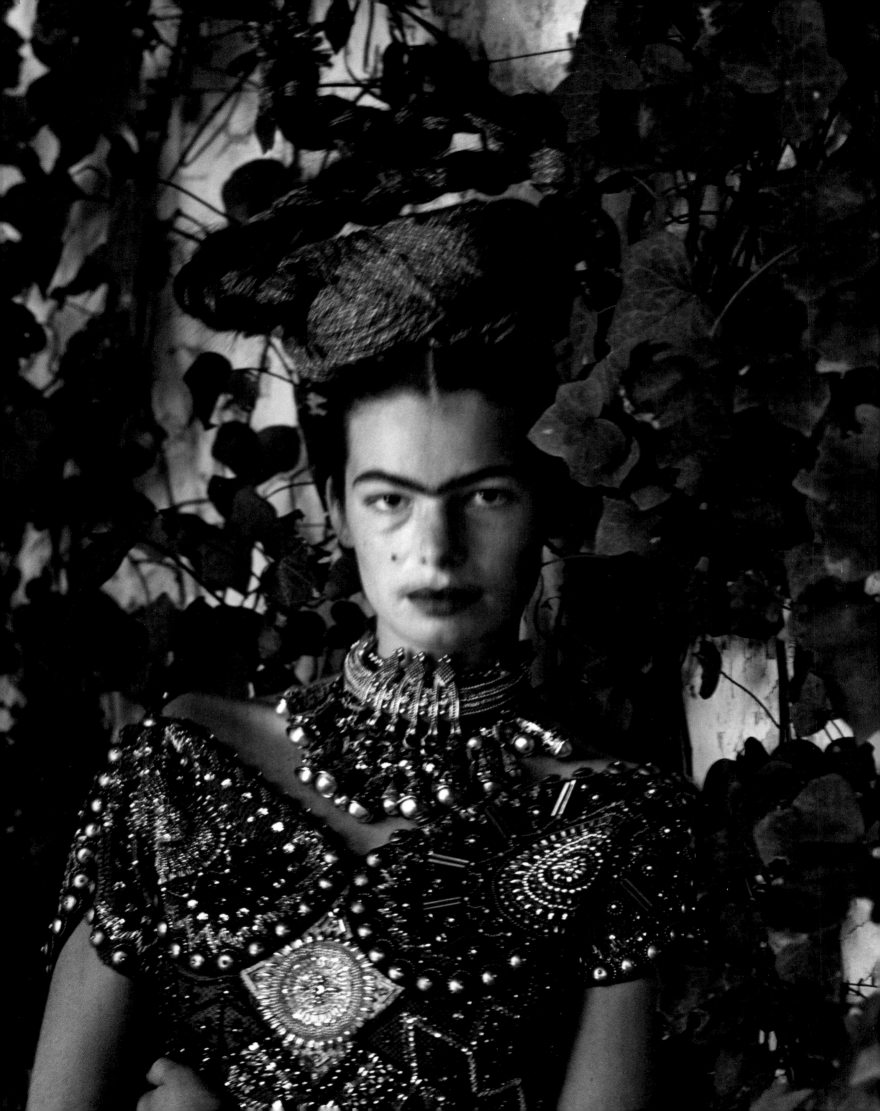

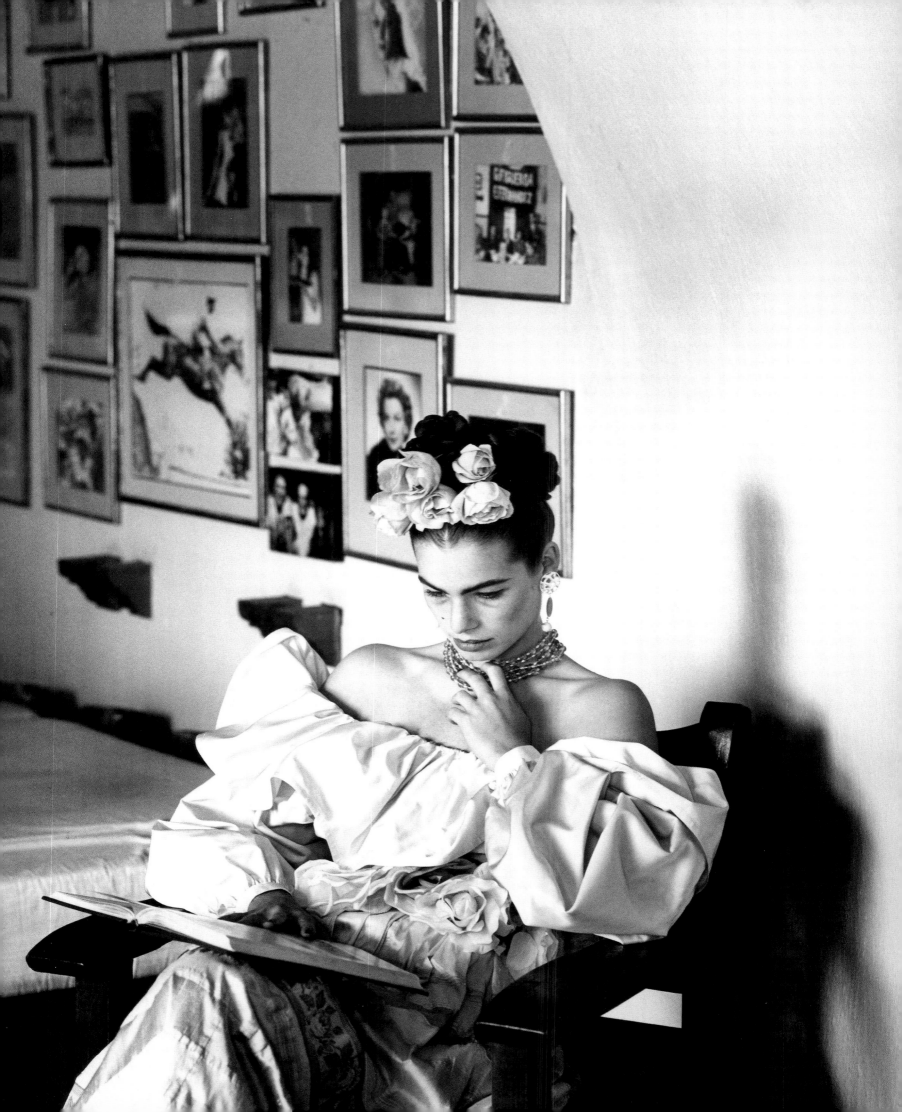

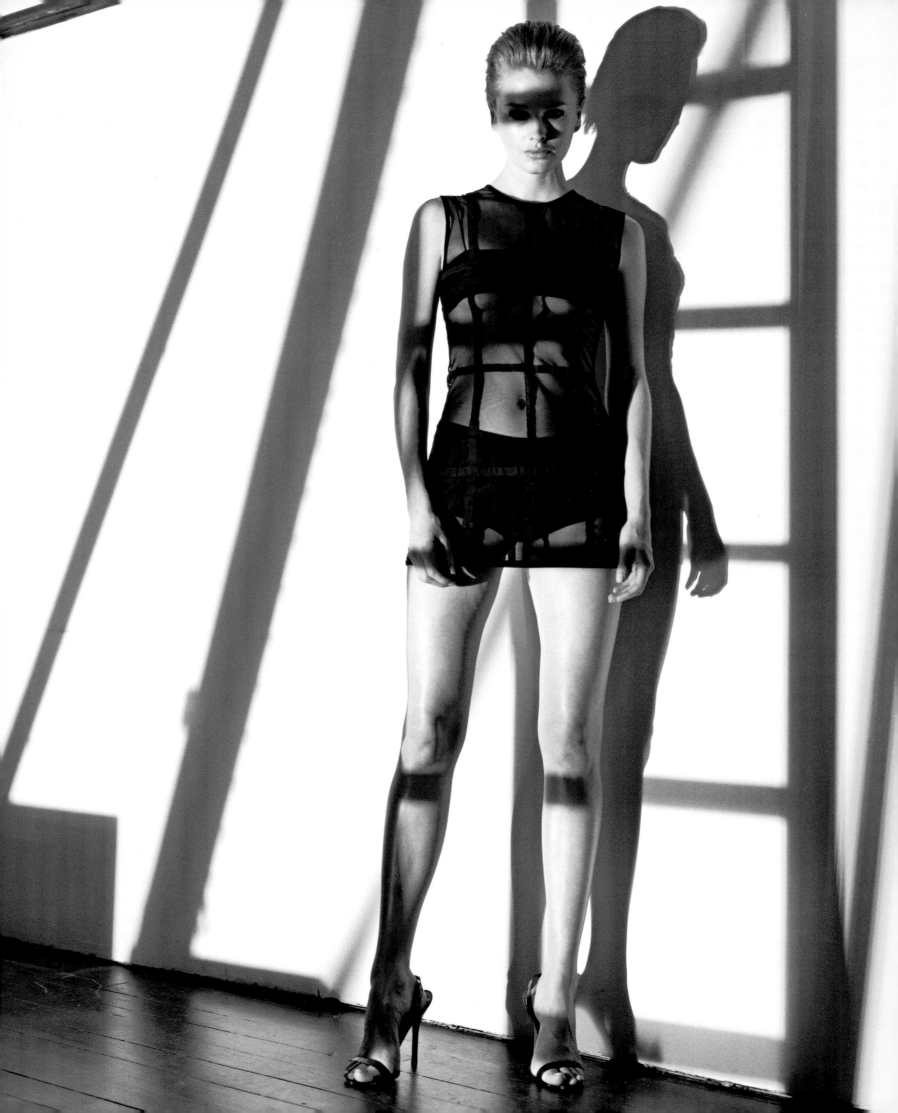

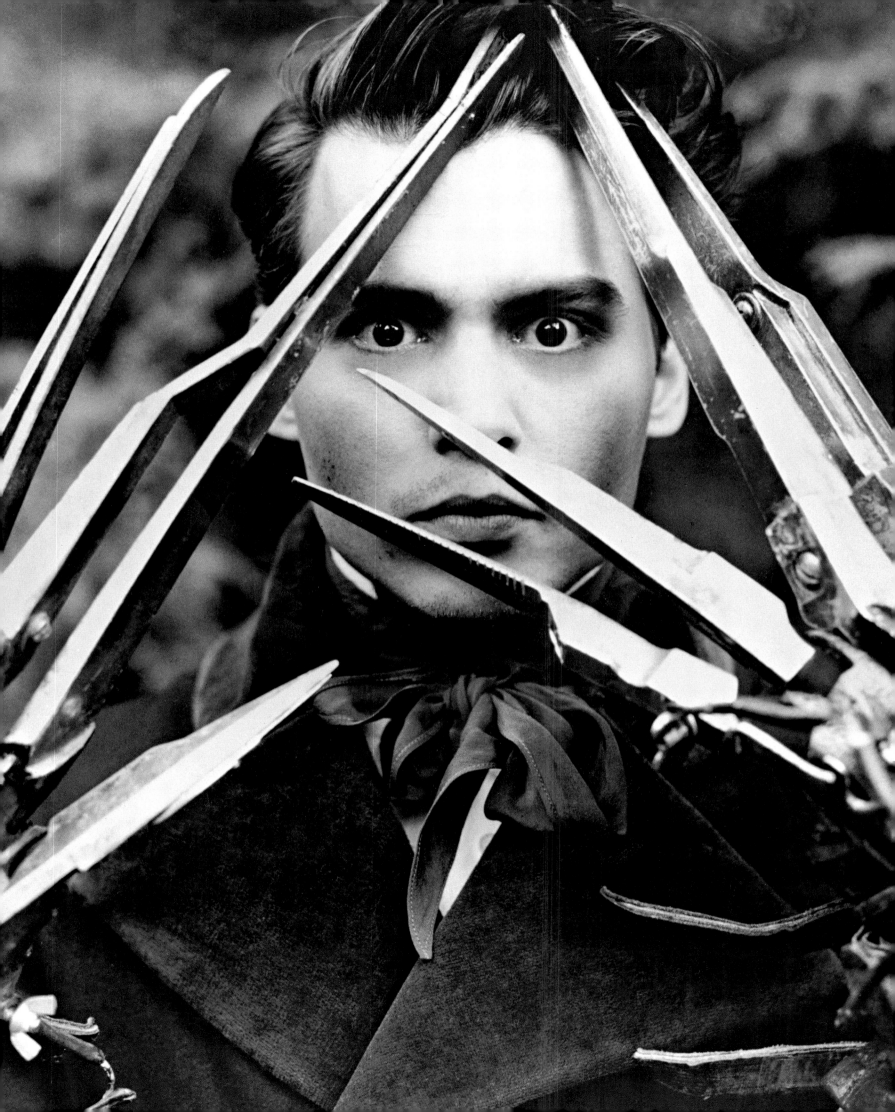

"I've been trying to call the location van for over, an hour, don't go over budget!" screamed Liz Tilberis. I couldn't face explaining that Lauren Hutton had been on the phone to L.A. nonstop.'

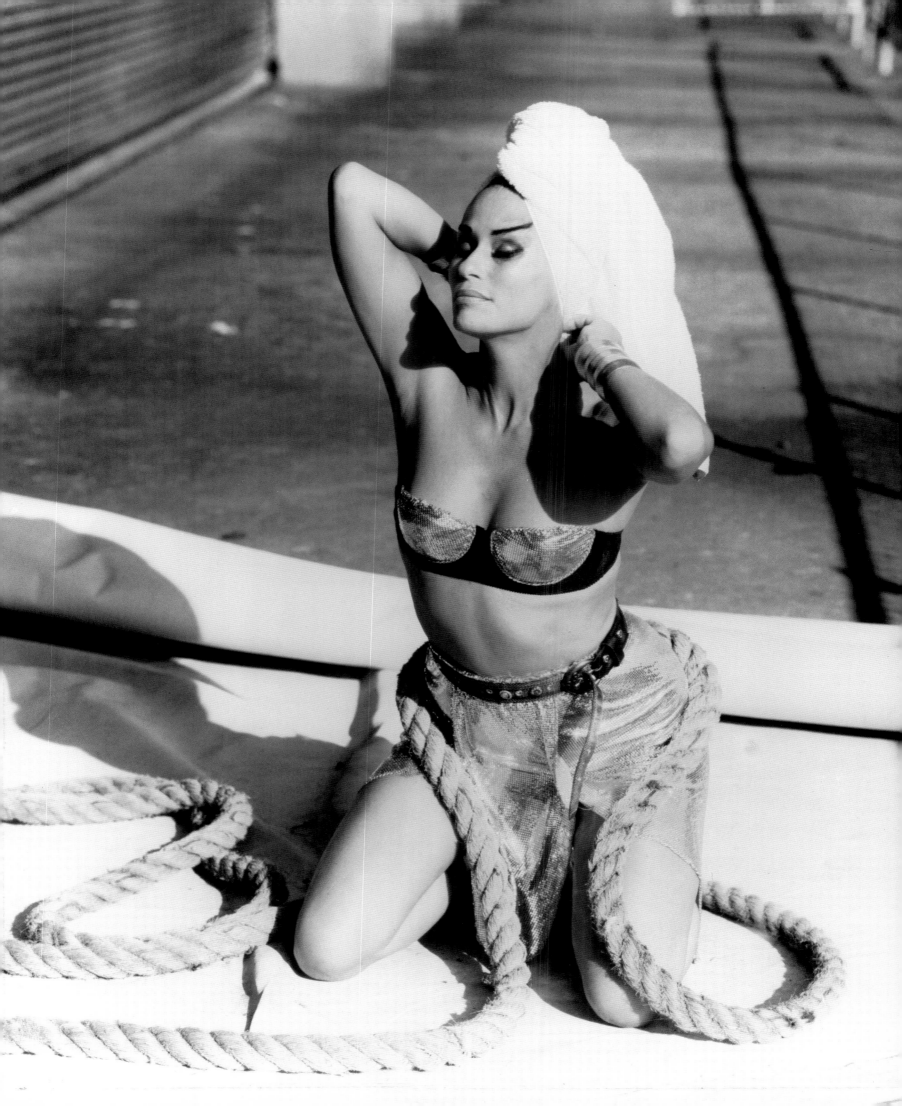

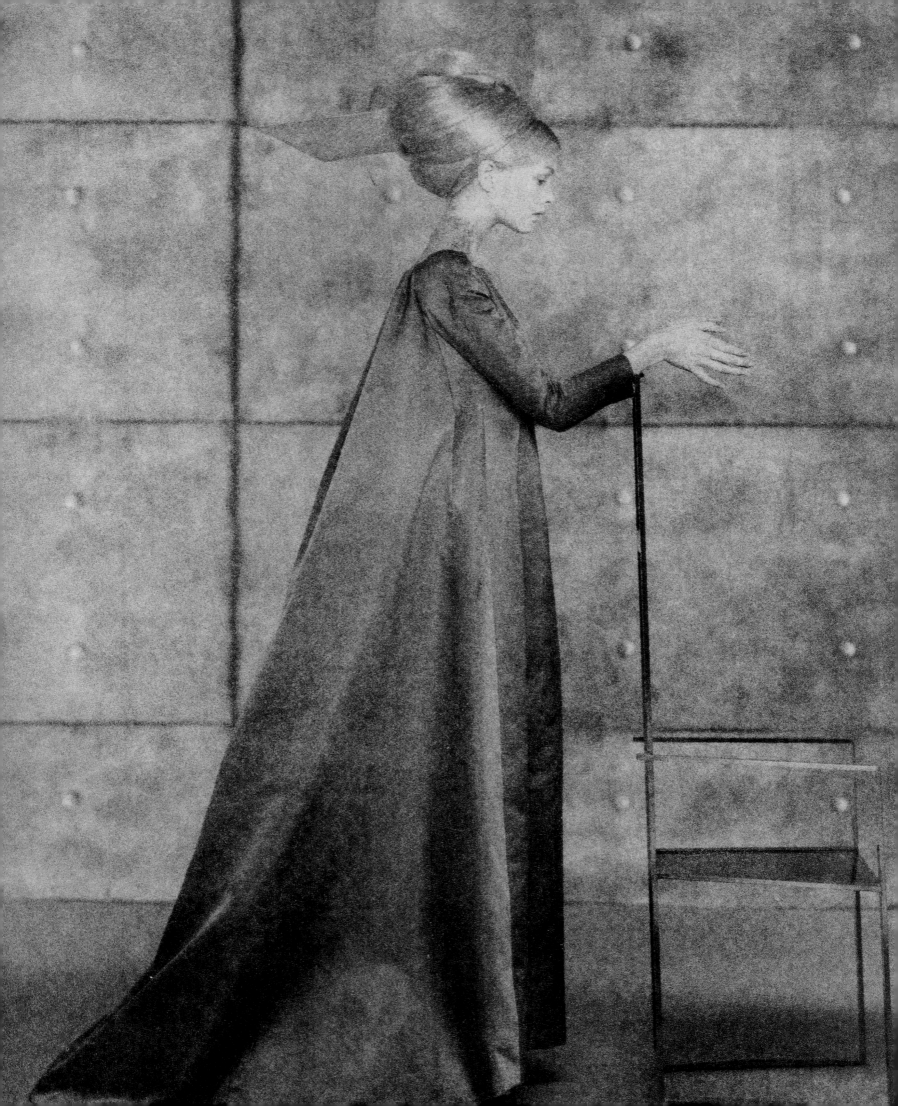

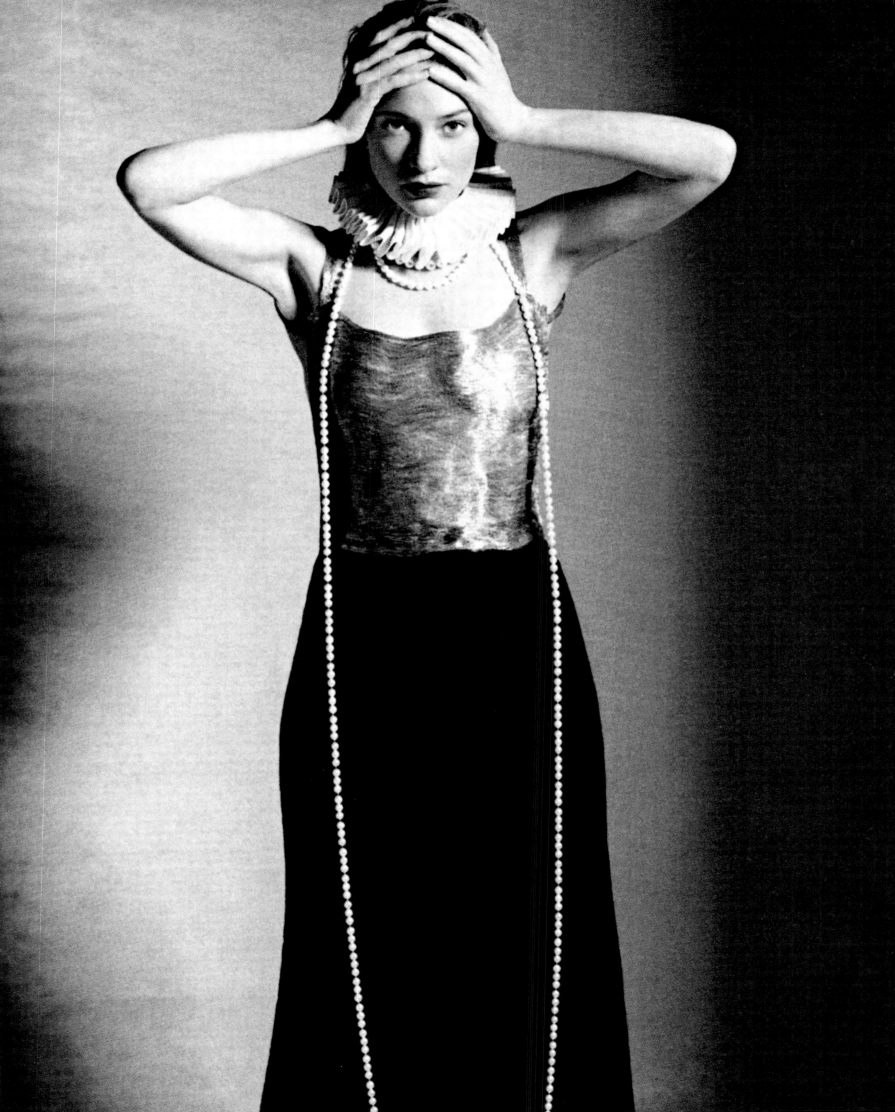

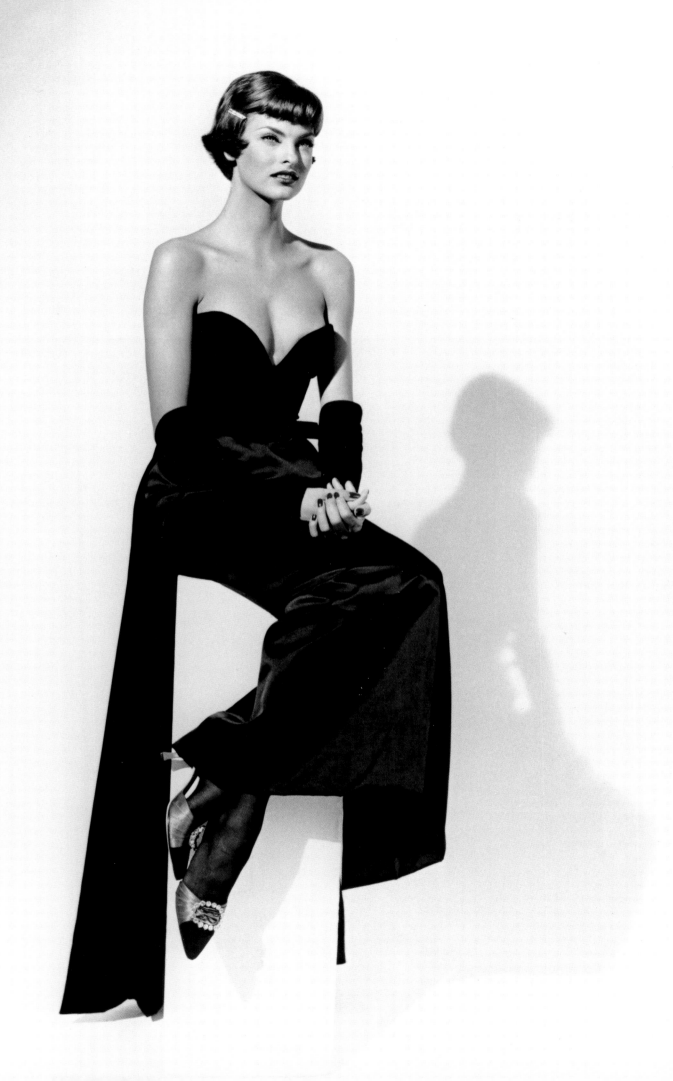

'This "hat thing" has to be an English obsession.'

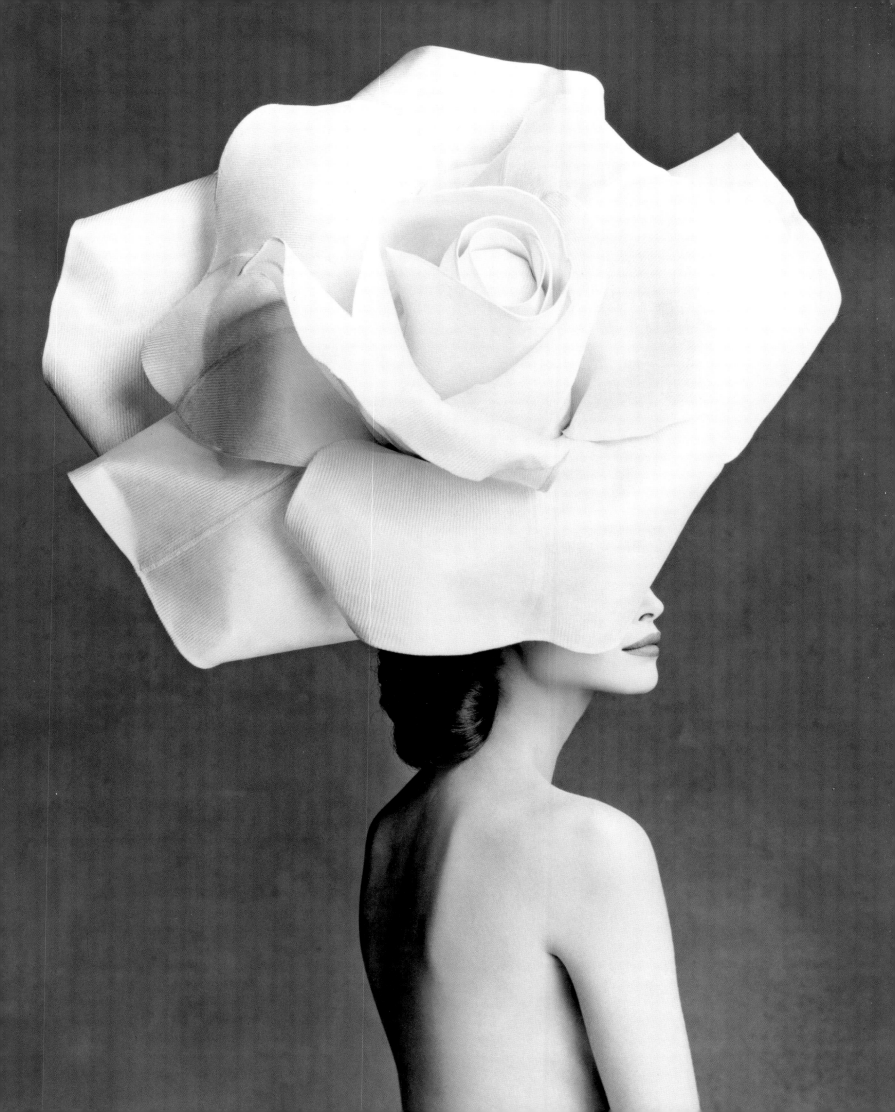

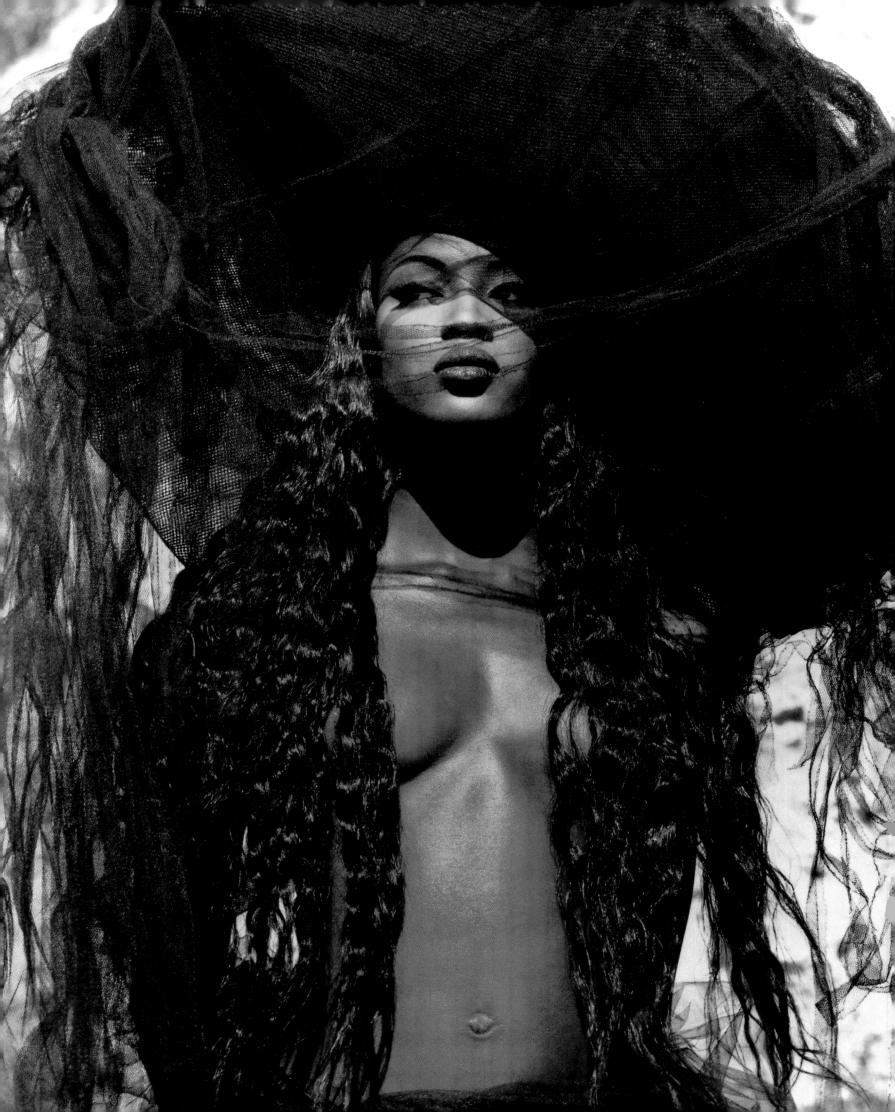

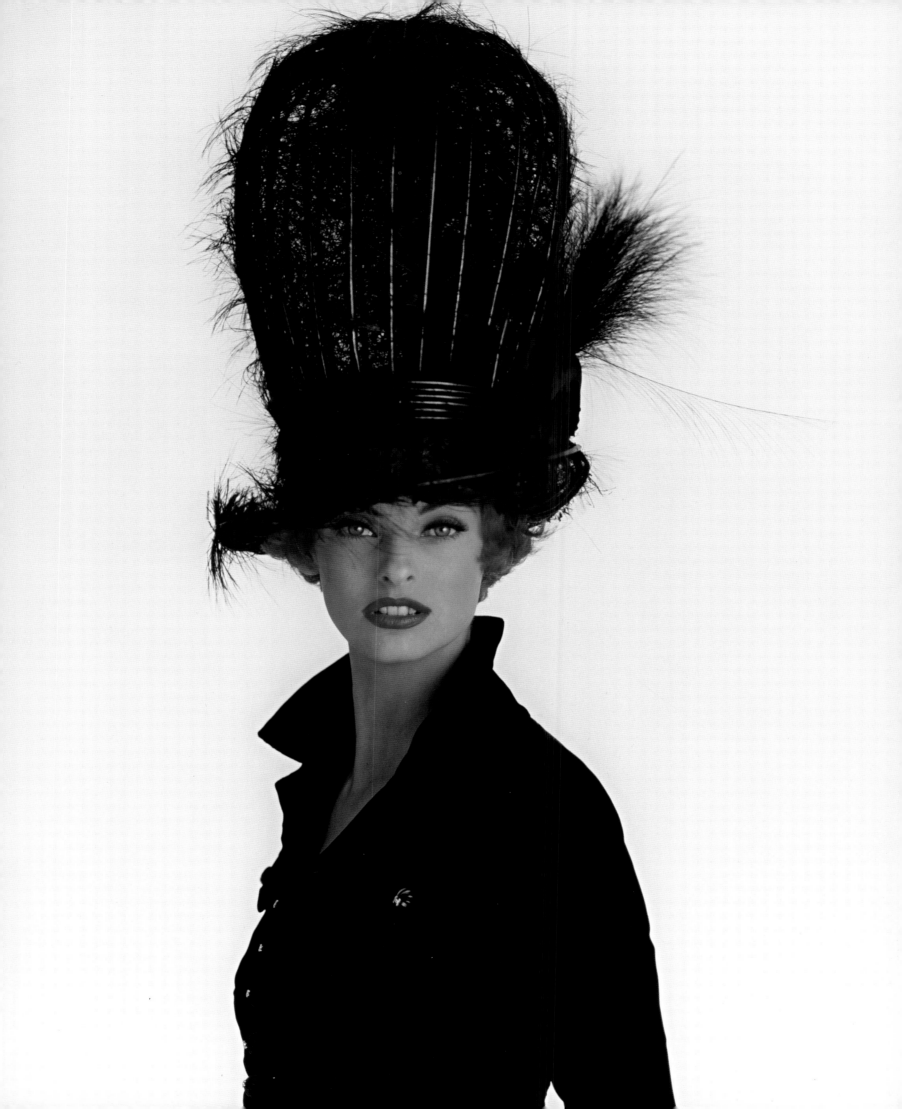

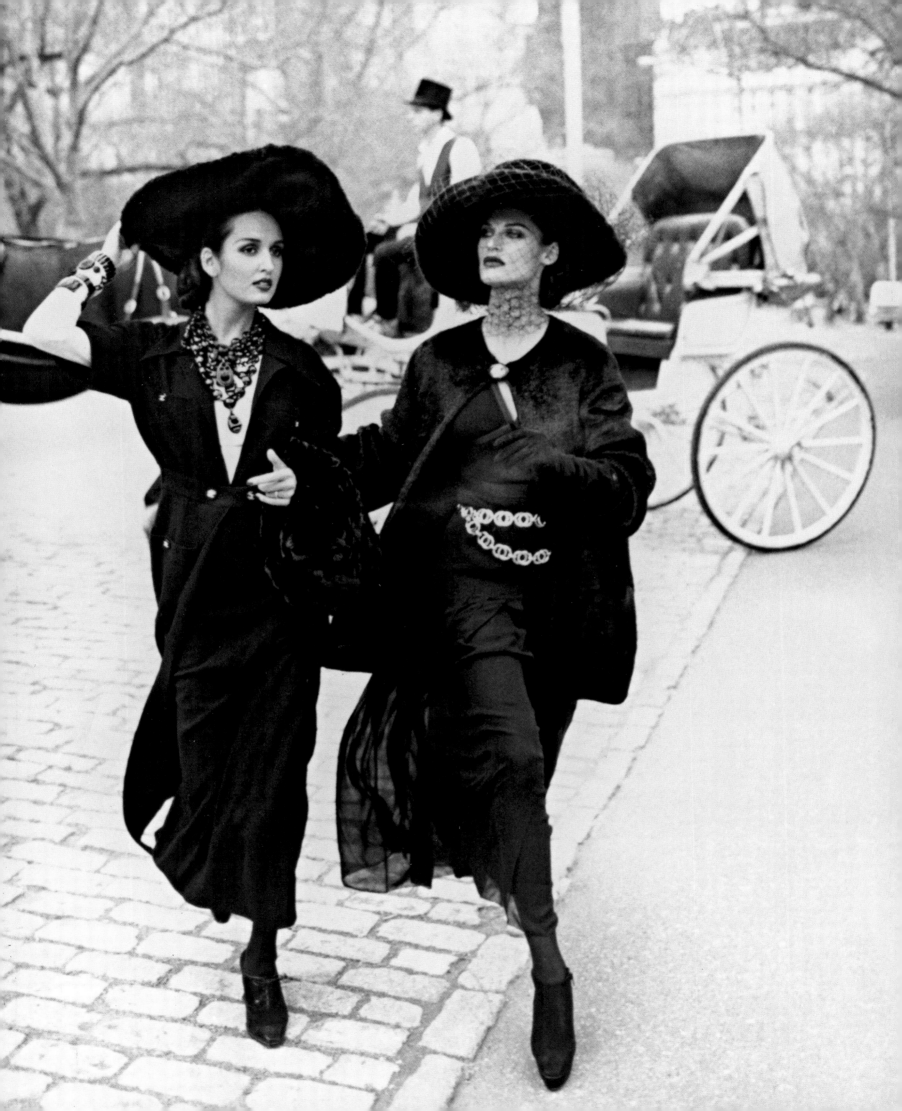

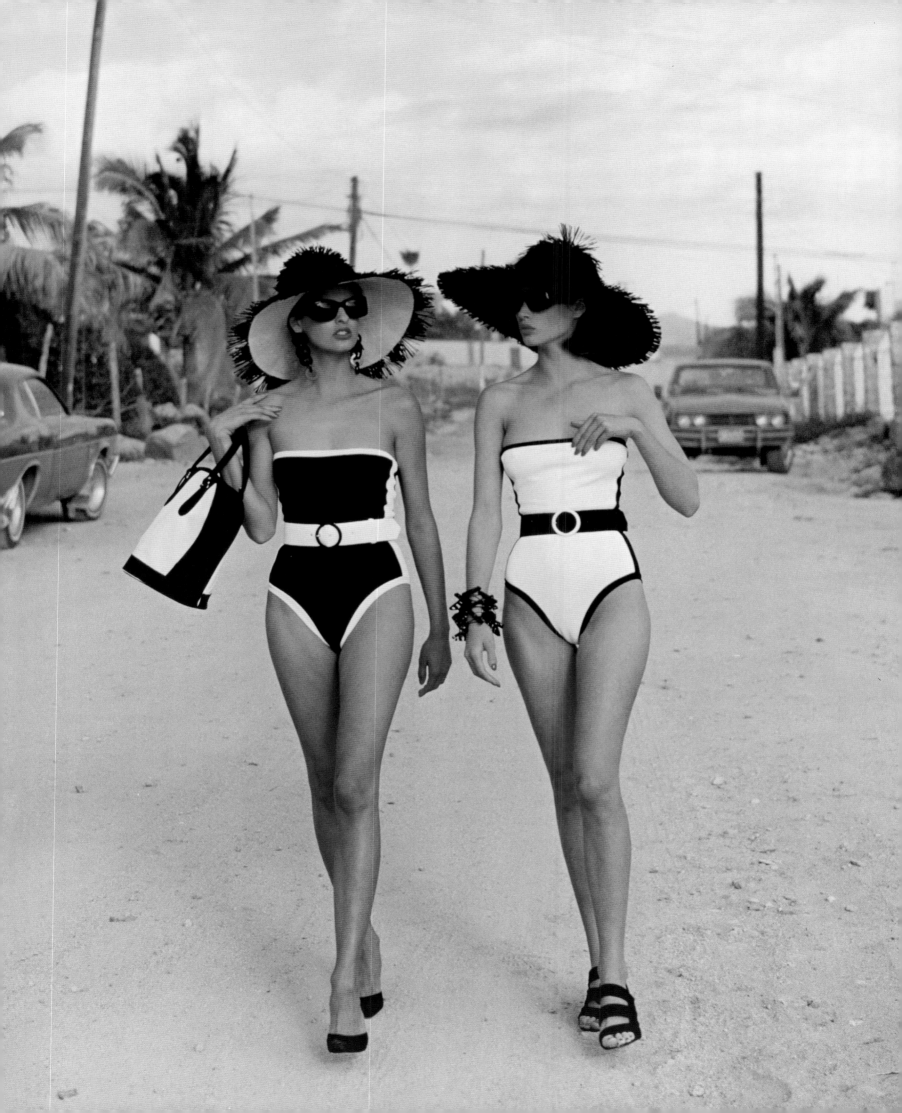

'Sometimes dresses are big. so They are larger than life.'

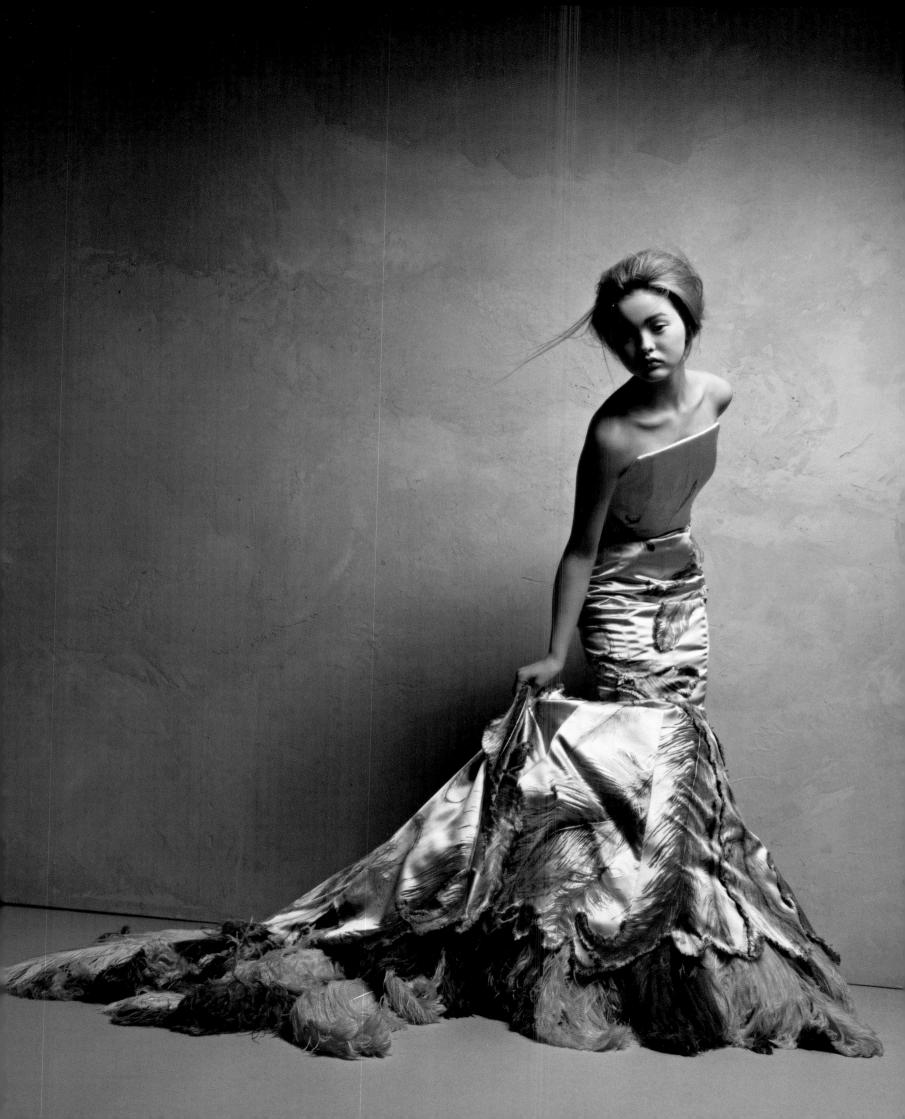

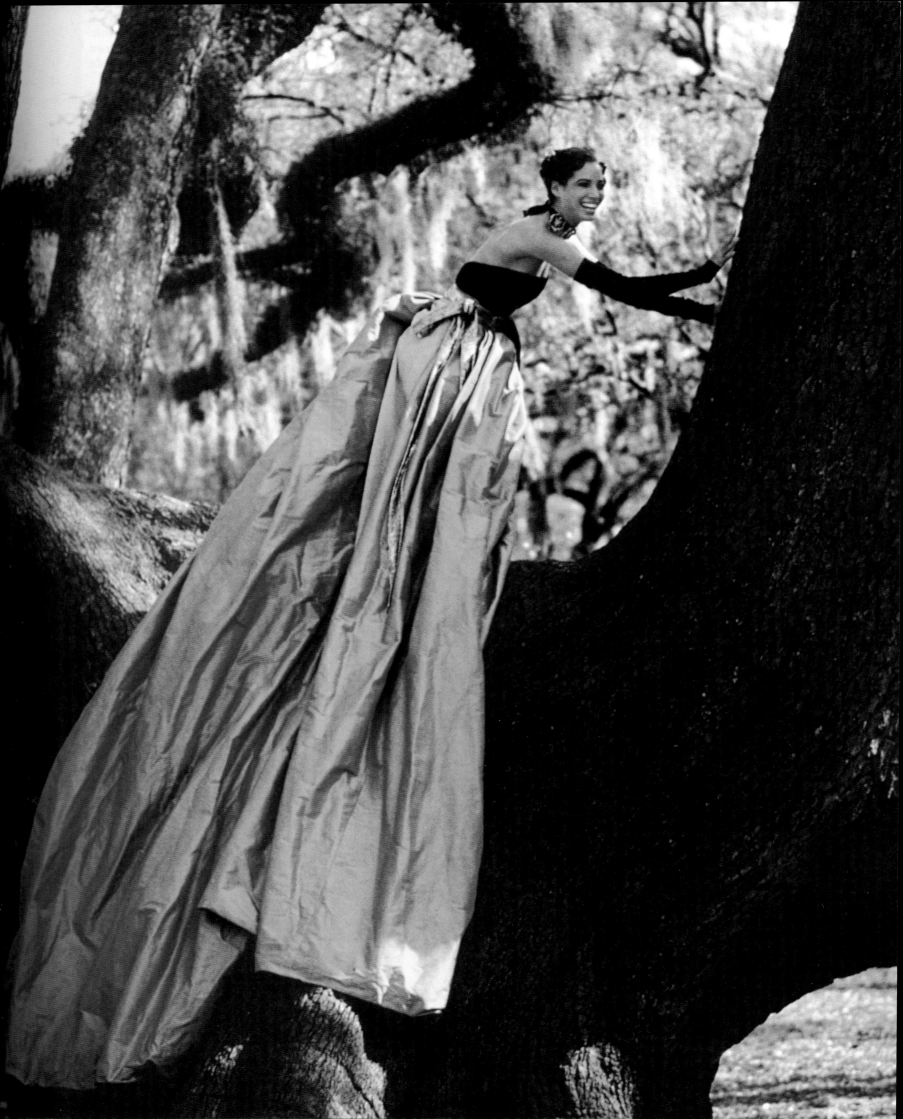

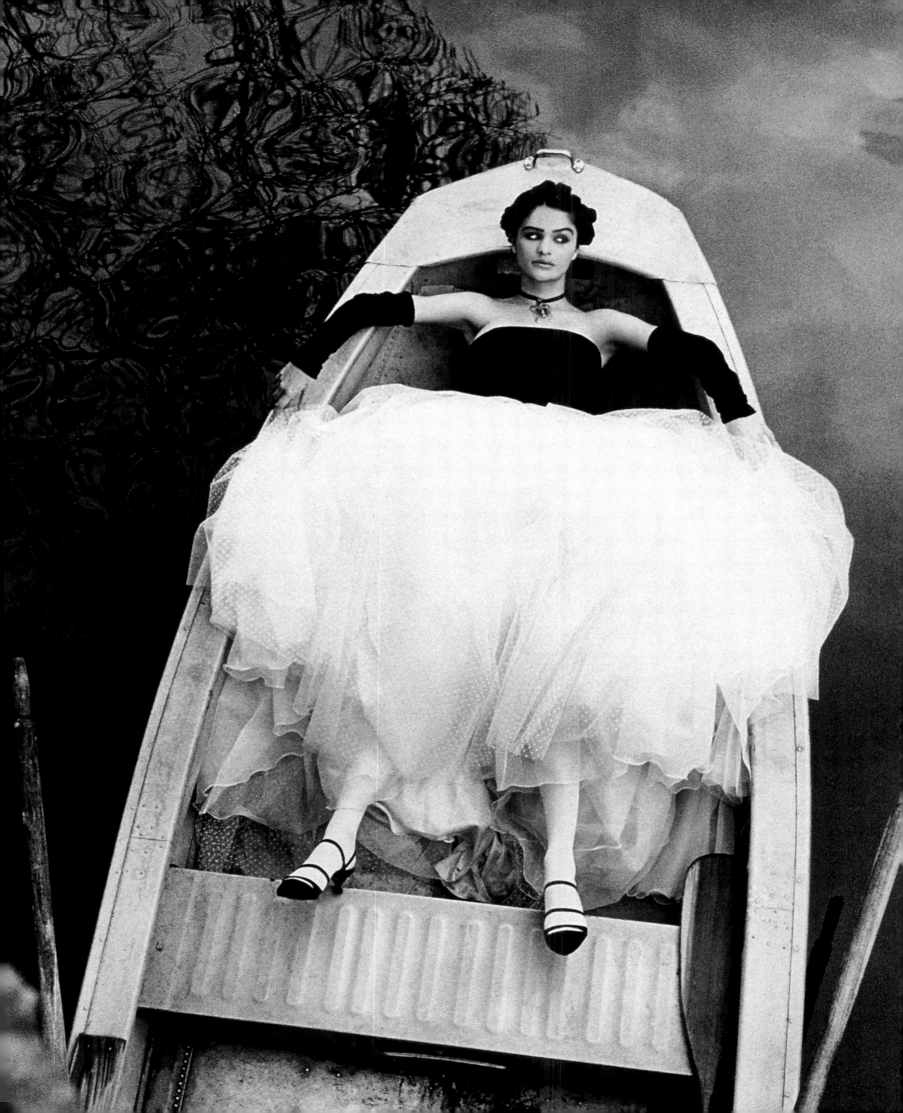

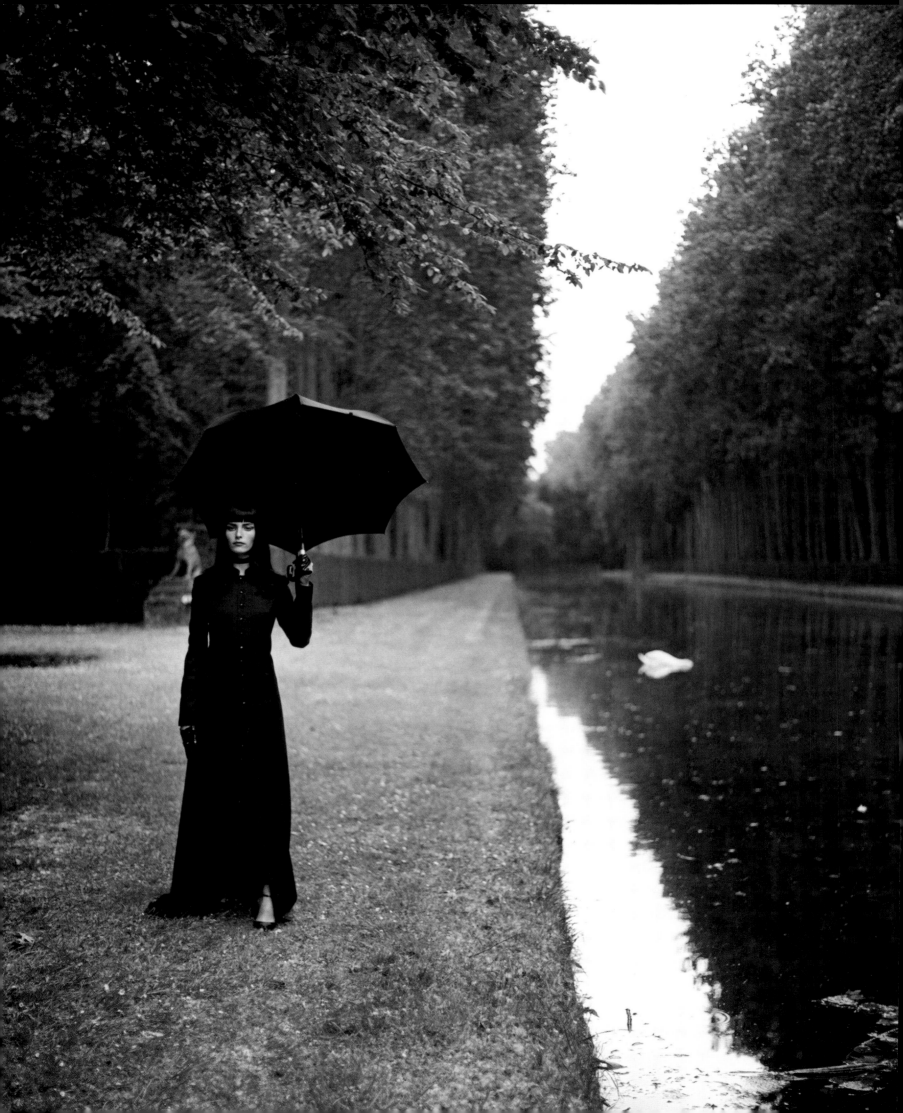

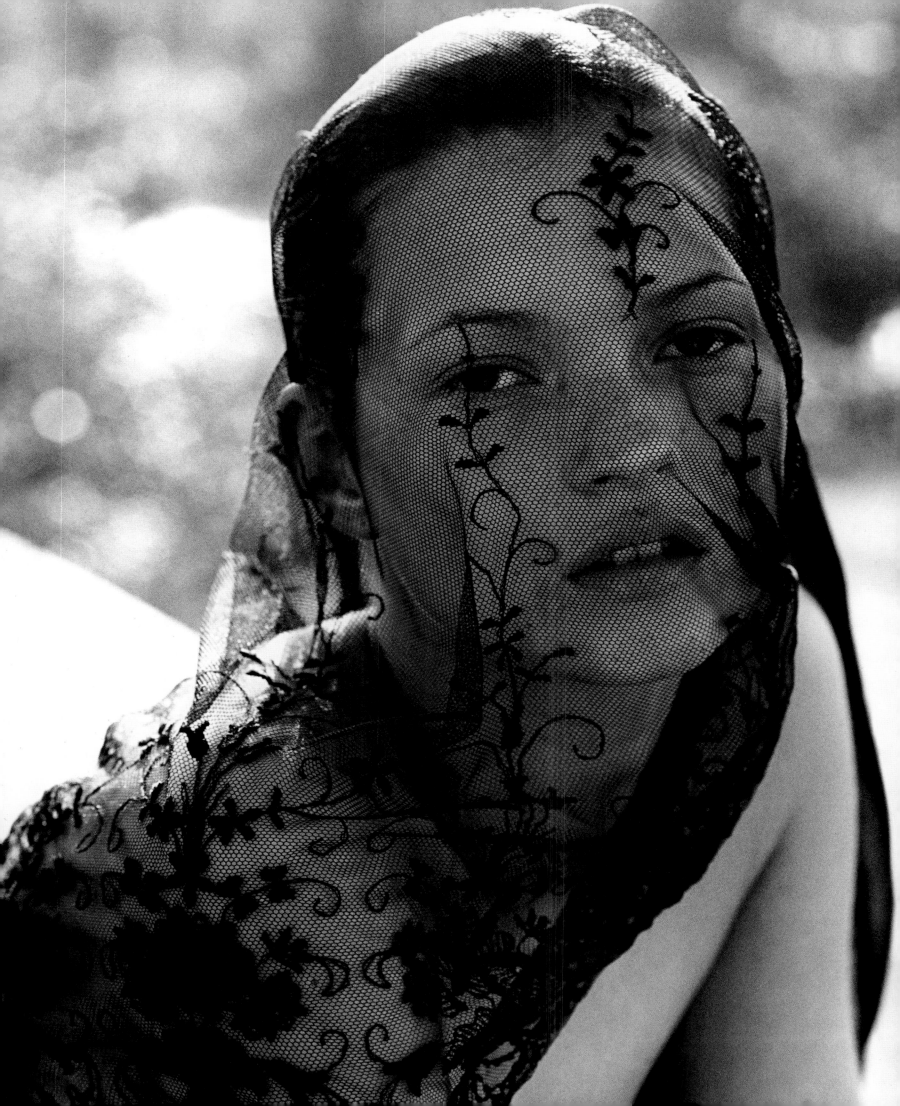

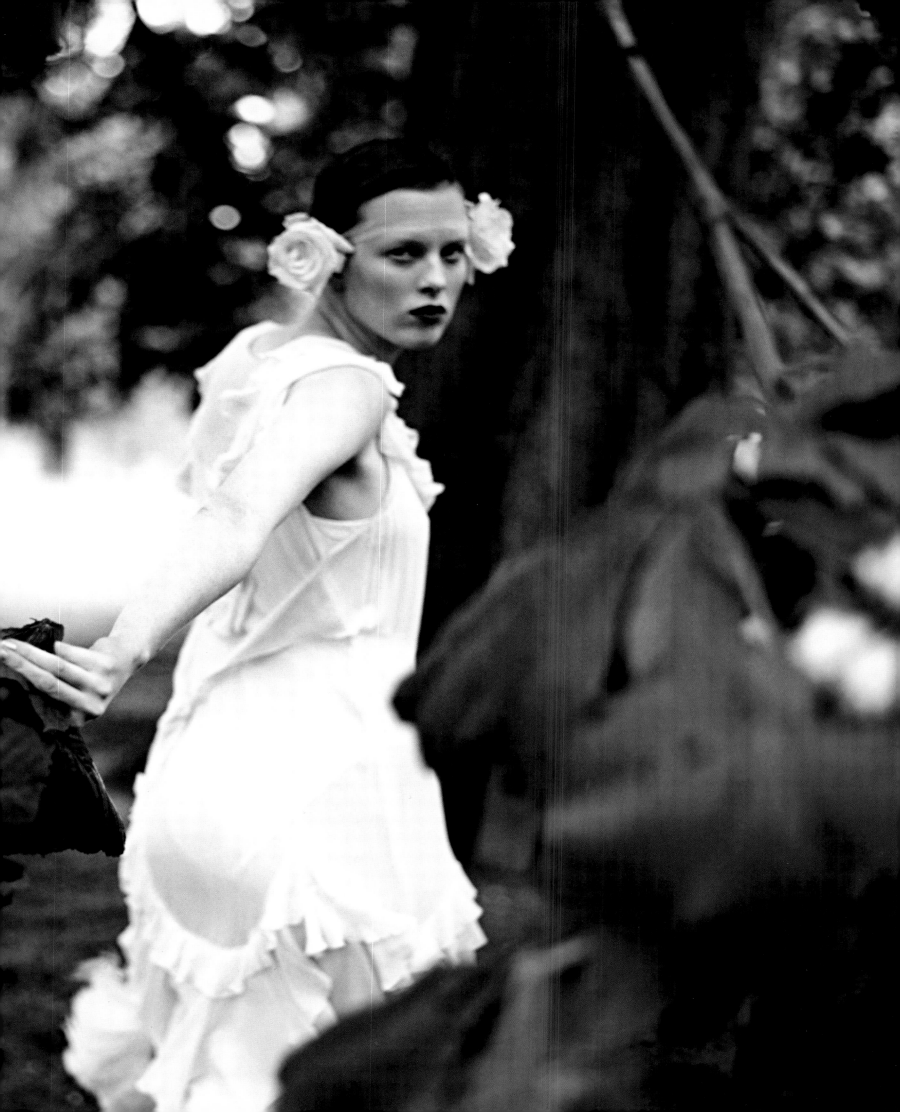

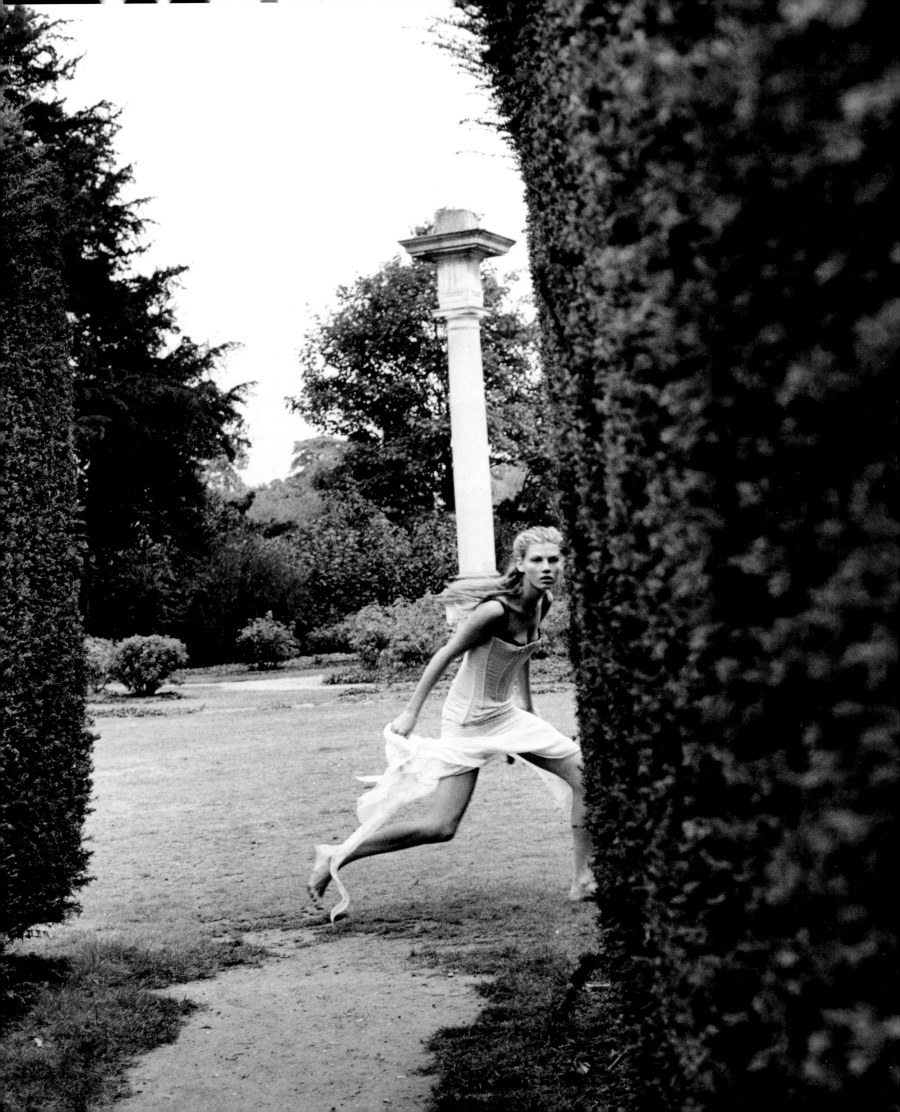

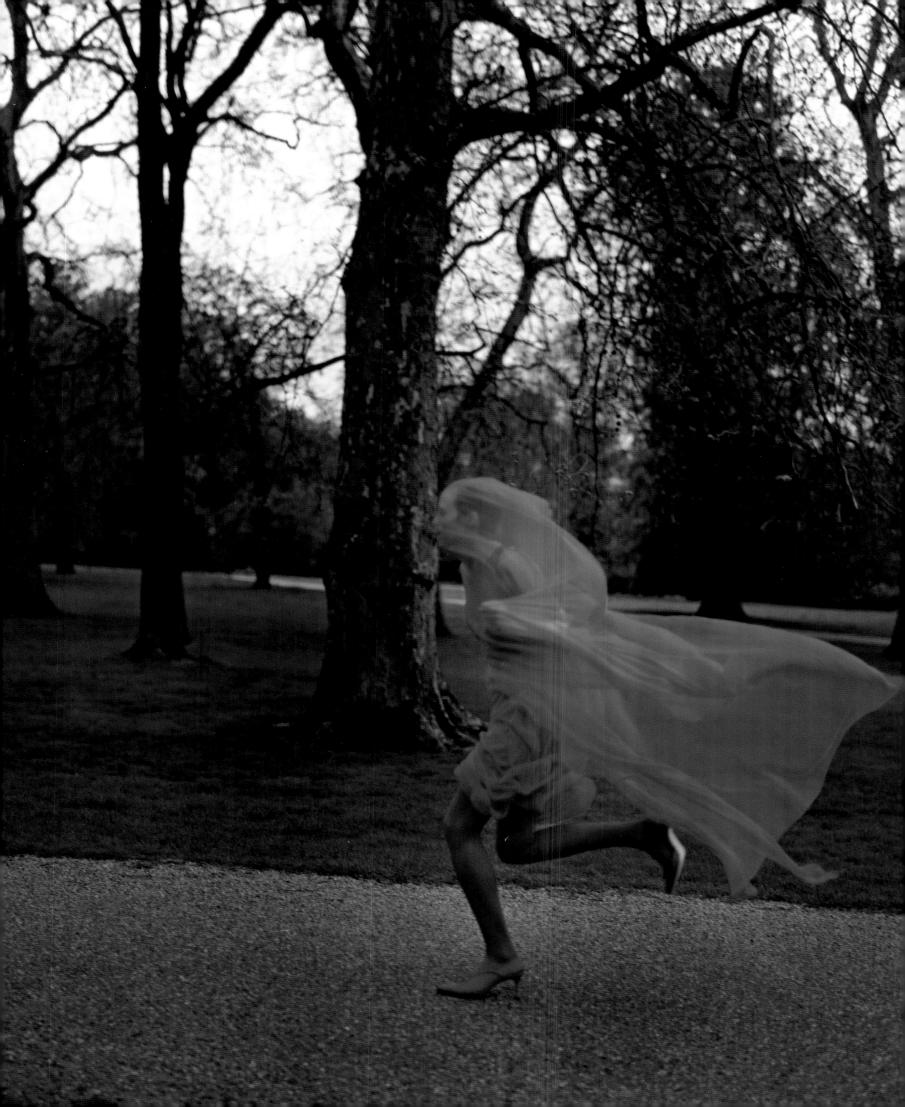

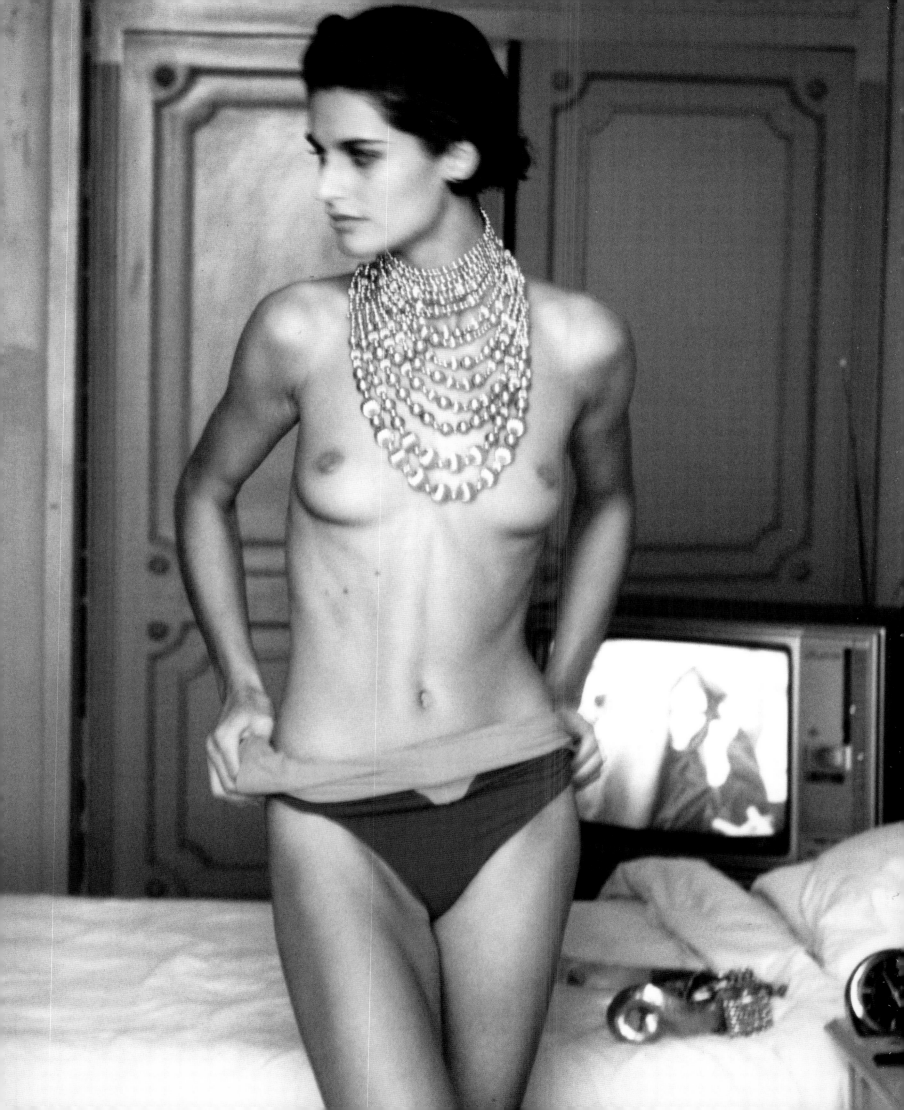

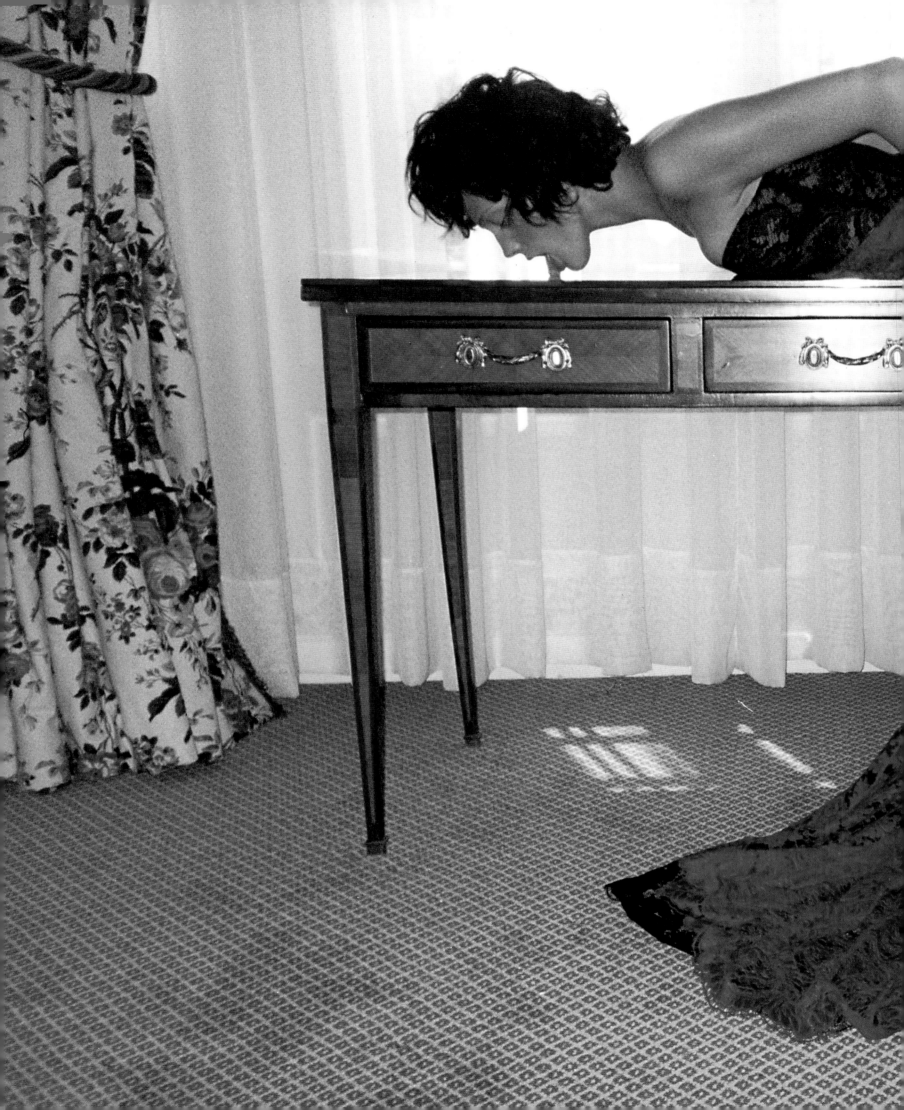

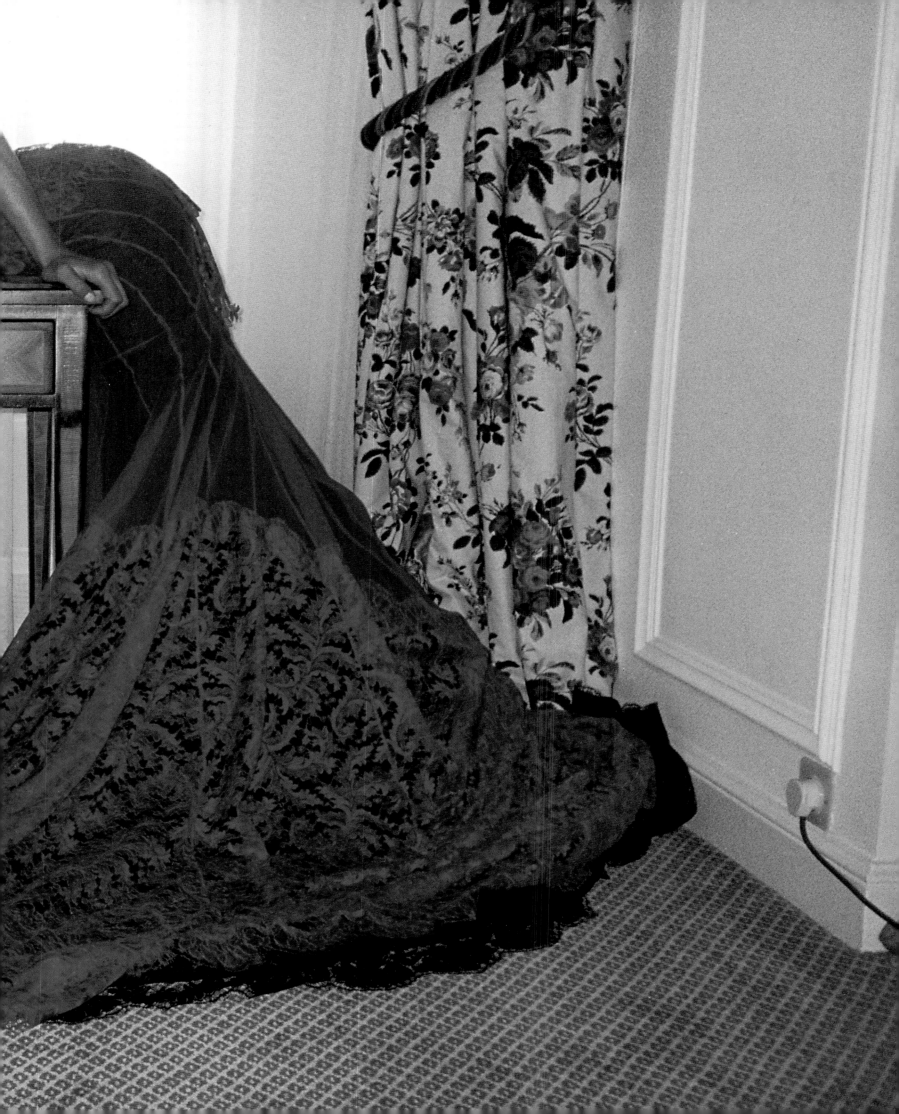

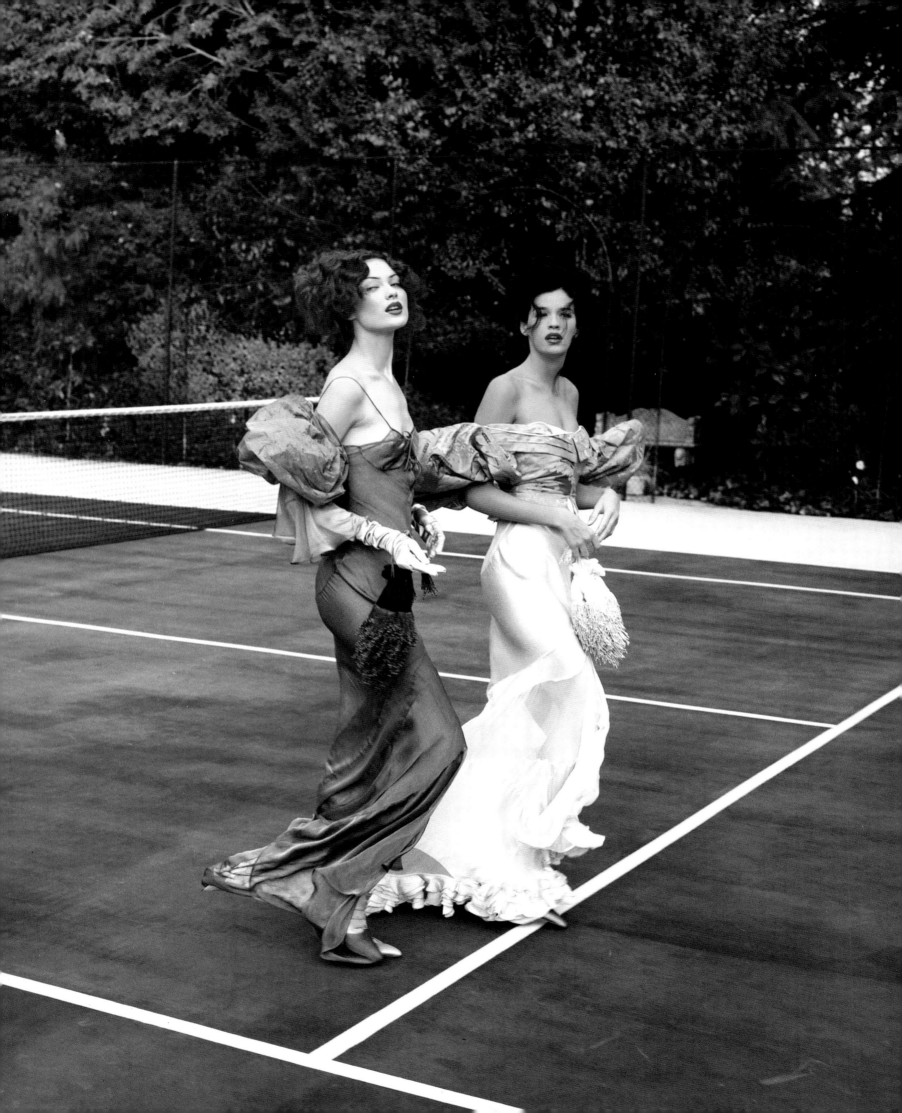

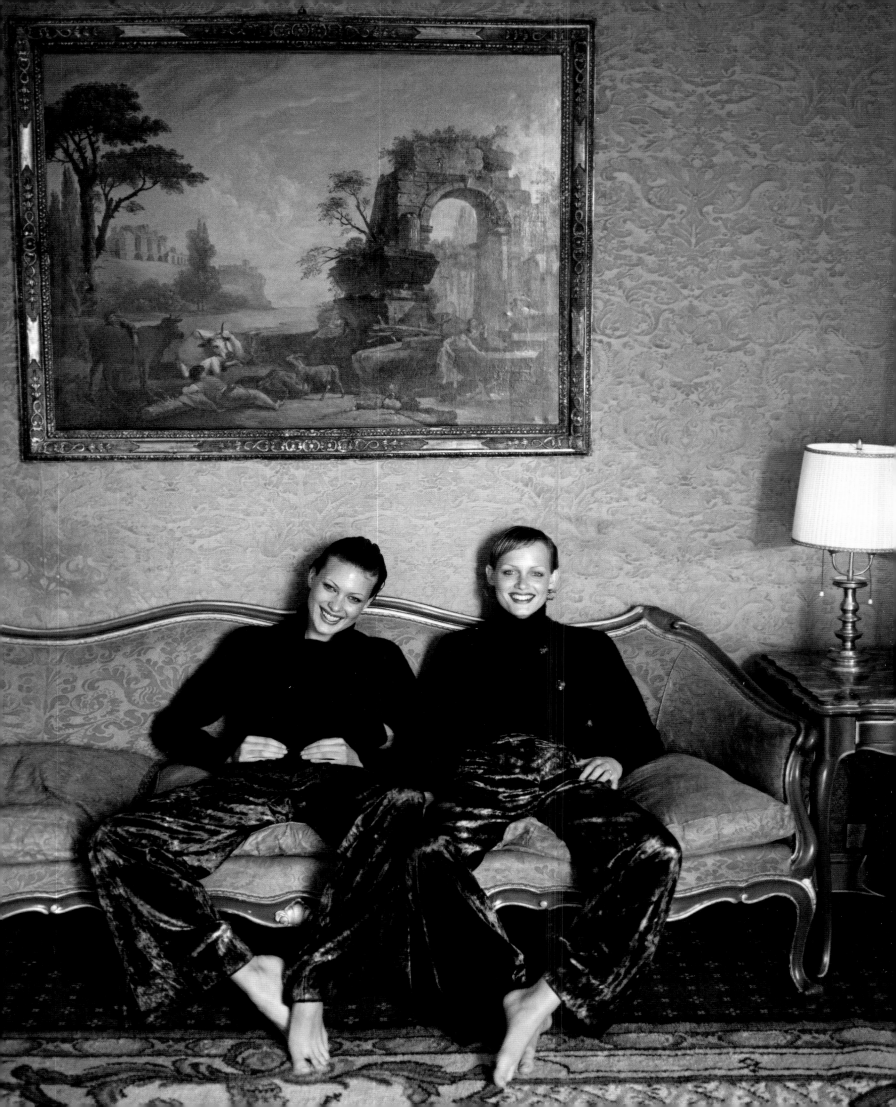

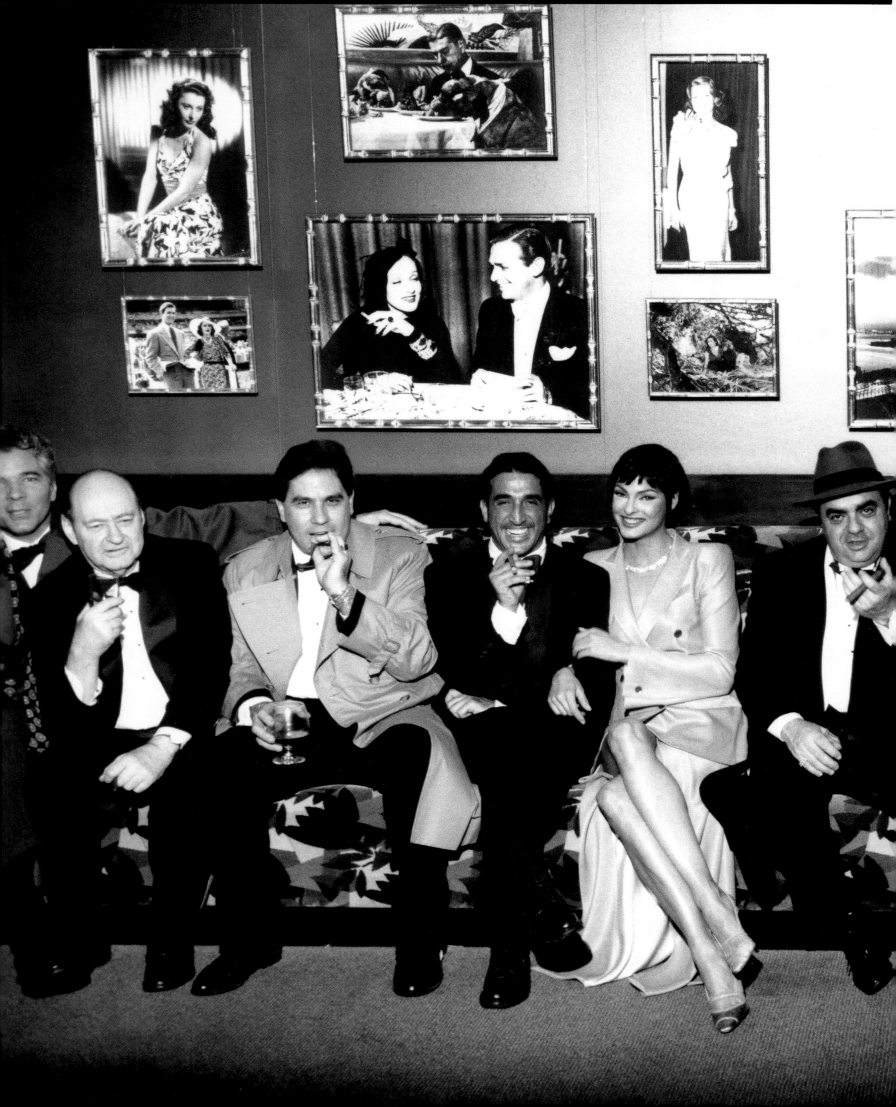

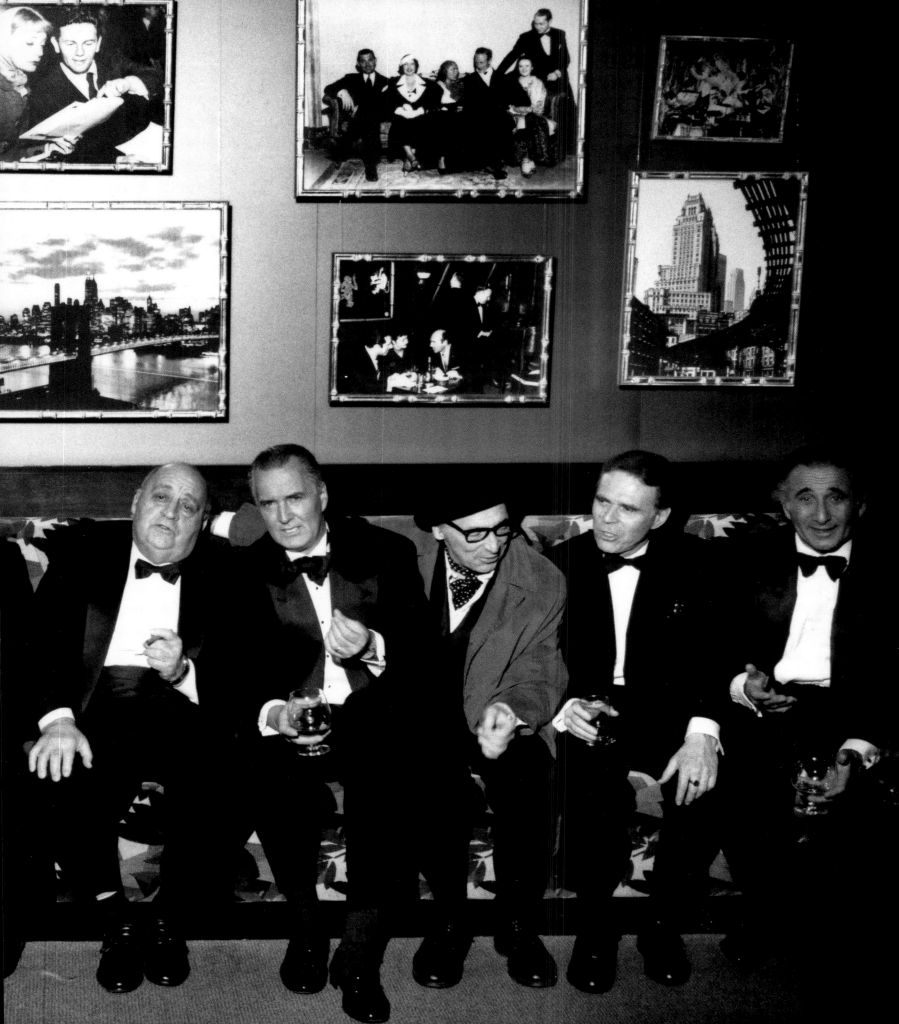

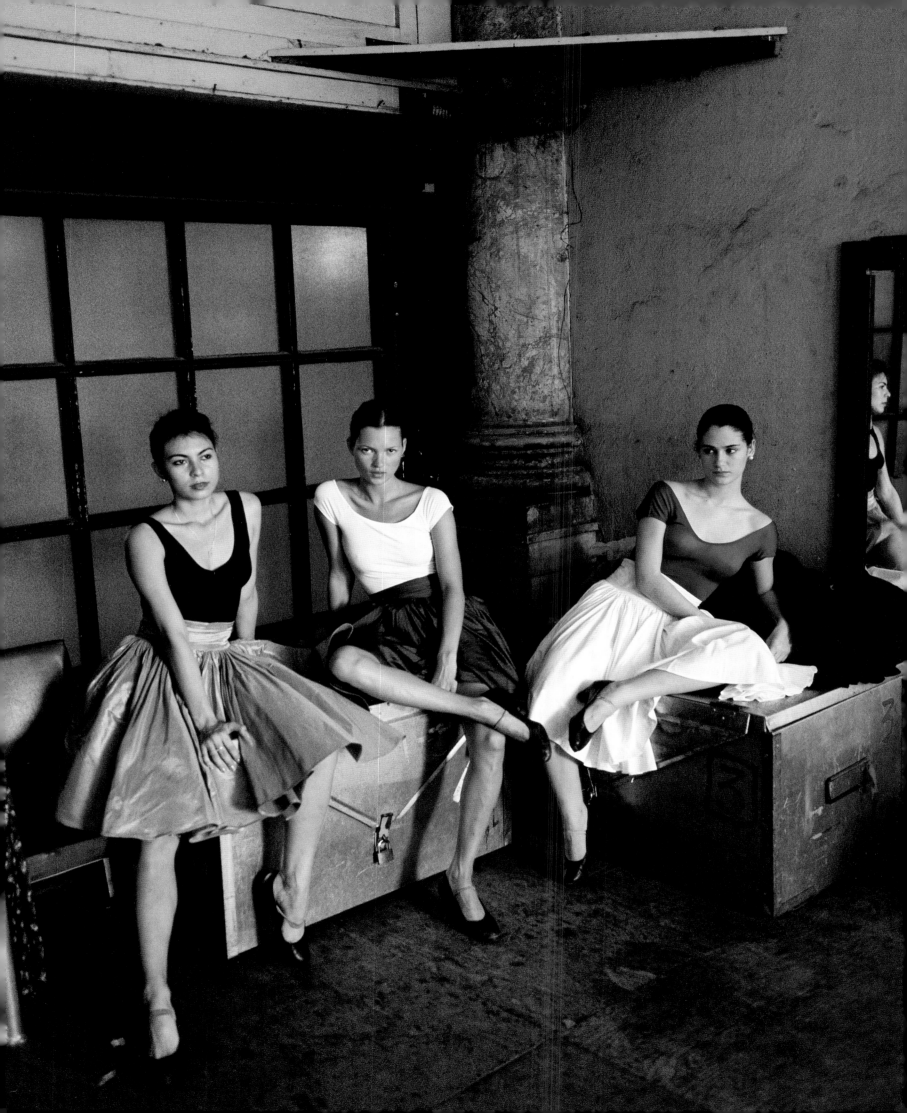

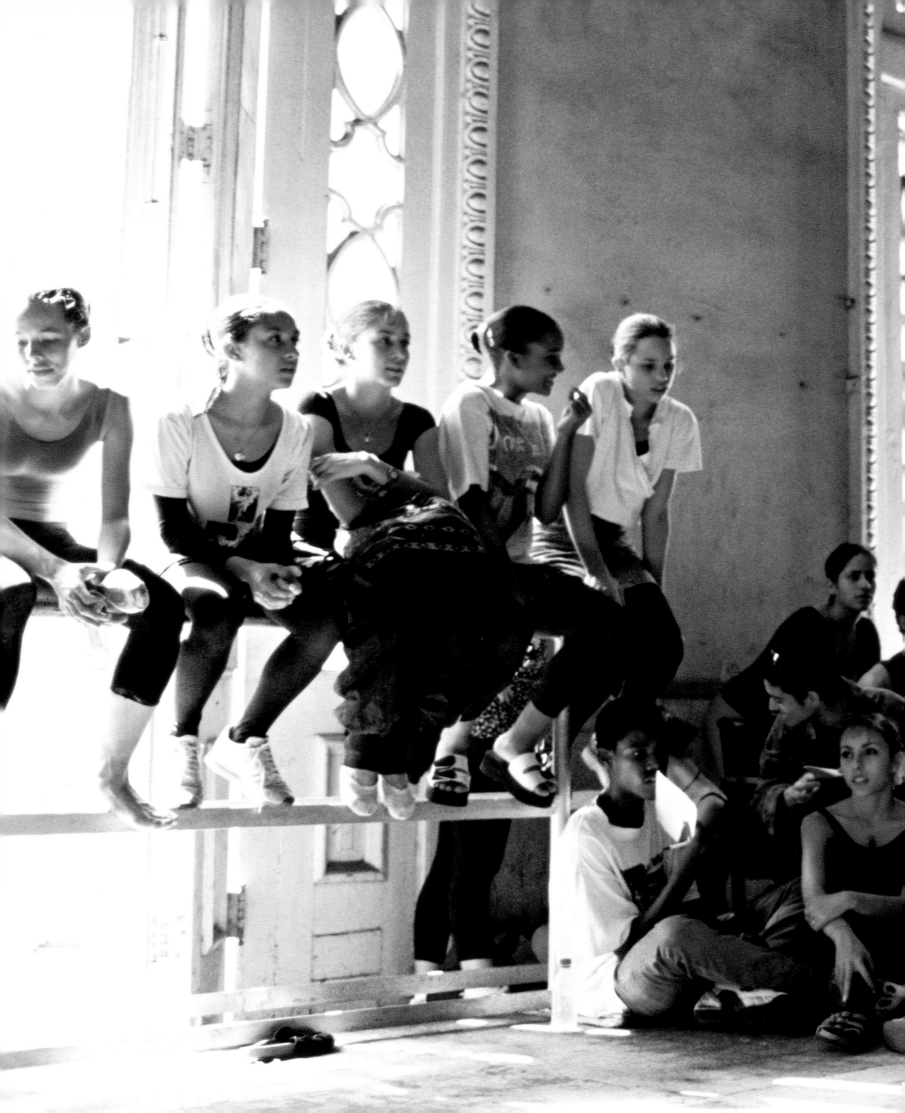

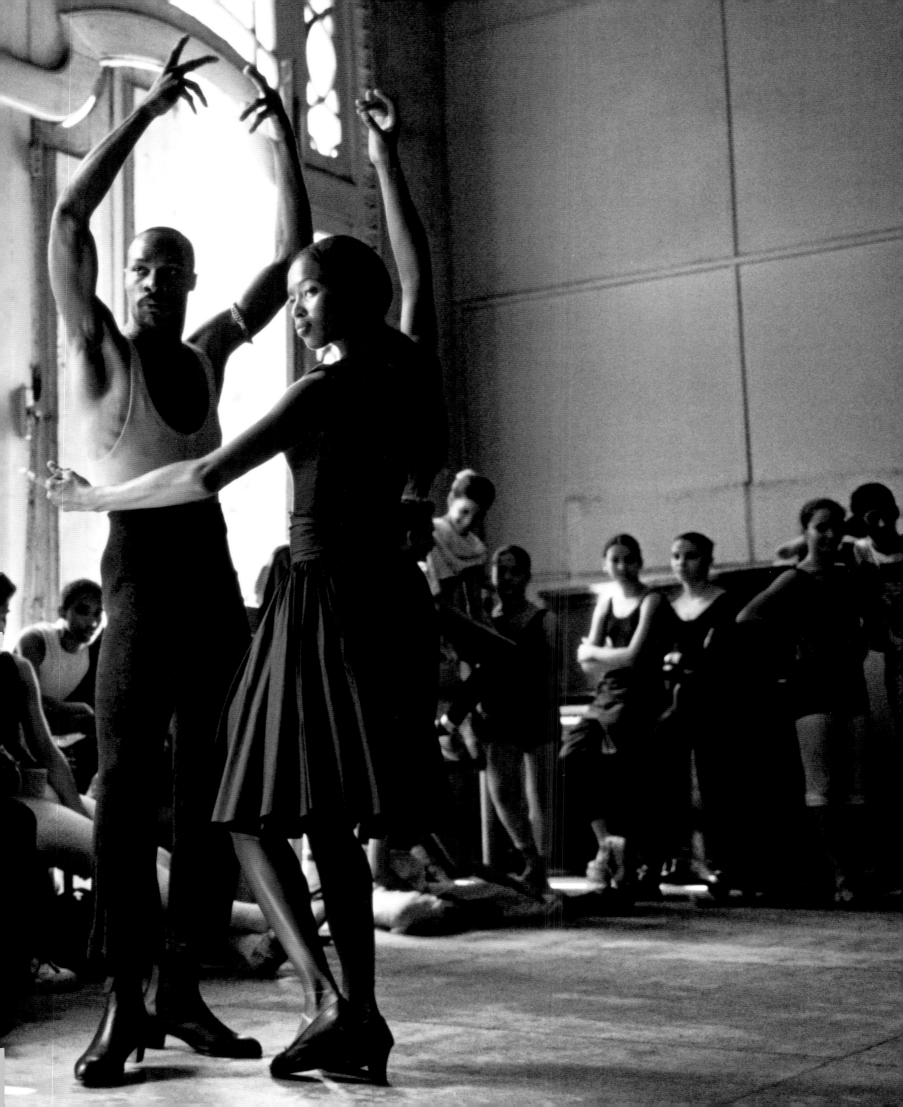

'When you go on location, there is a good chance of returning home with unexpected surprises.'

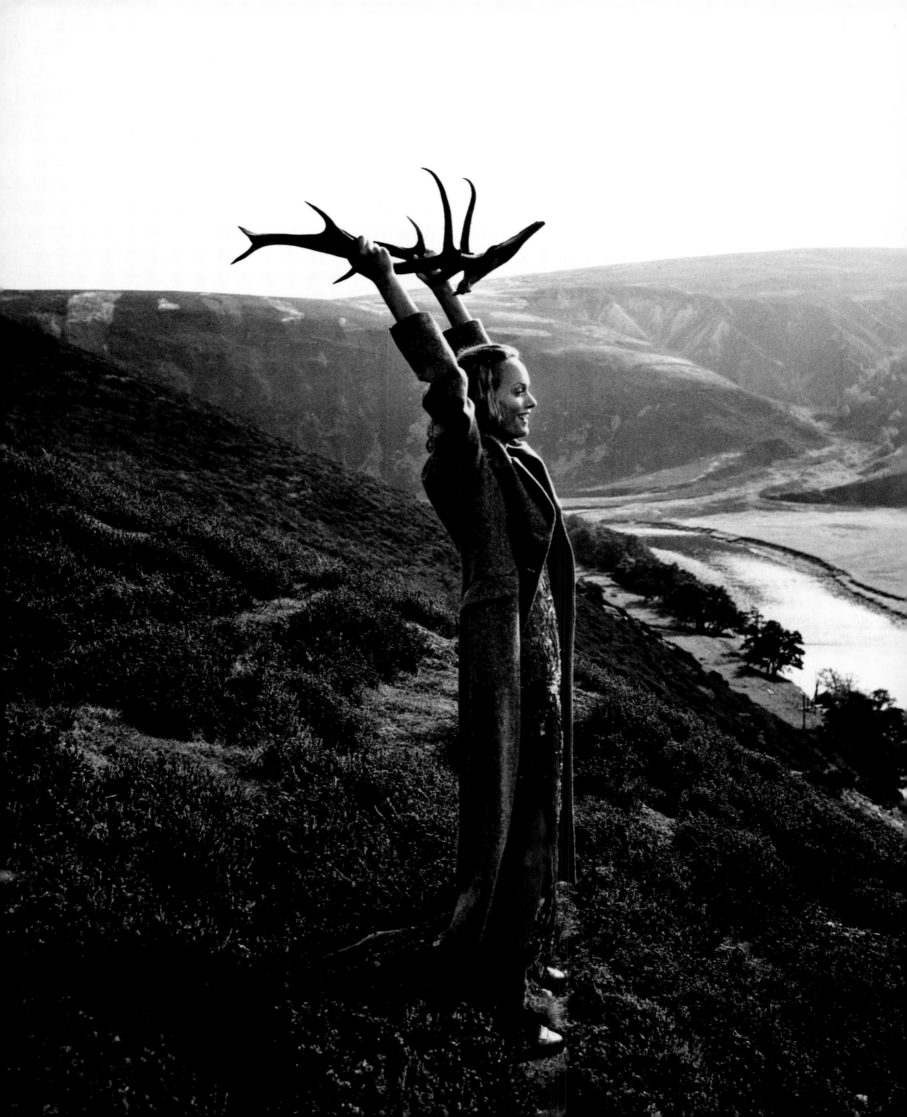

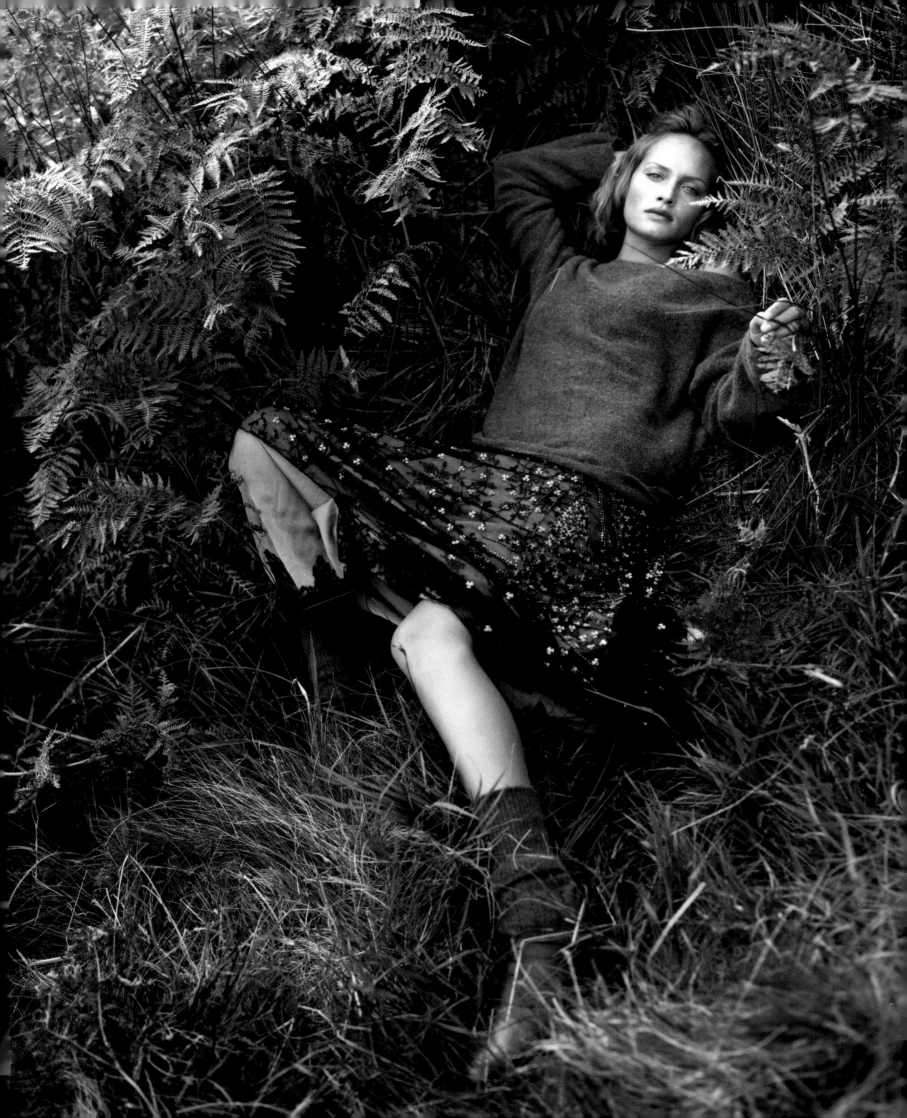

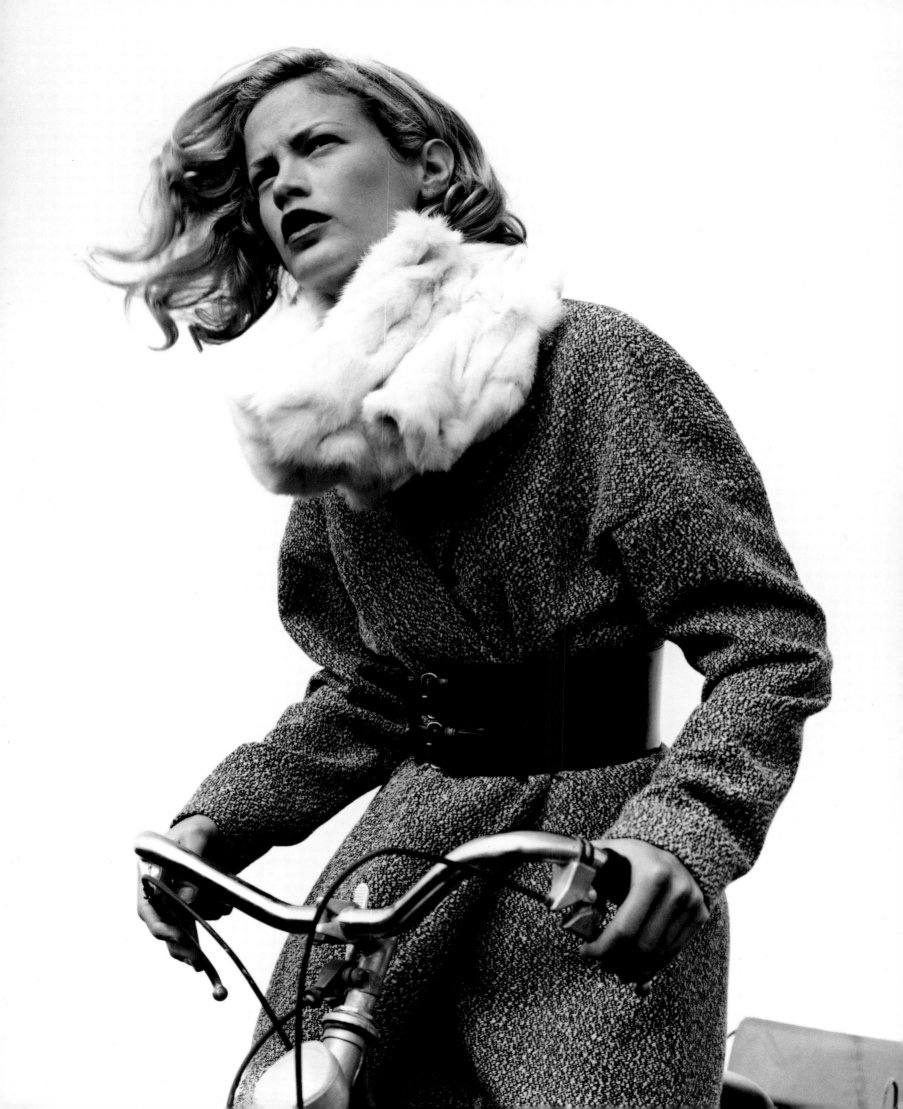

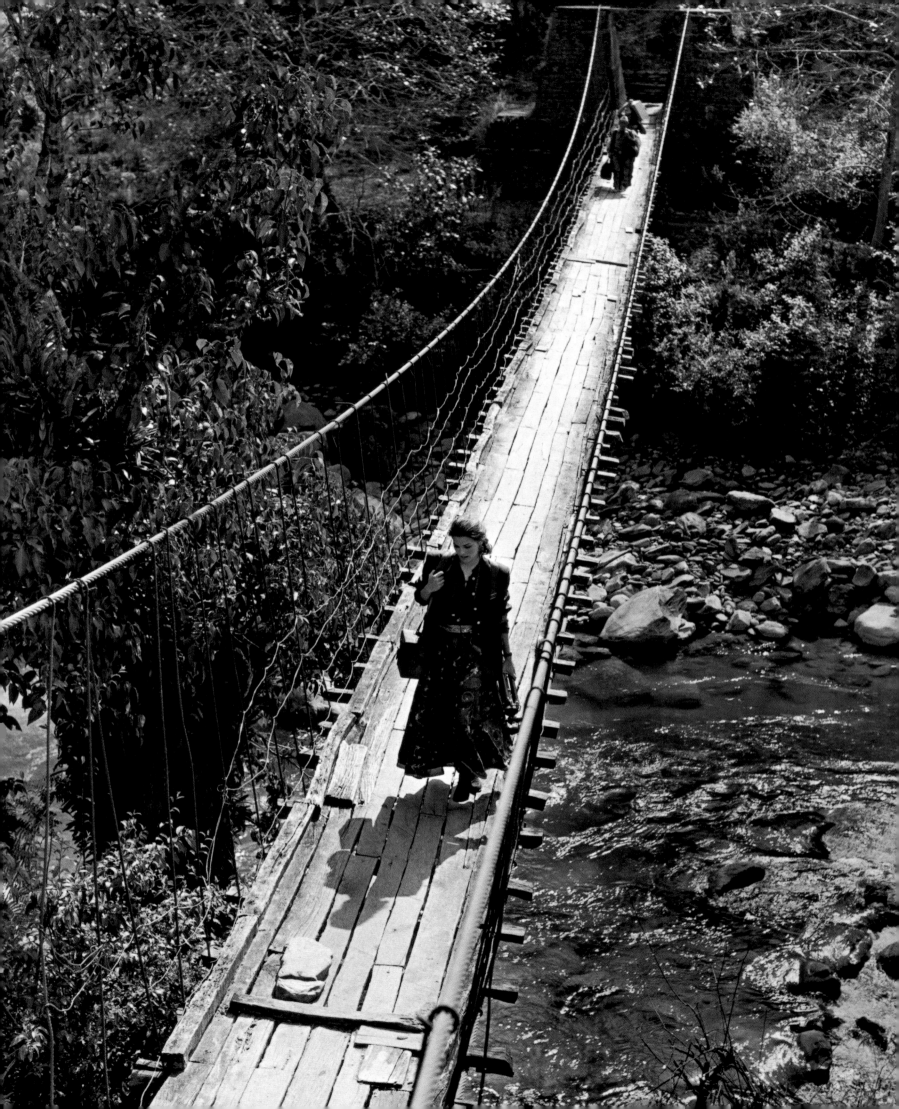

'An
expedition to Nepal,
to accomplish the feat
of getting Fishtail Mountain
as a backdrop for our
Freya Stark story,
entailed seven hours of
hiking a day
with a dozen Sherpas
and Ghurkhas
carrying our stuff.'

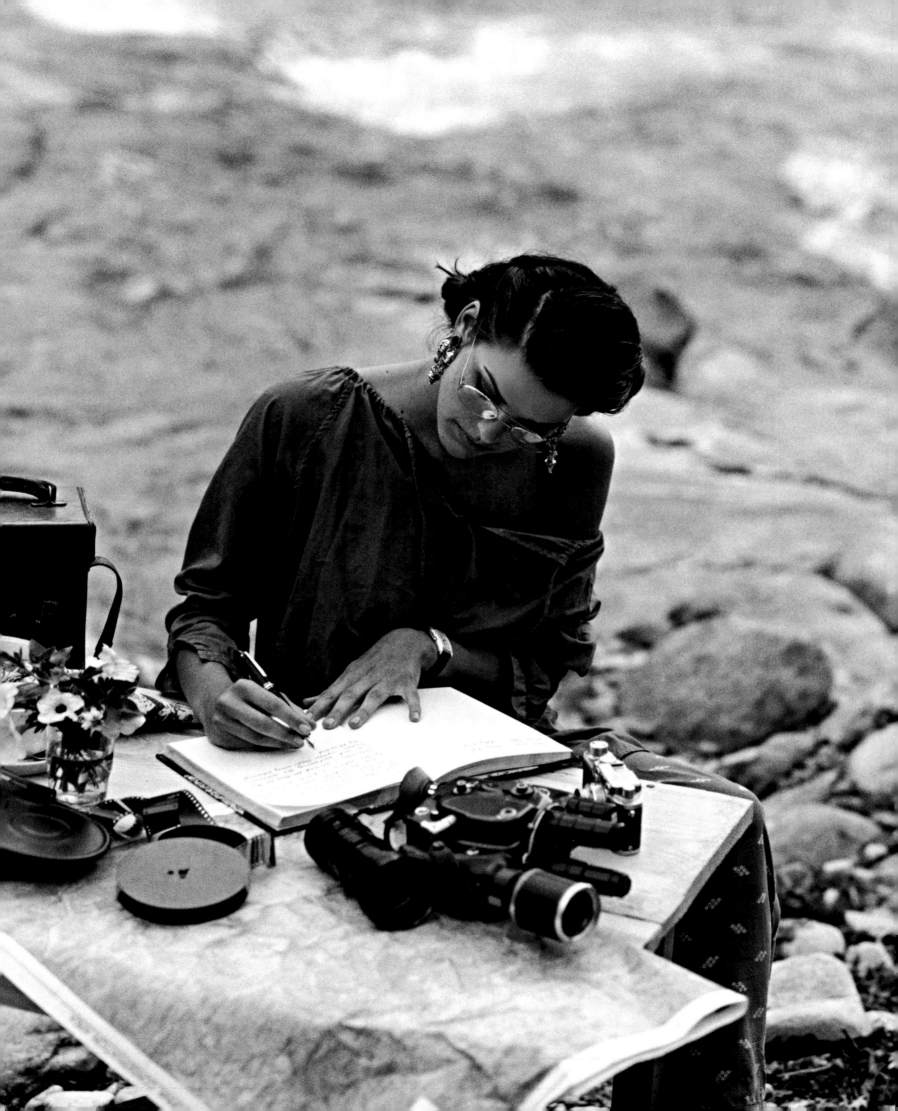

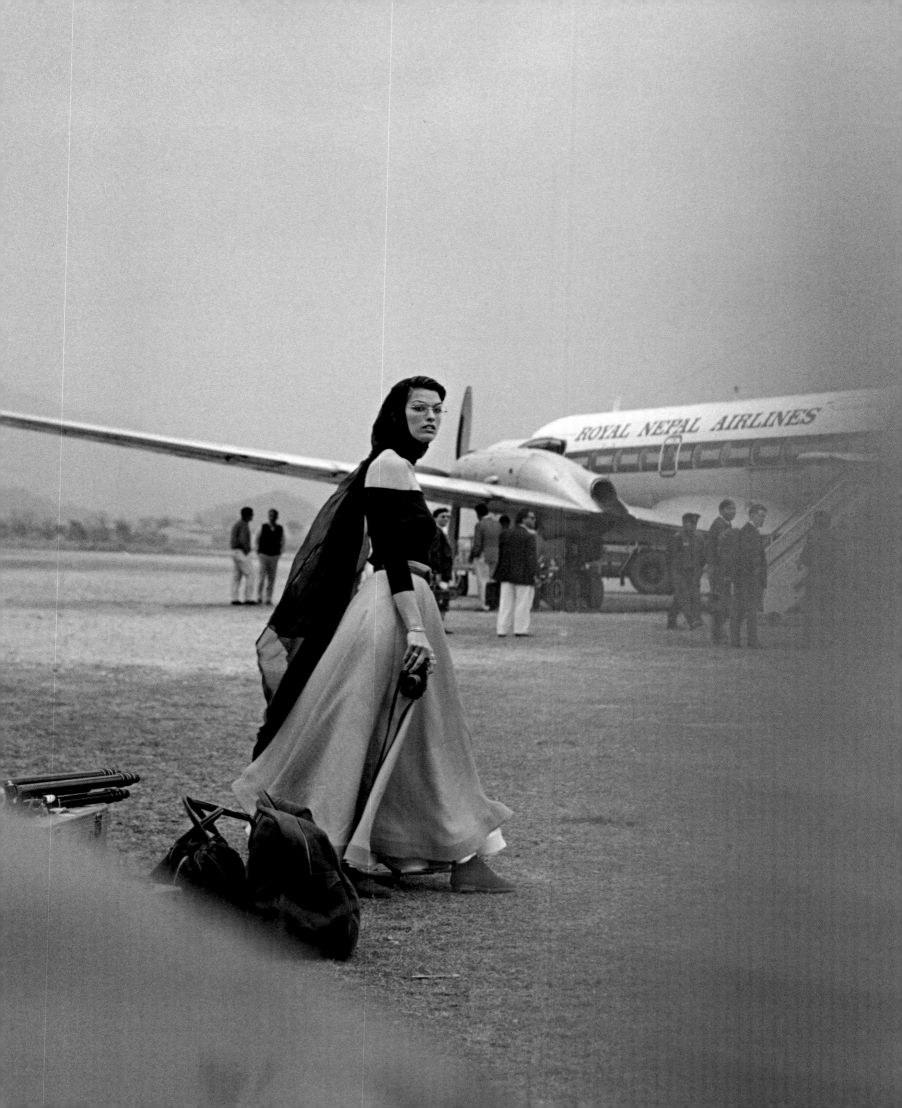

'Having
flown
halfway across
the globe
from N.Y. to Mali,
I finally get to have
a meeting with
the African
photographer
Seydou Keita
to discuss
the shoot.
Sitting on an upside-down
tin bucket under
the corrugated iron roof
of his house,
I was confronted
with a frail,
shriveled up man
barely able
to stand after
a month
of fasting
and a bout
of malaria.'

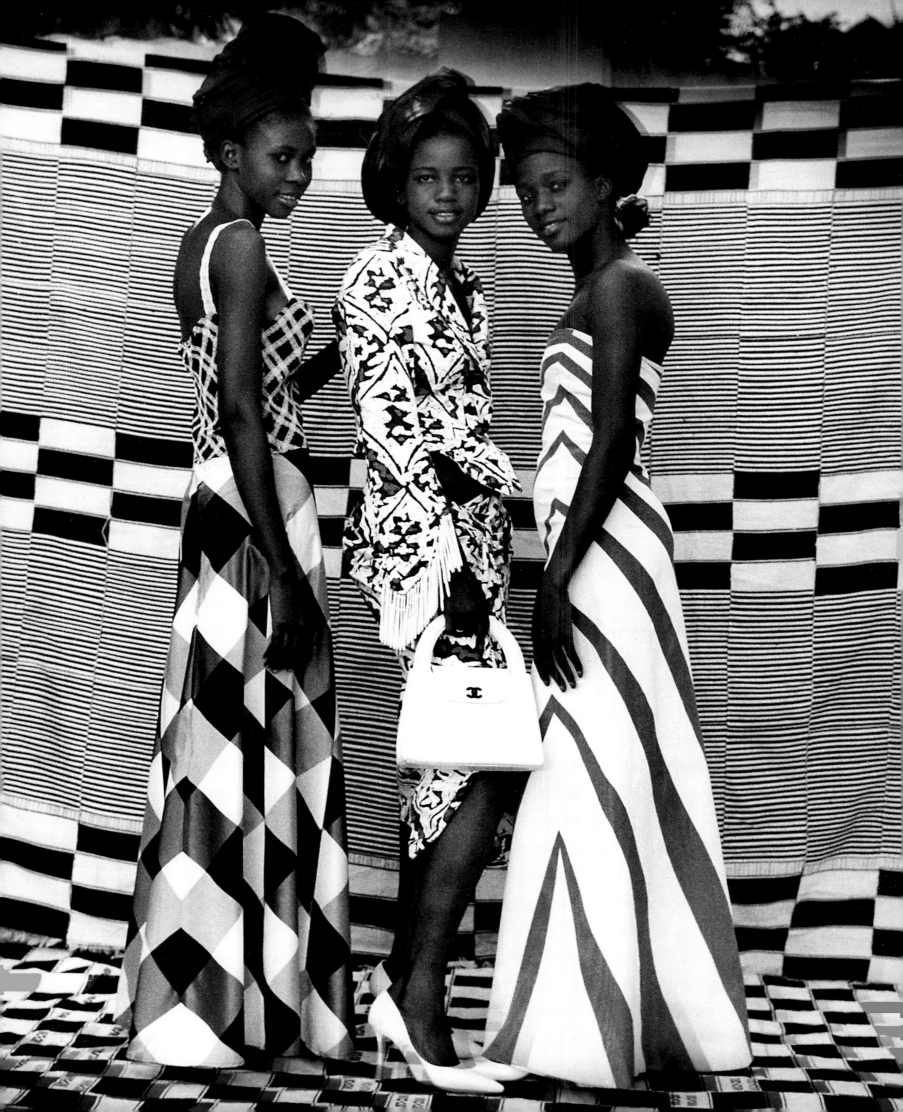

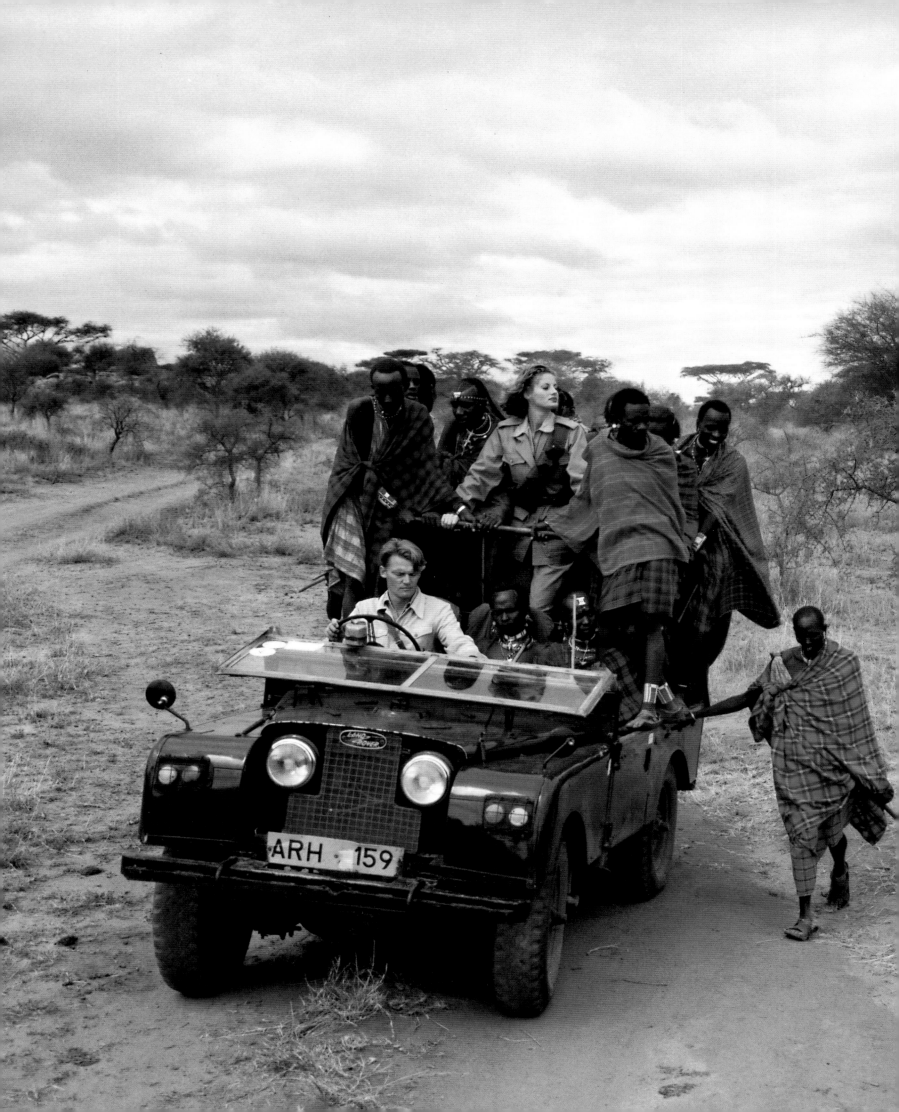

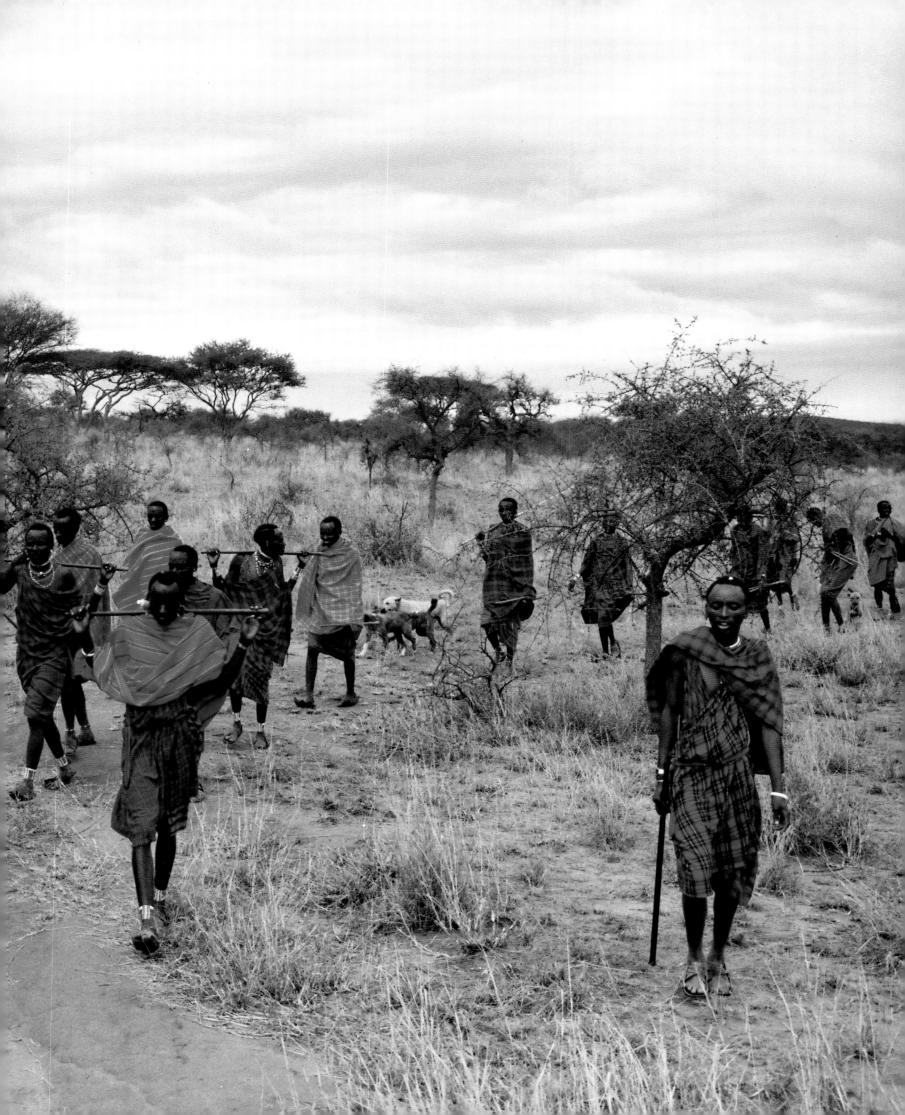

'In the deepest, darkest Africa, one quiet Masai warrior told me, "I don't do stills, I only do movies."'

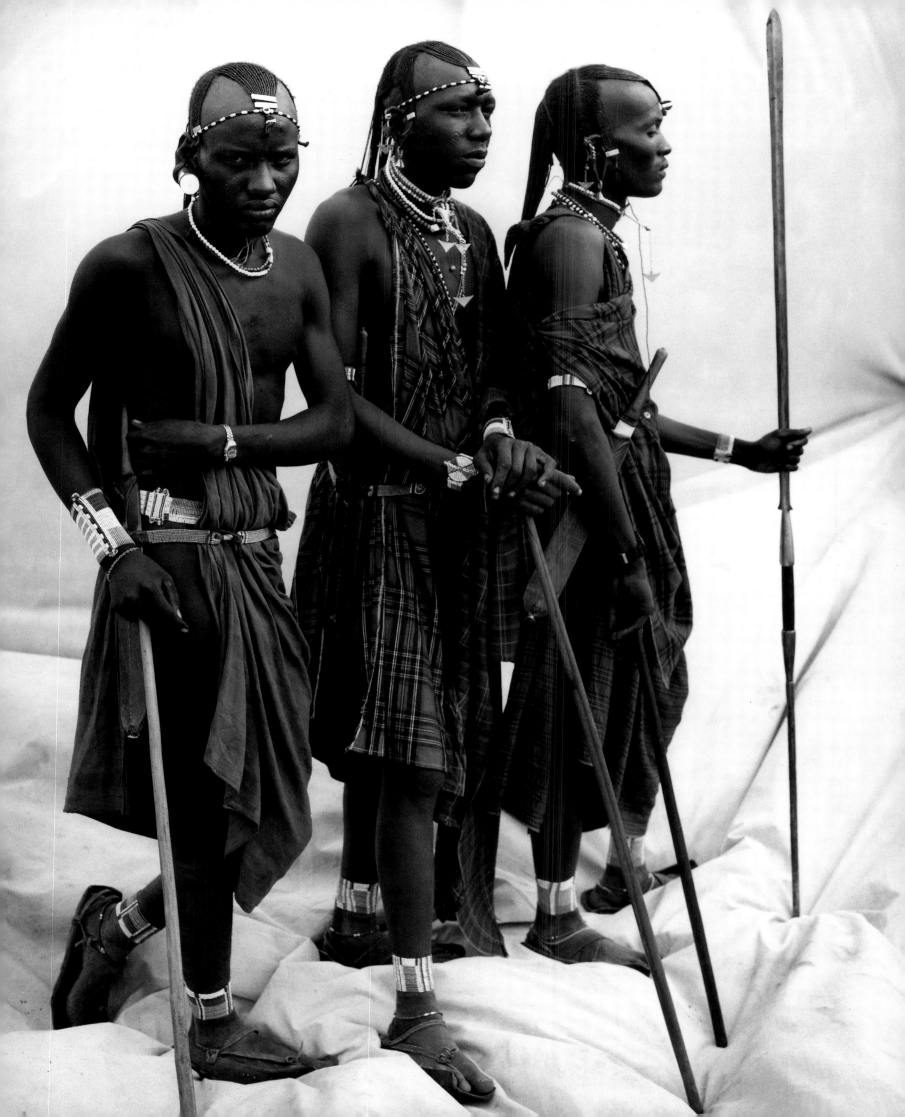

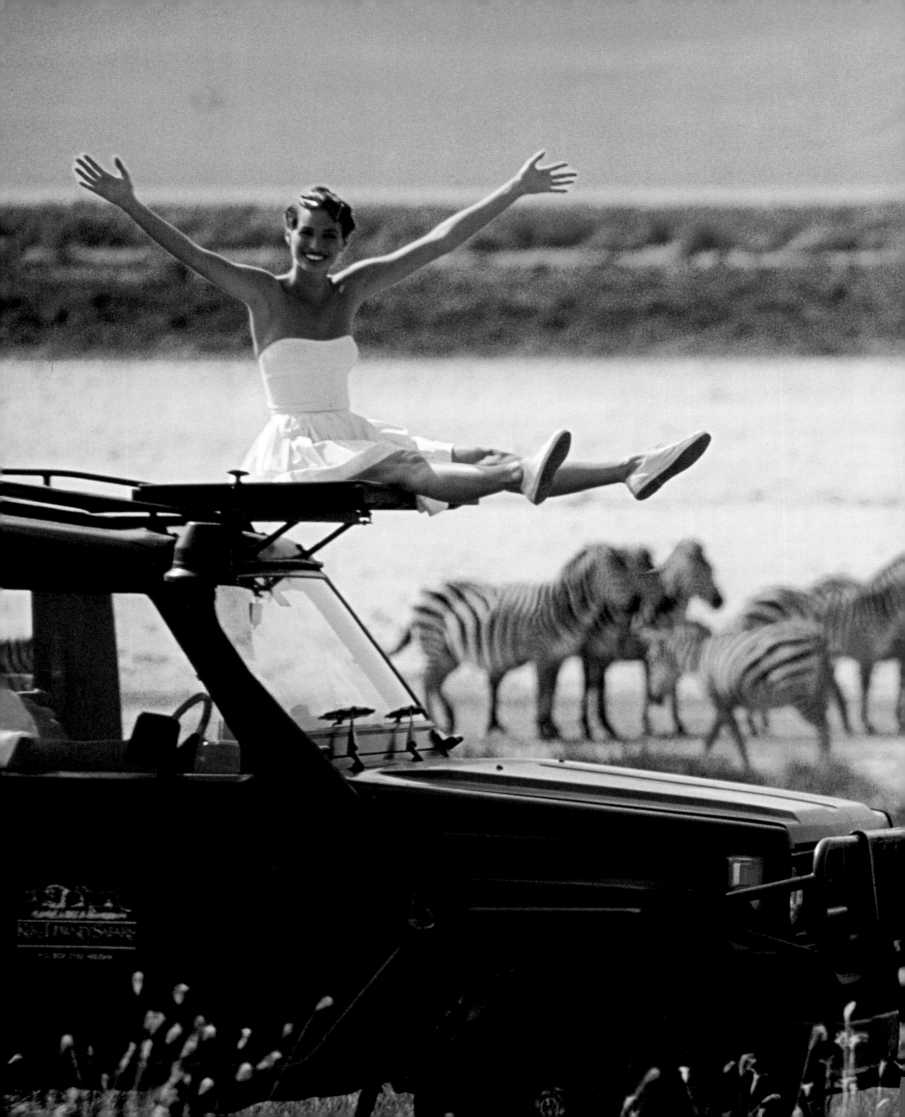

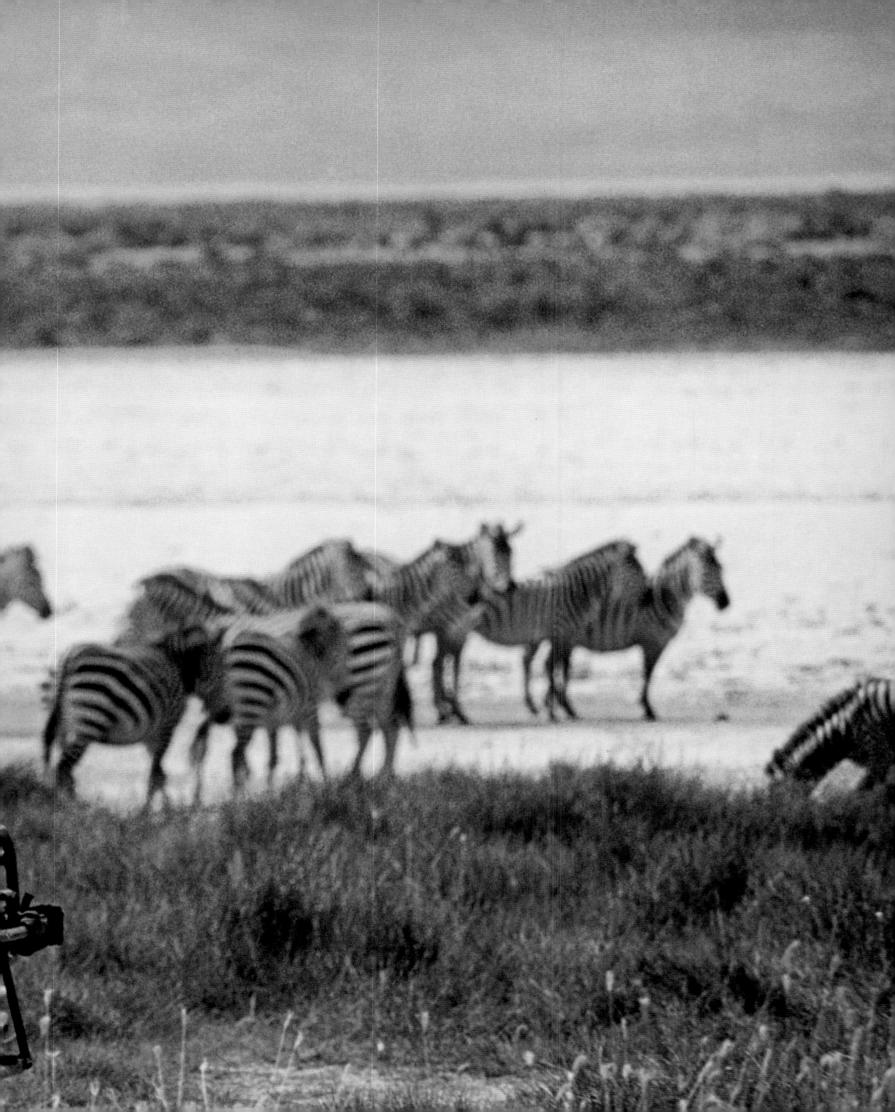

'This rhino posed fabulously. He was more placid than a piece of furniture. But the next day the beast charged at anything and everything.'

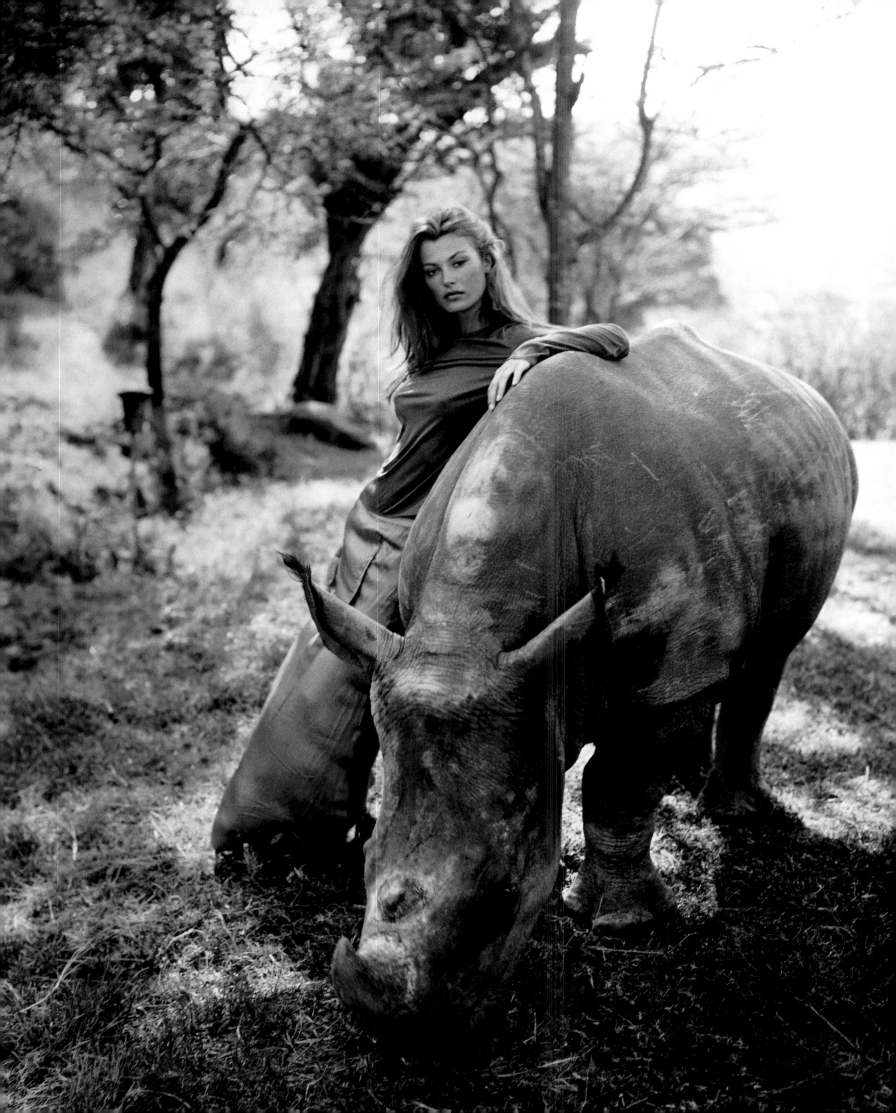

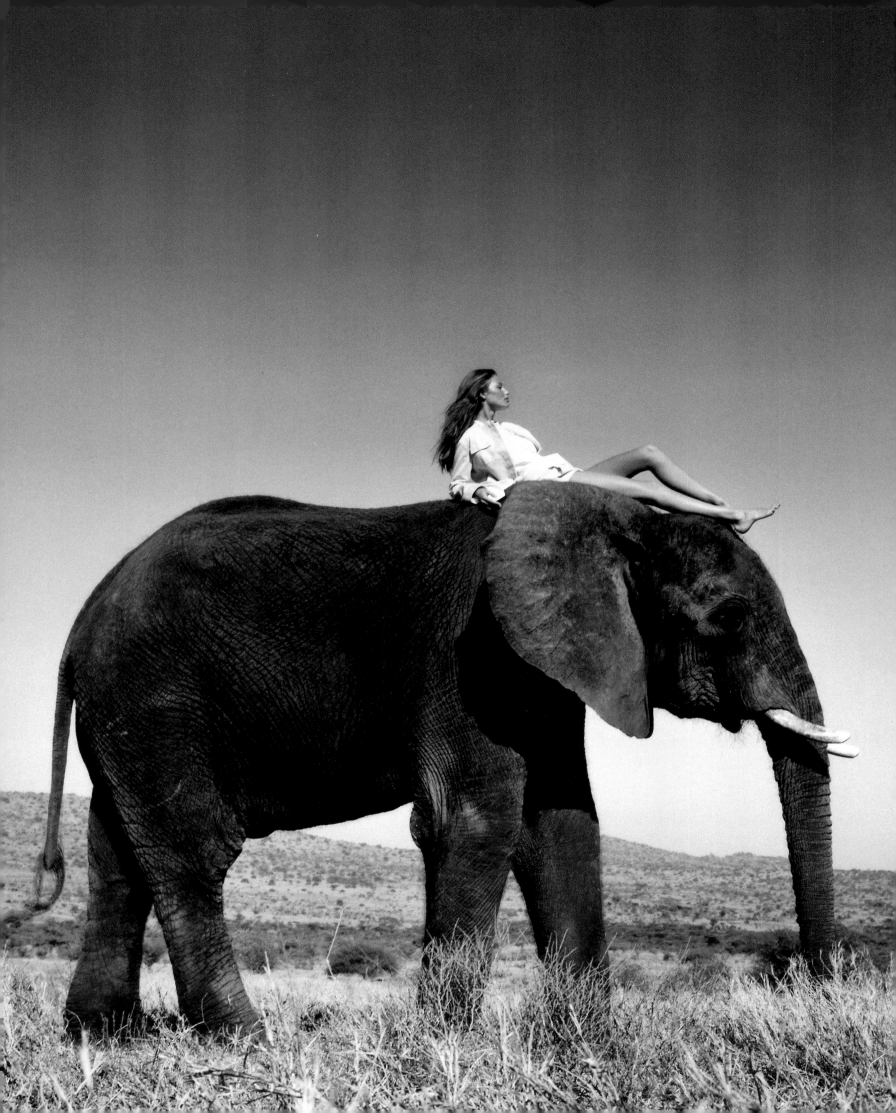

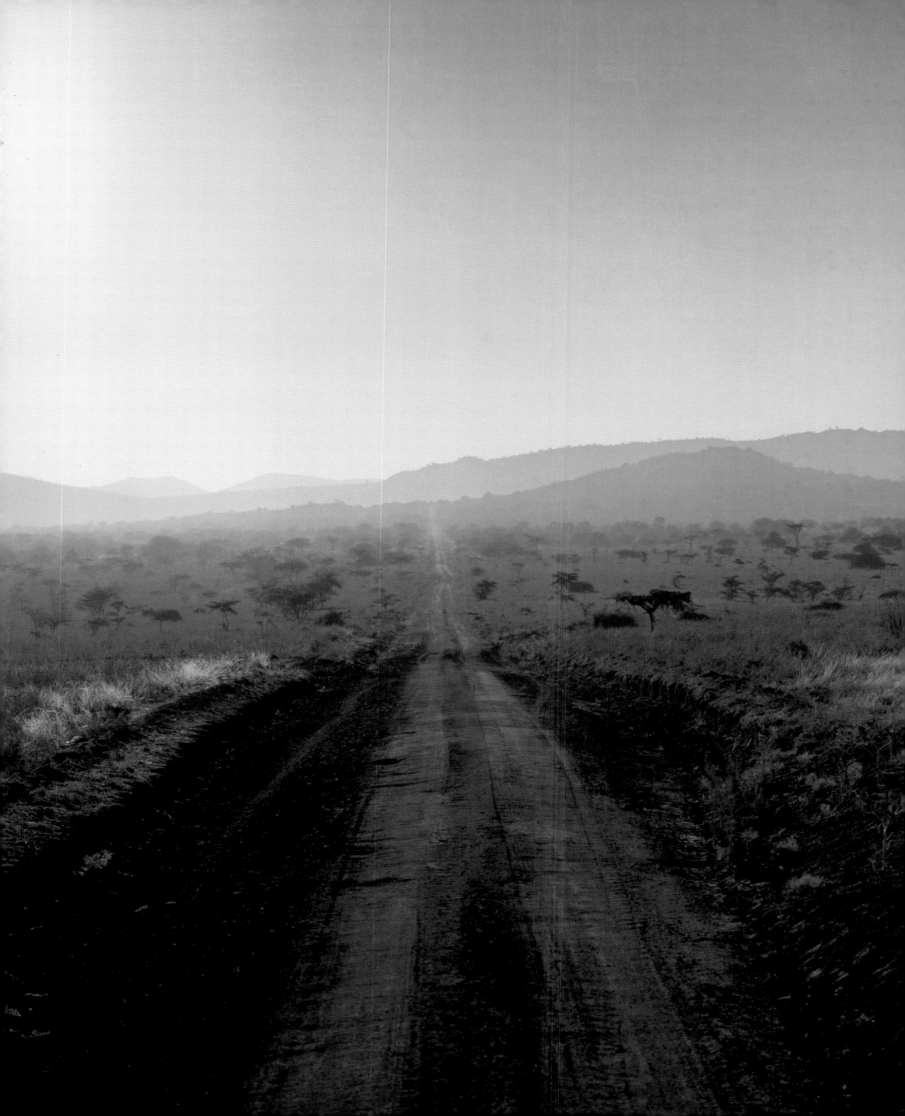

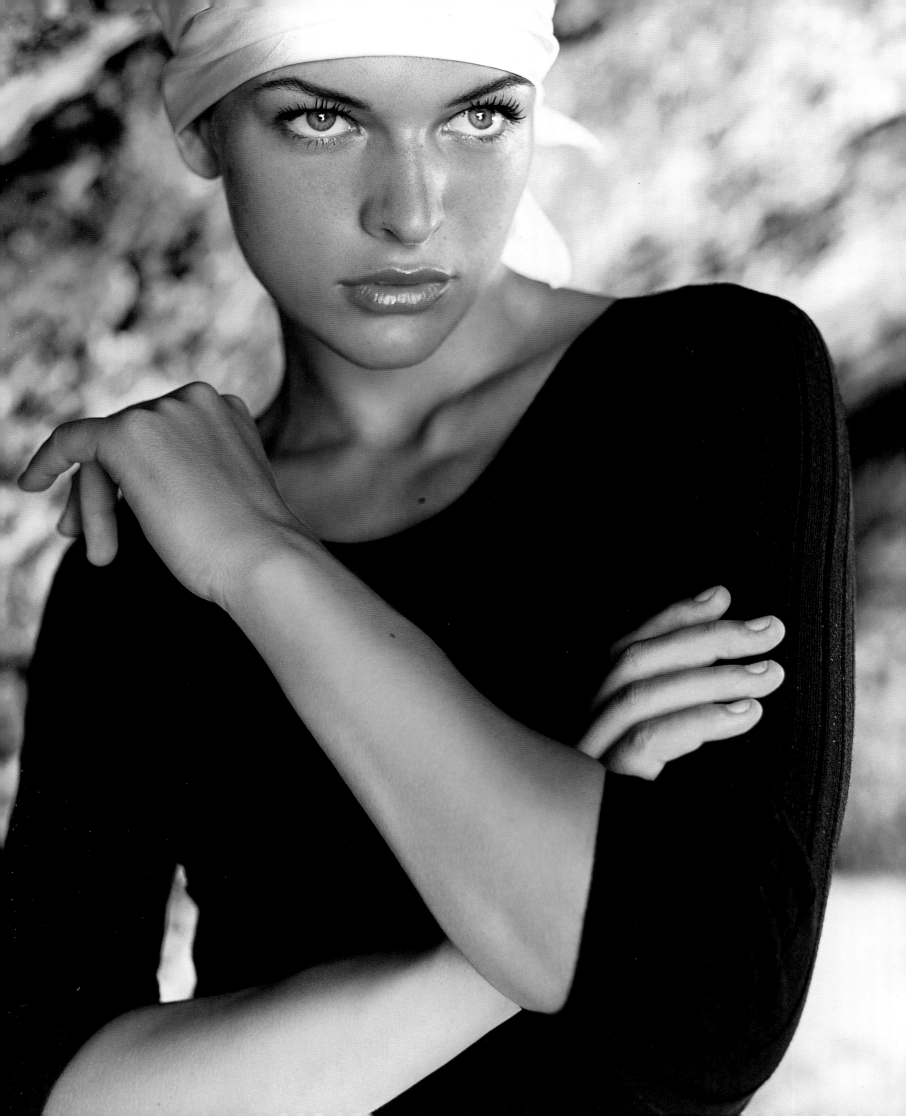

'On my first trip to East Africa, I managed to misread my malaria medication: I took one Larium a day for three days, instead of one a week for three weeks. Result: hallucinations.'

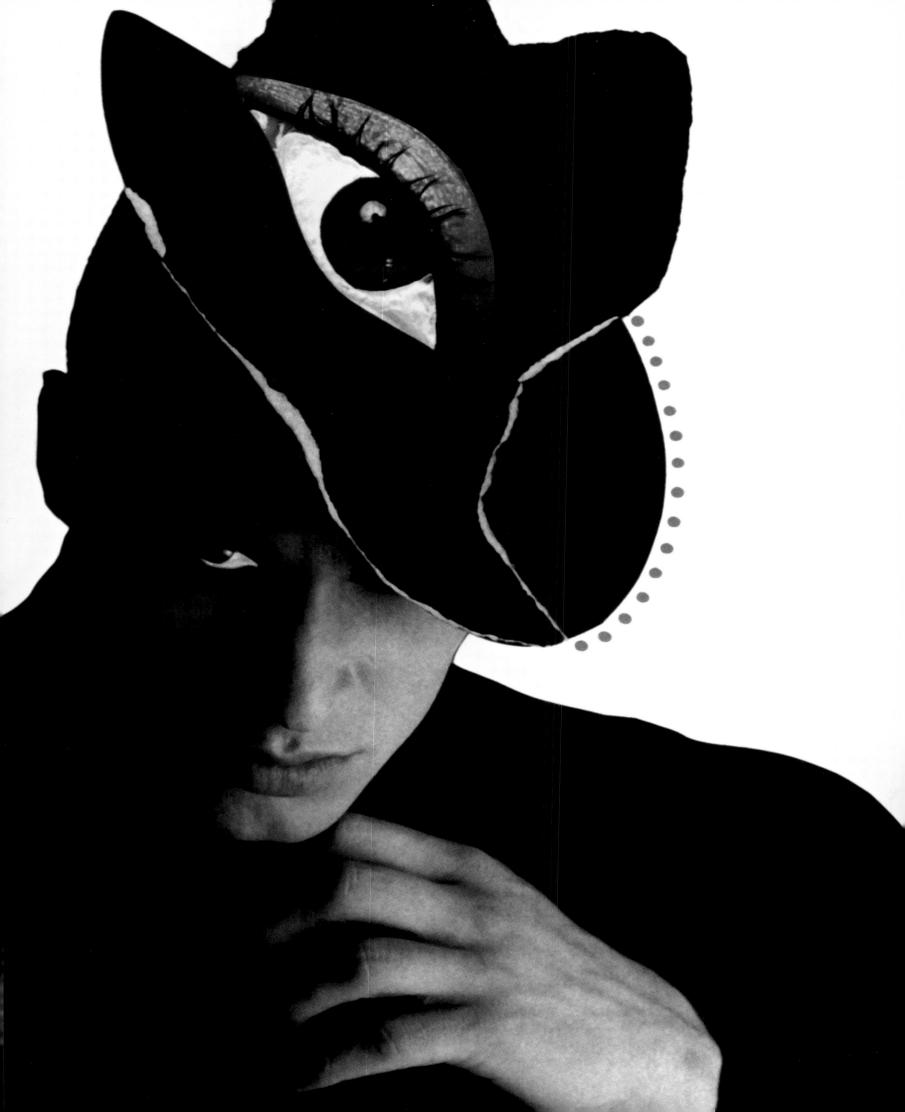

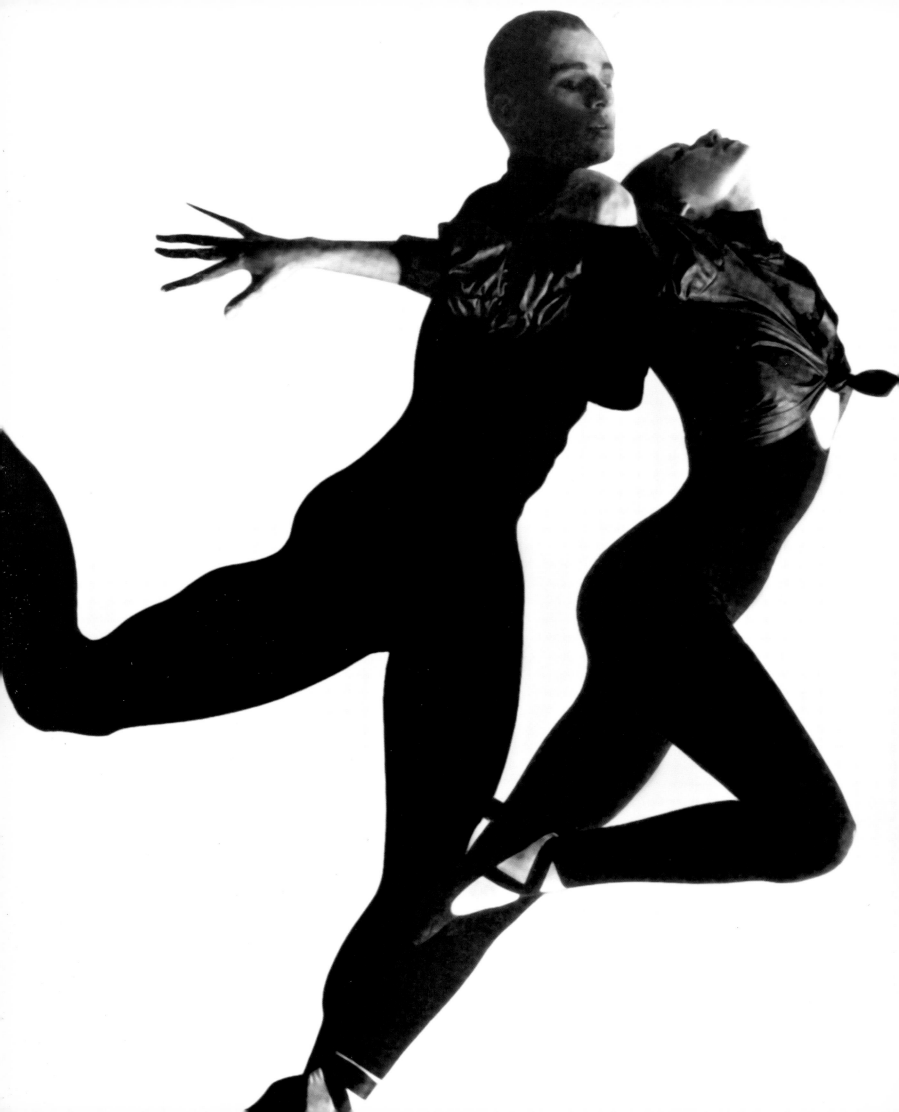

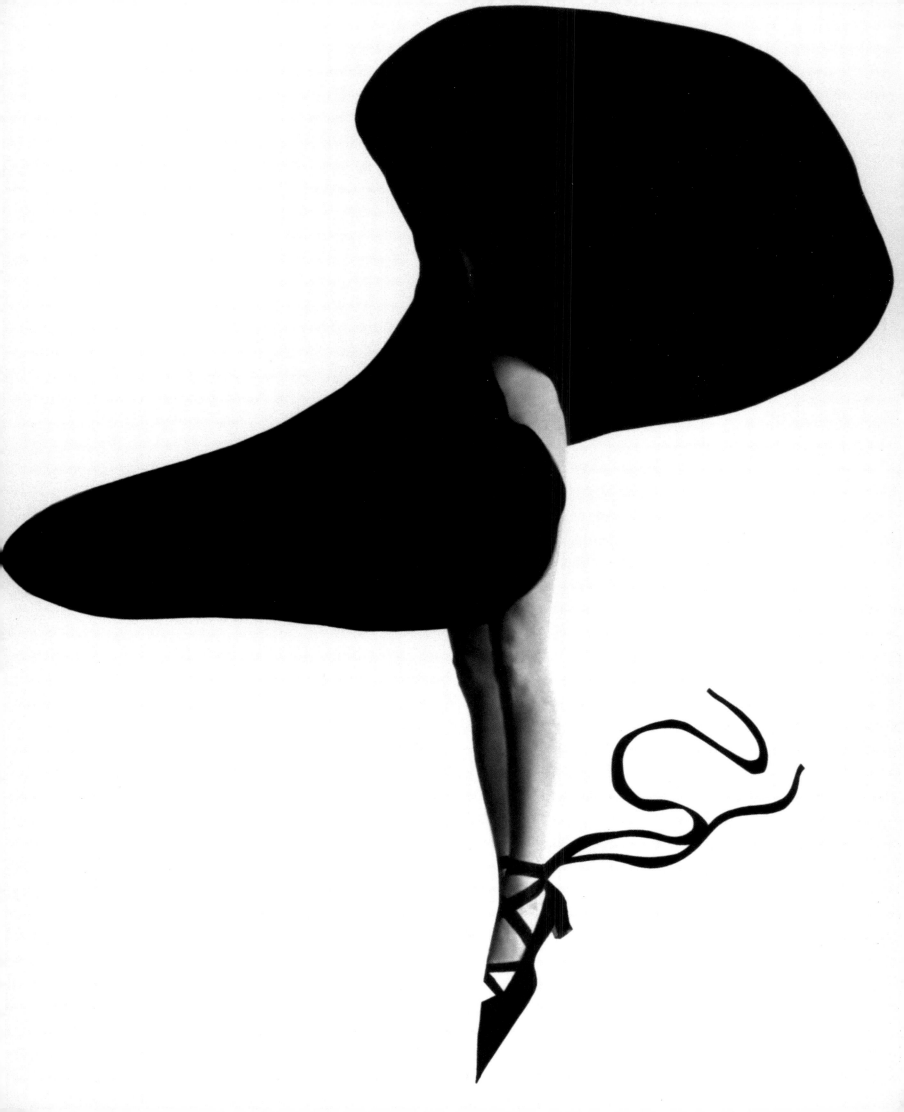

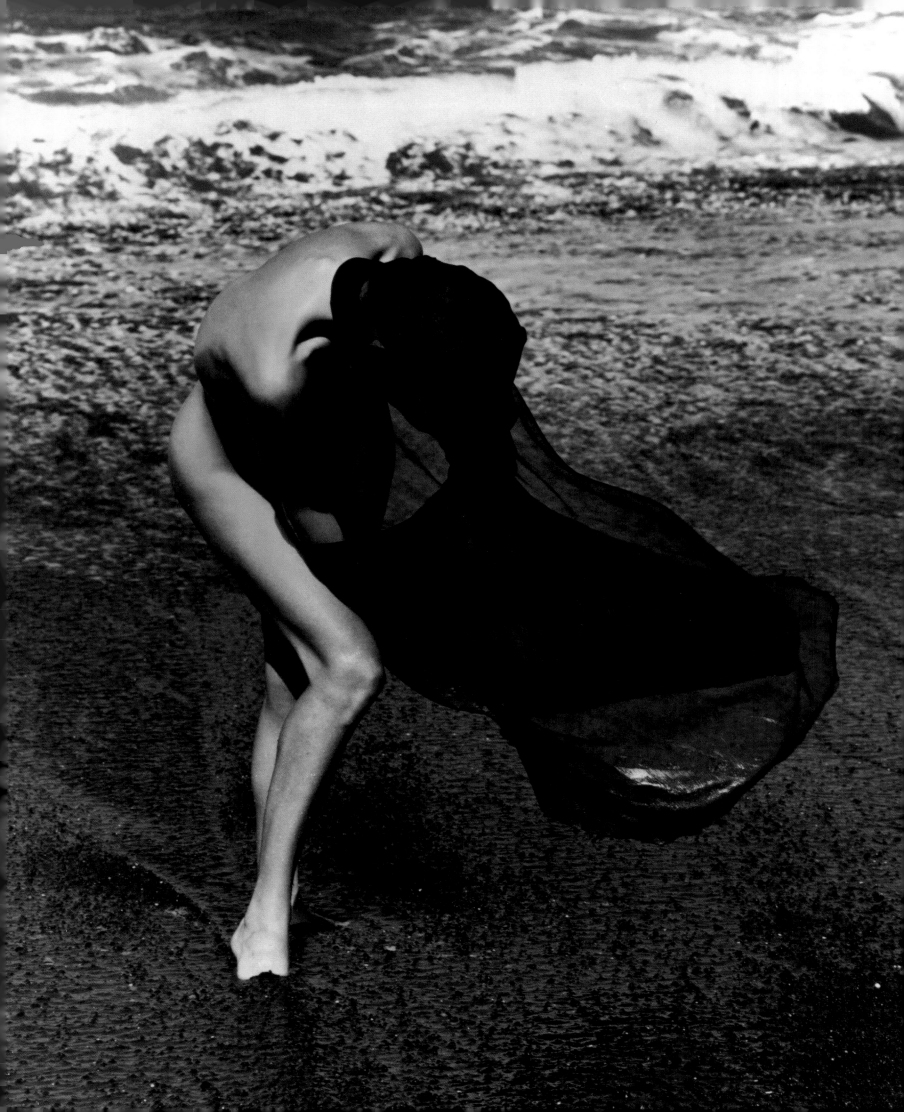

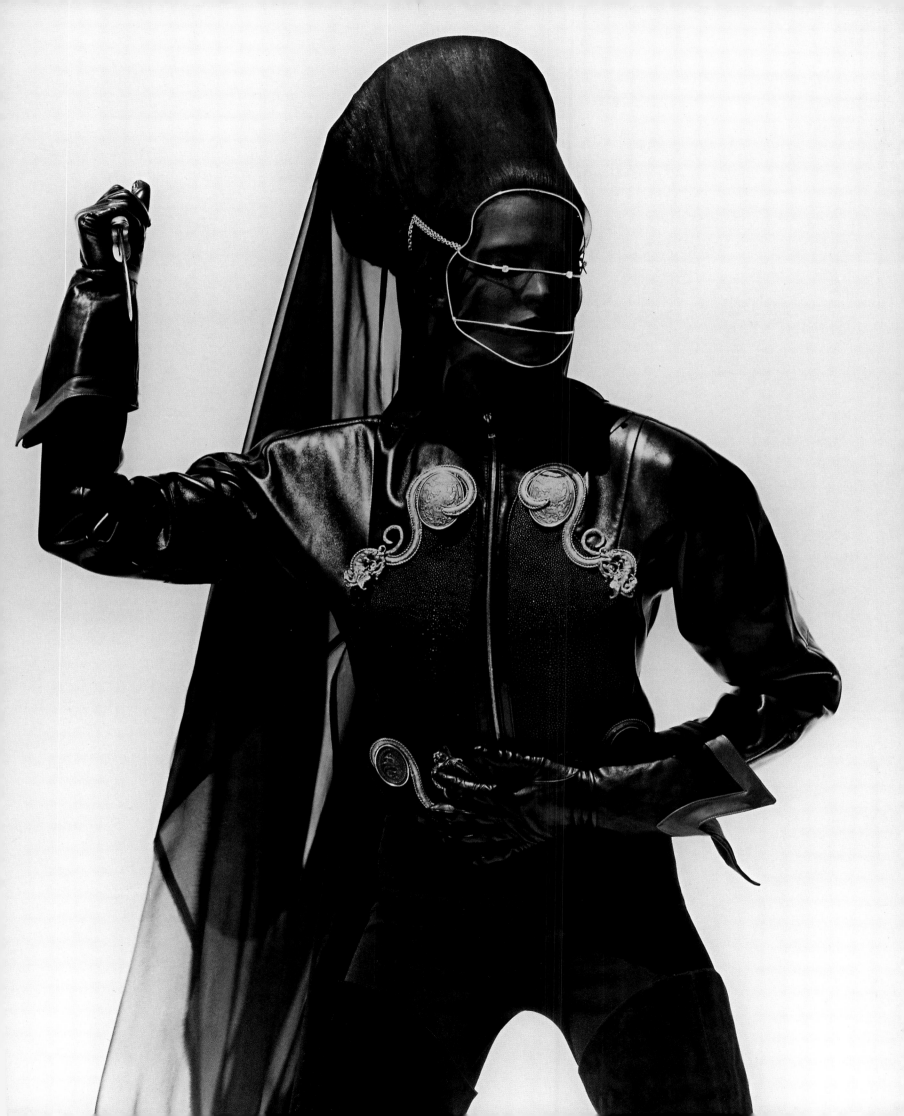

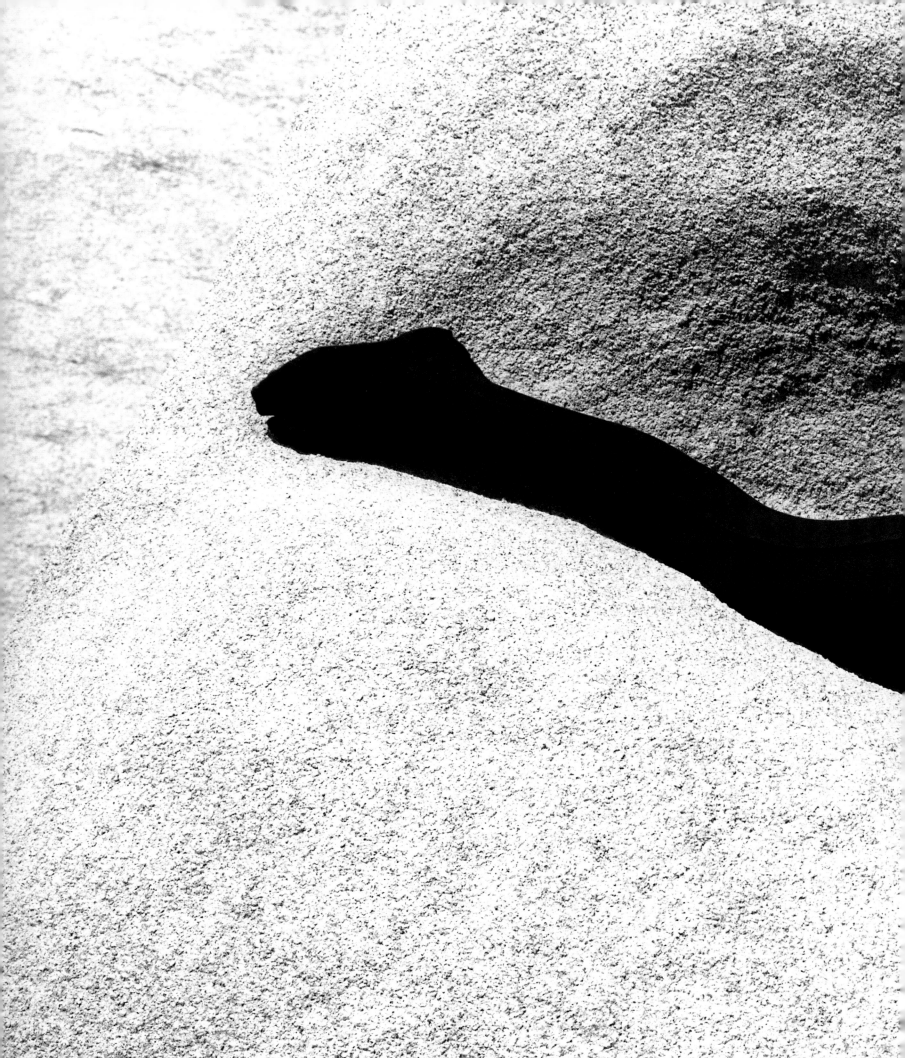

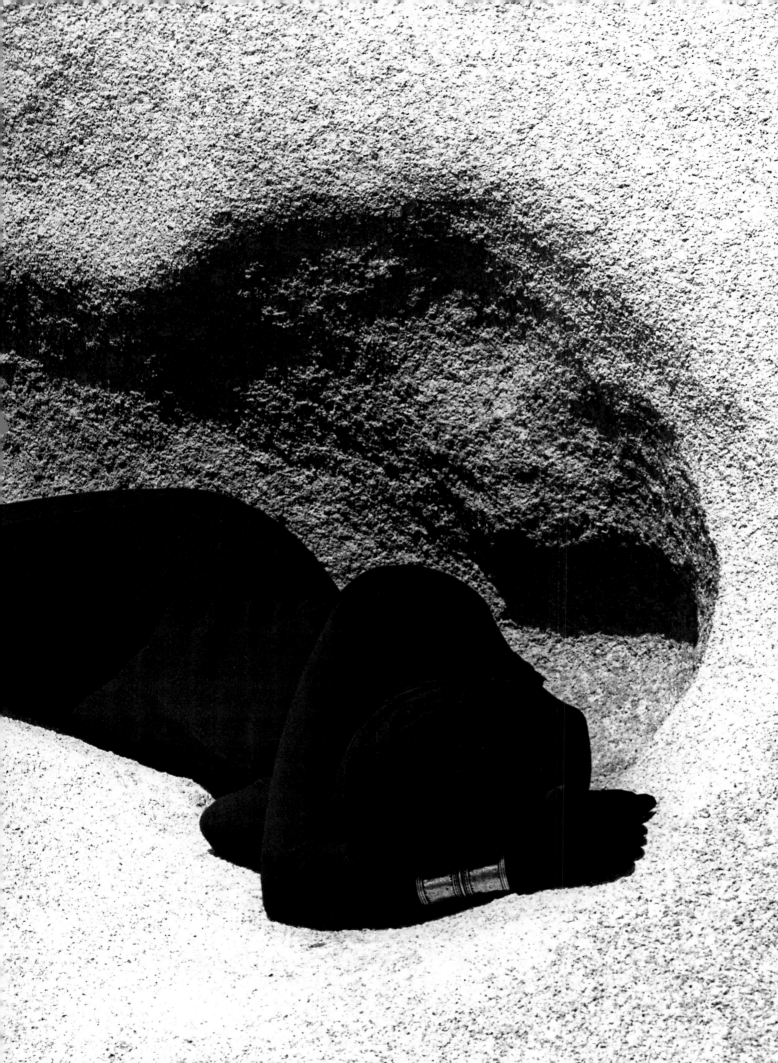

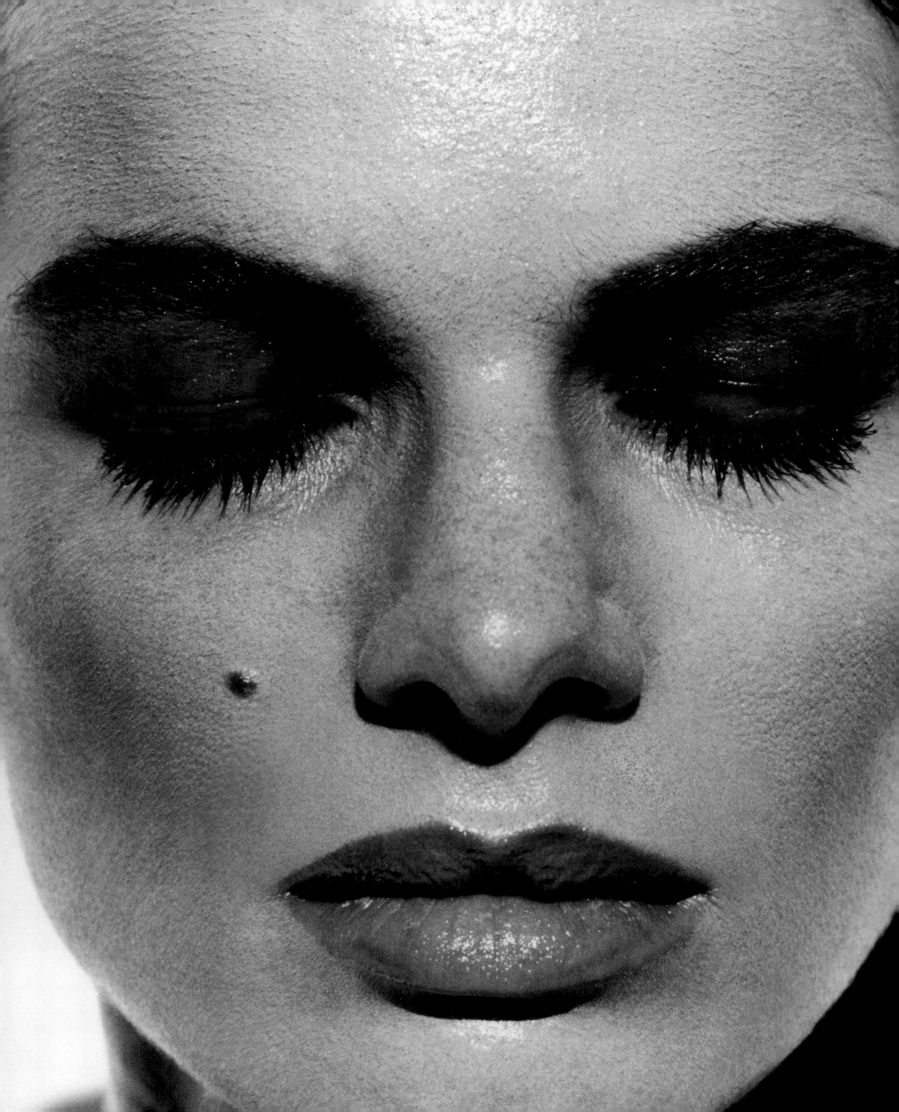

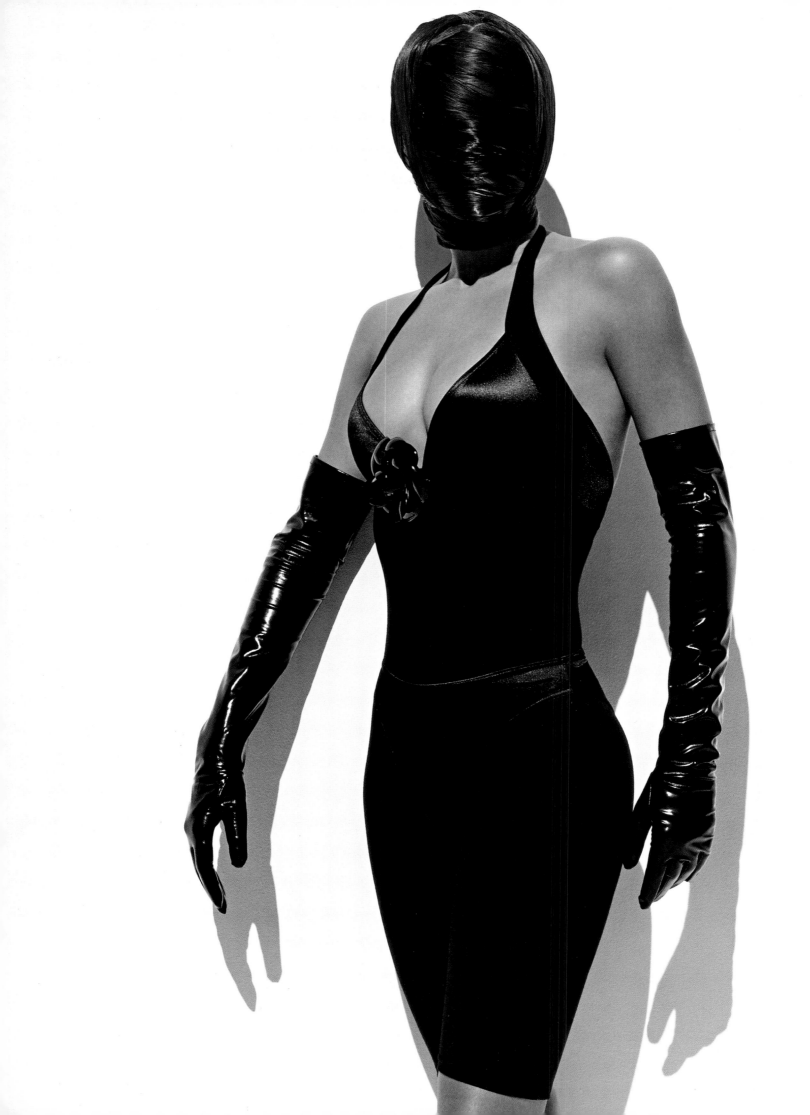

'For this shoot, as well as a white horse, we laid on crates of white rabbits, more crates of white doves, and three white huskies, all with their own trainers. Talk about devices.'

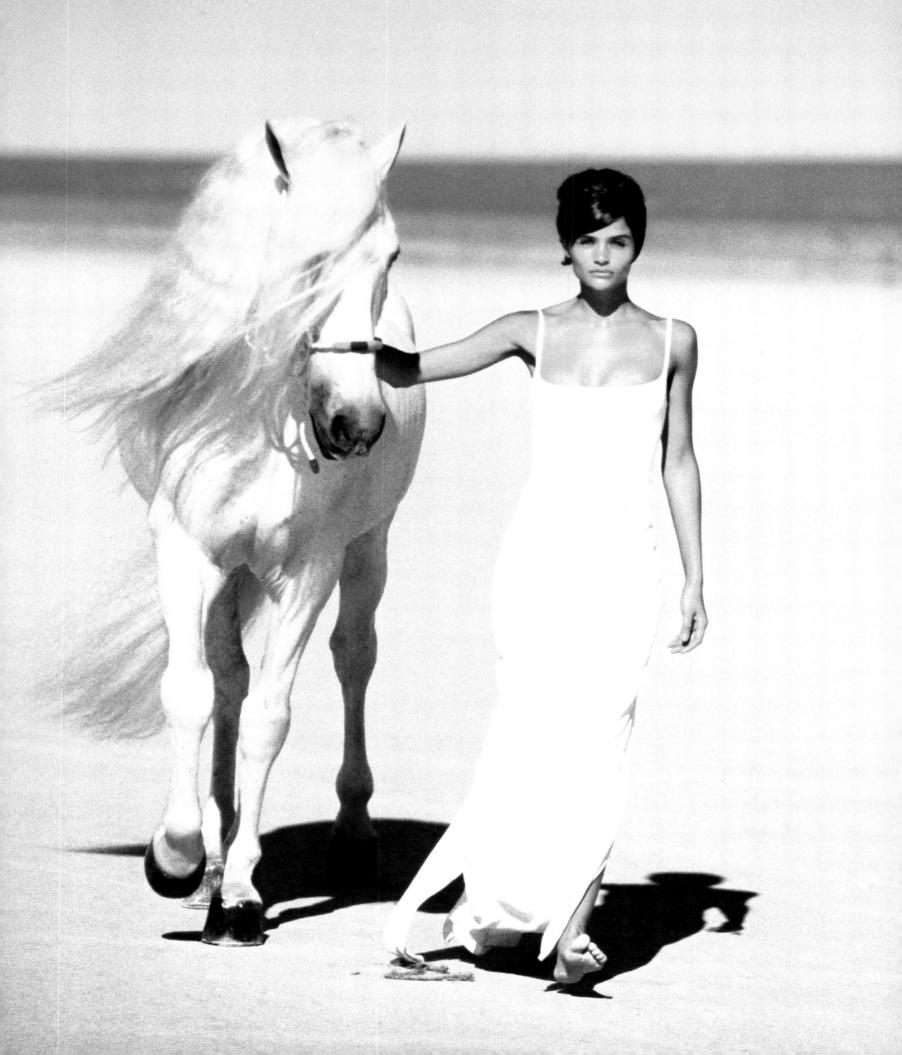

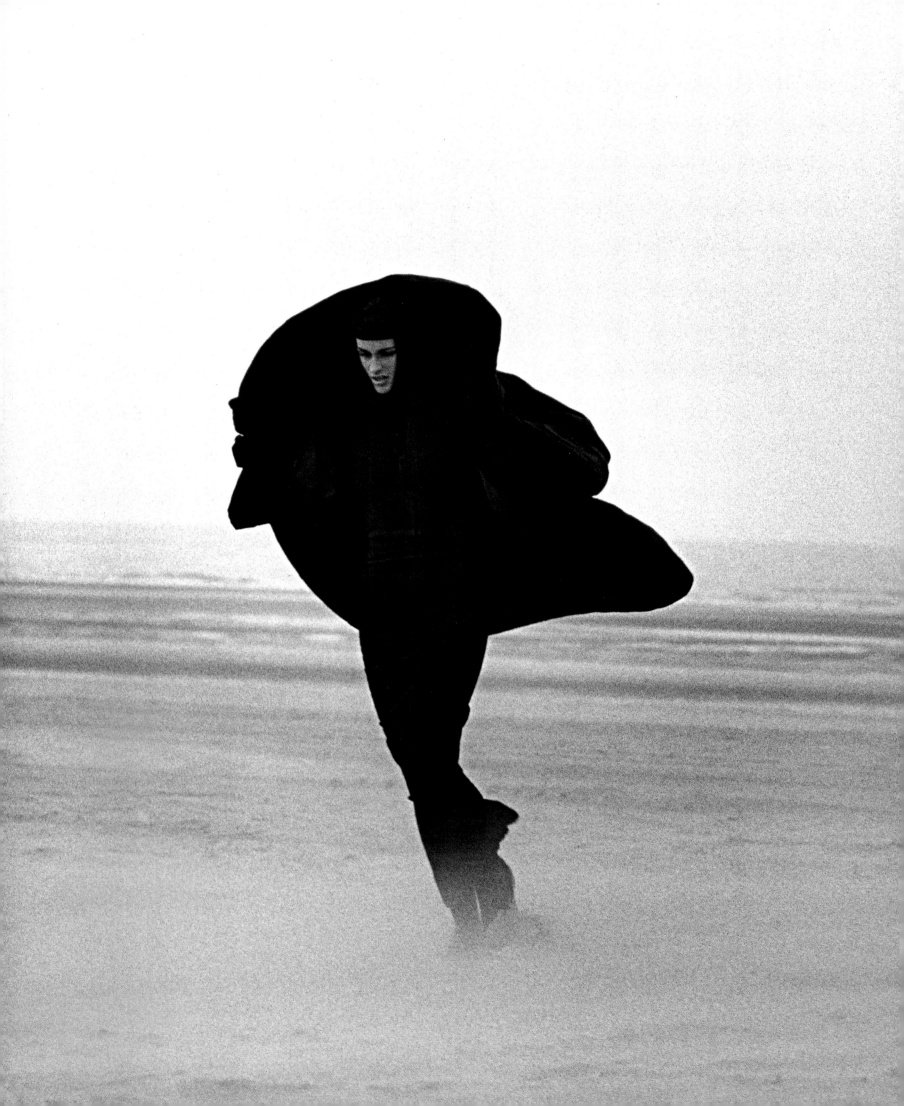

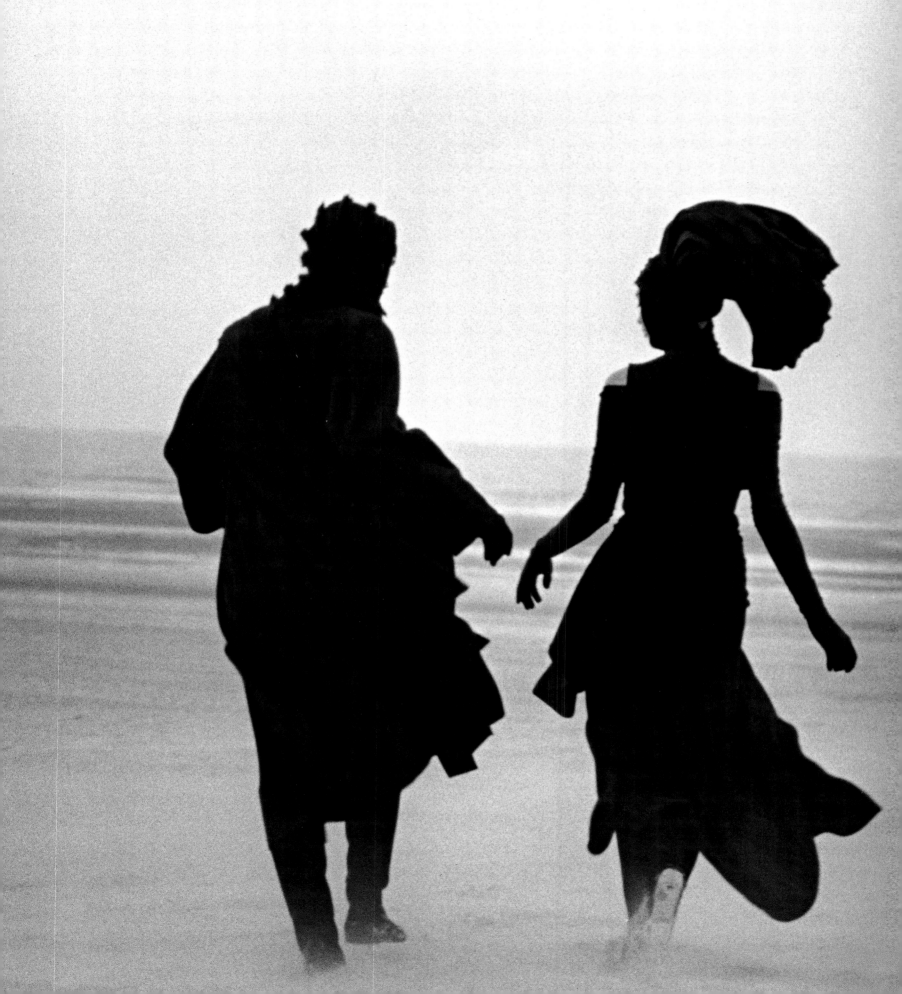

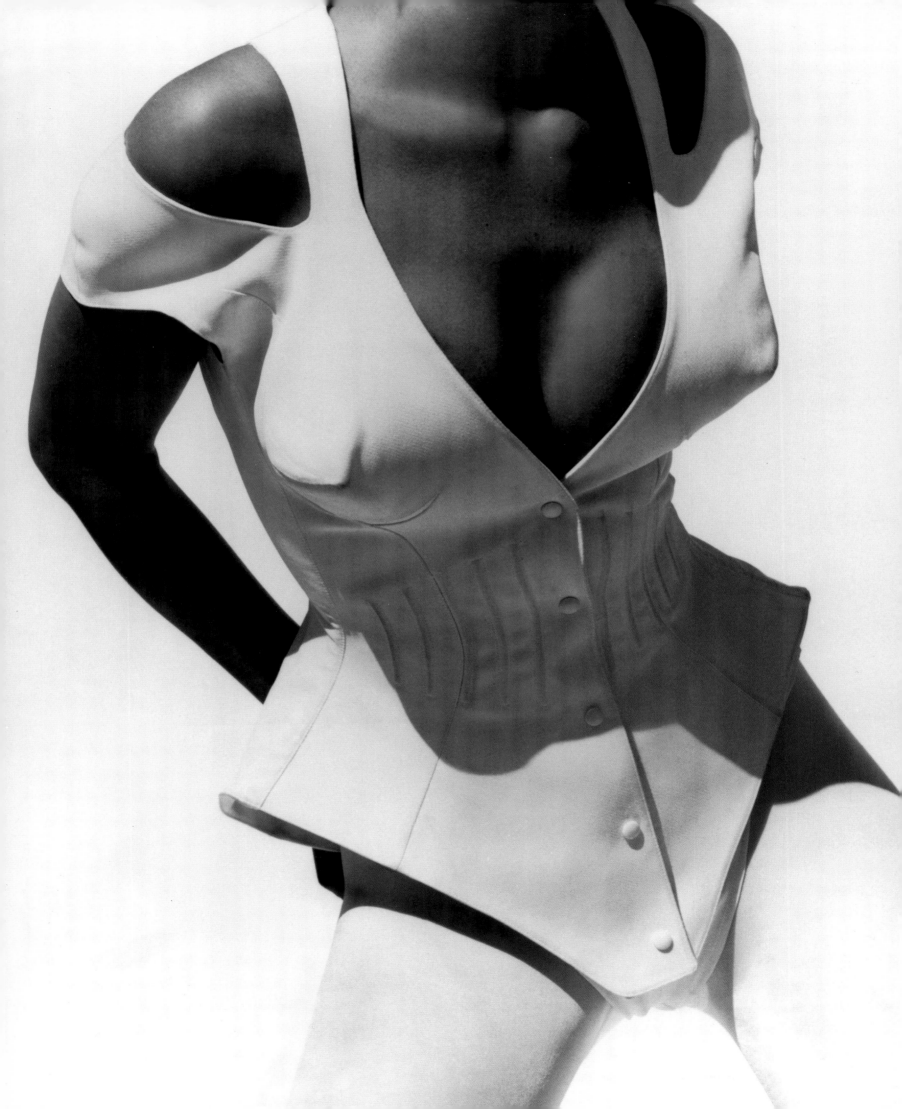

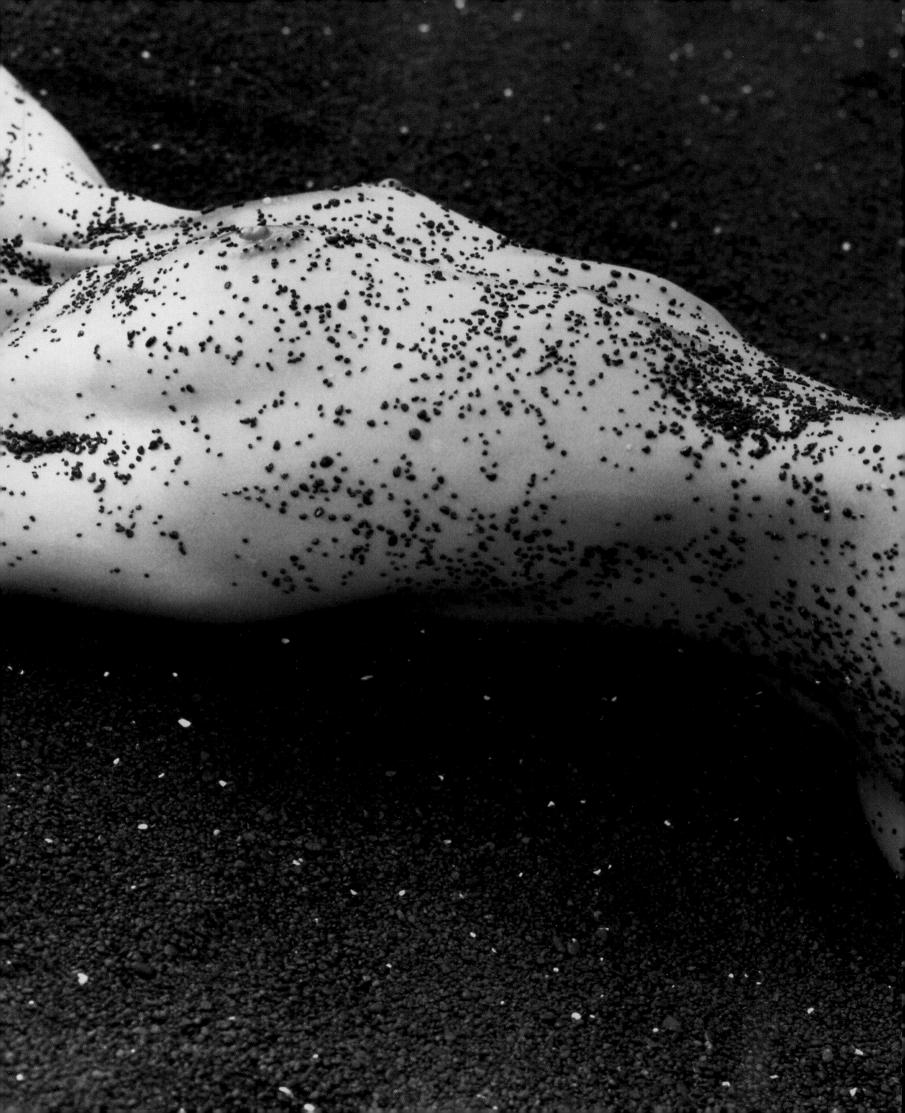

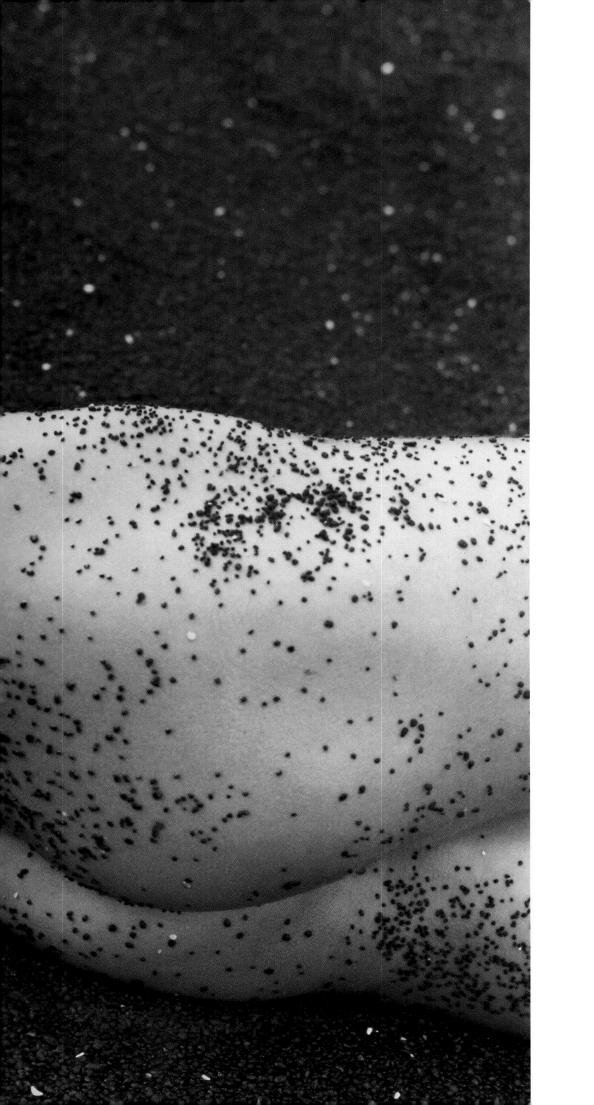

'The best models are those who also know how to work their bodies to make great photographs.'

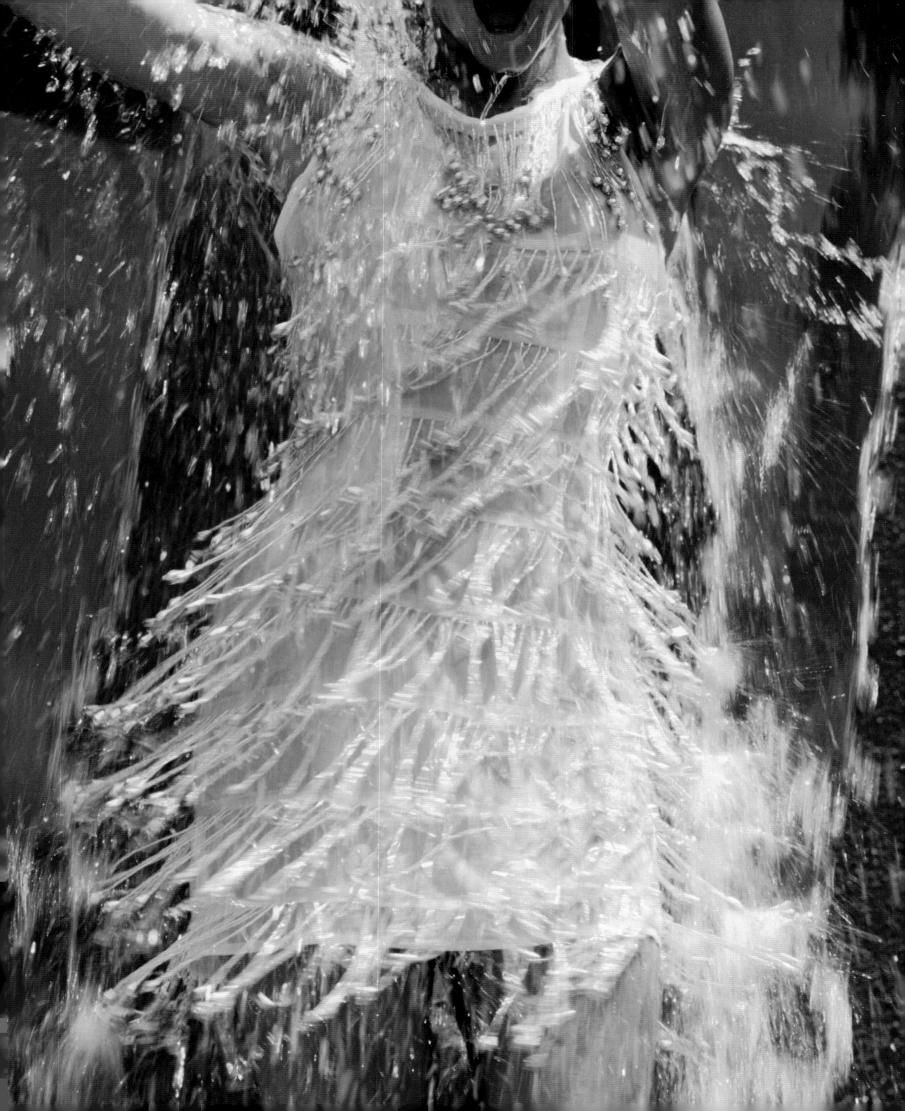

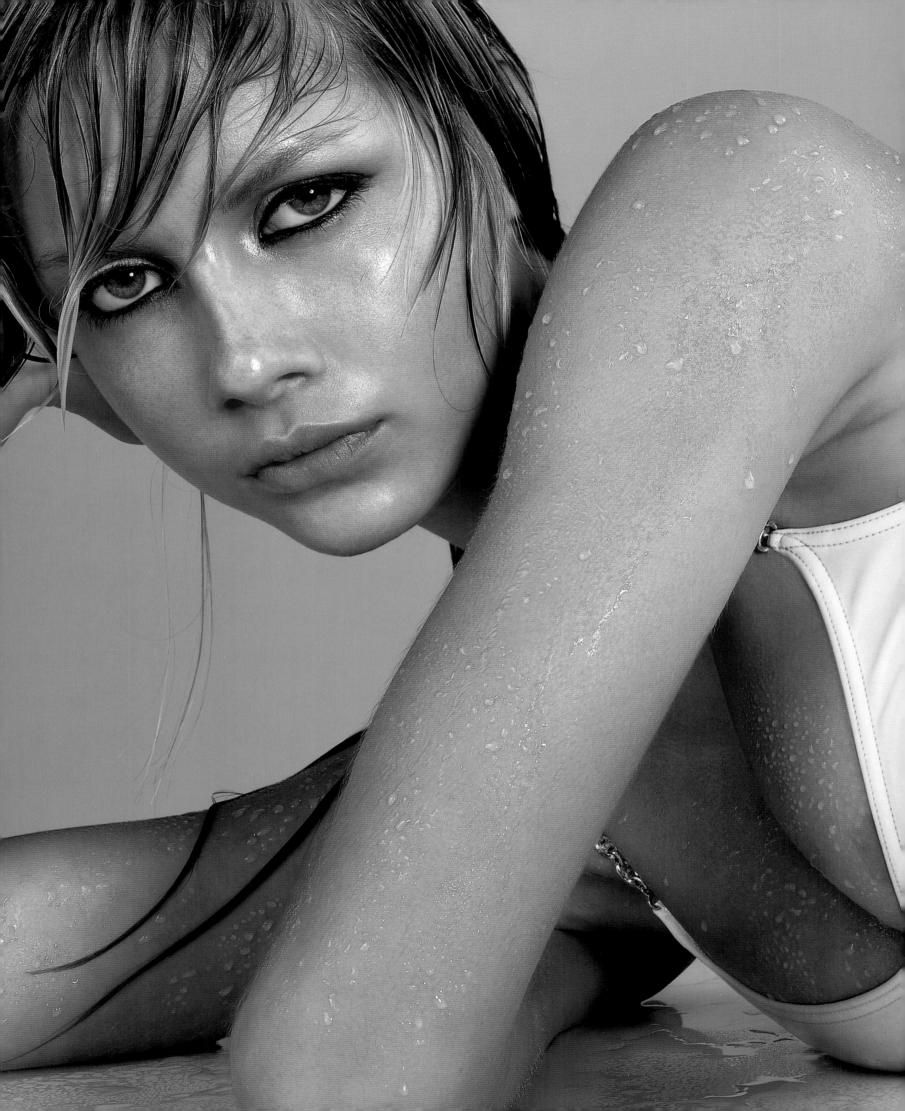

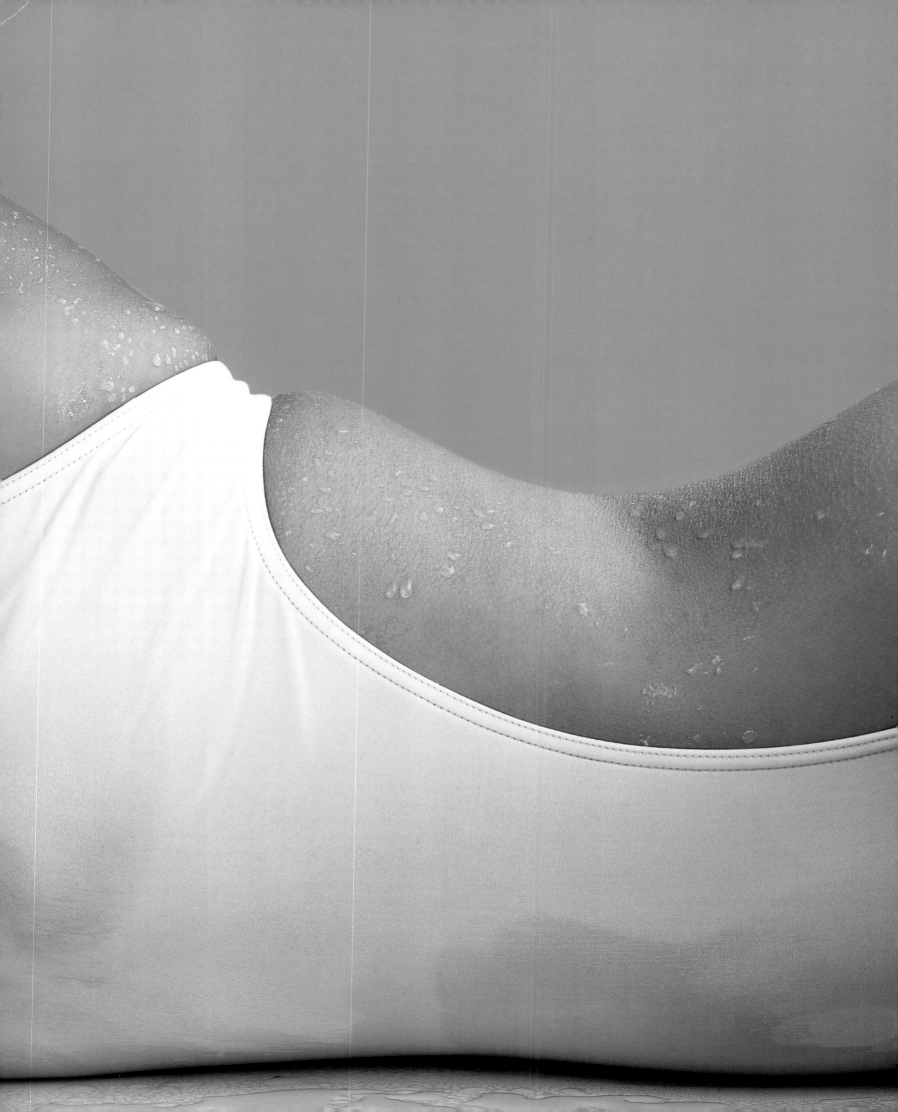

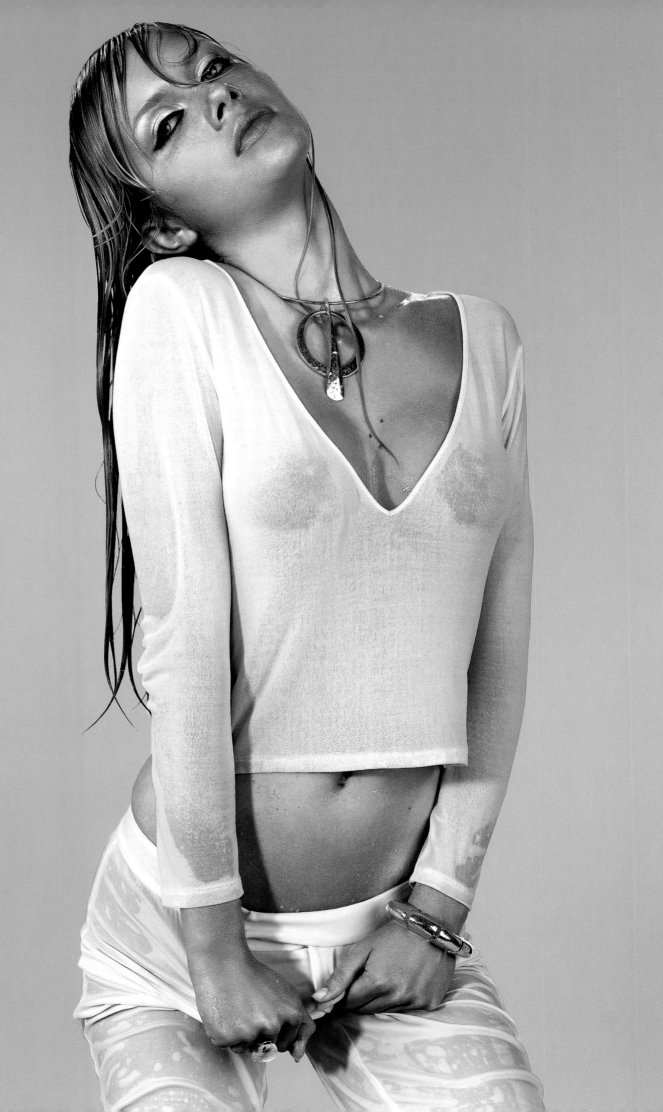

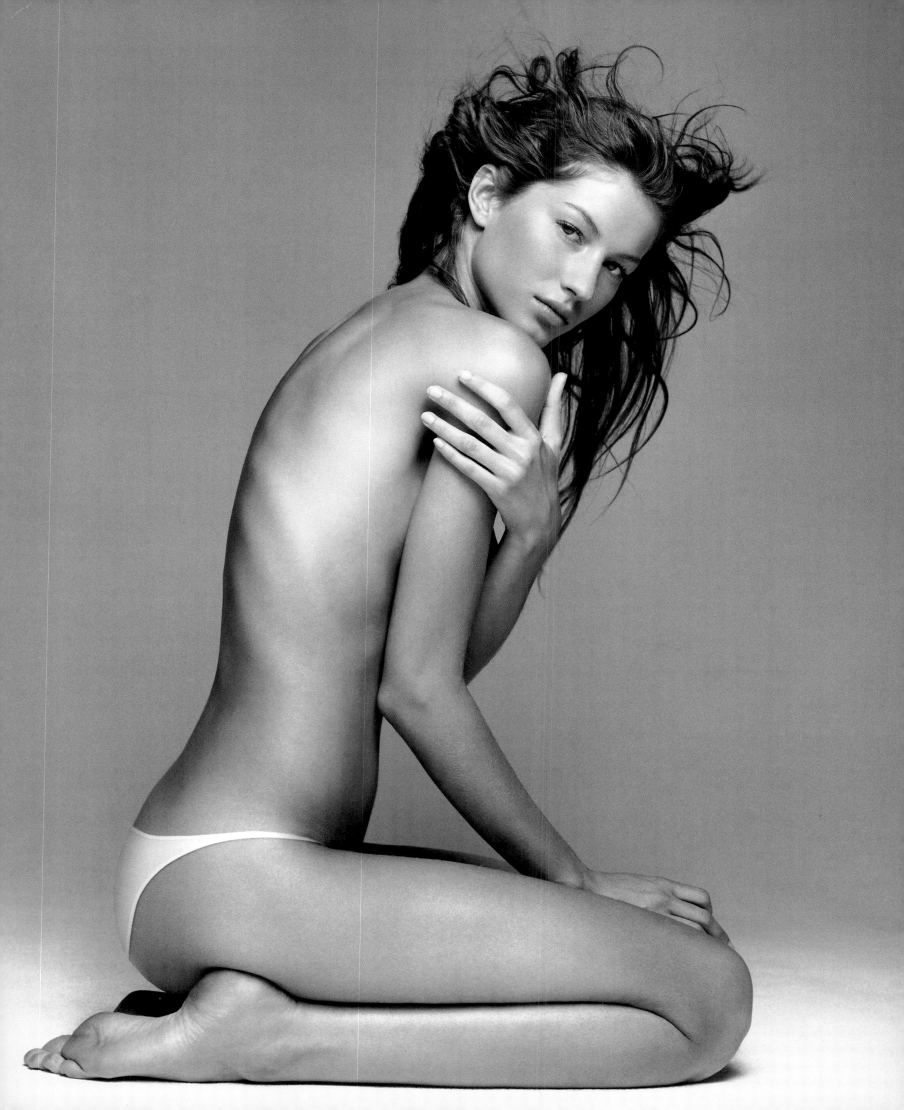

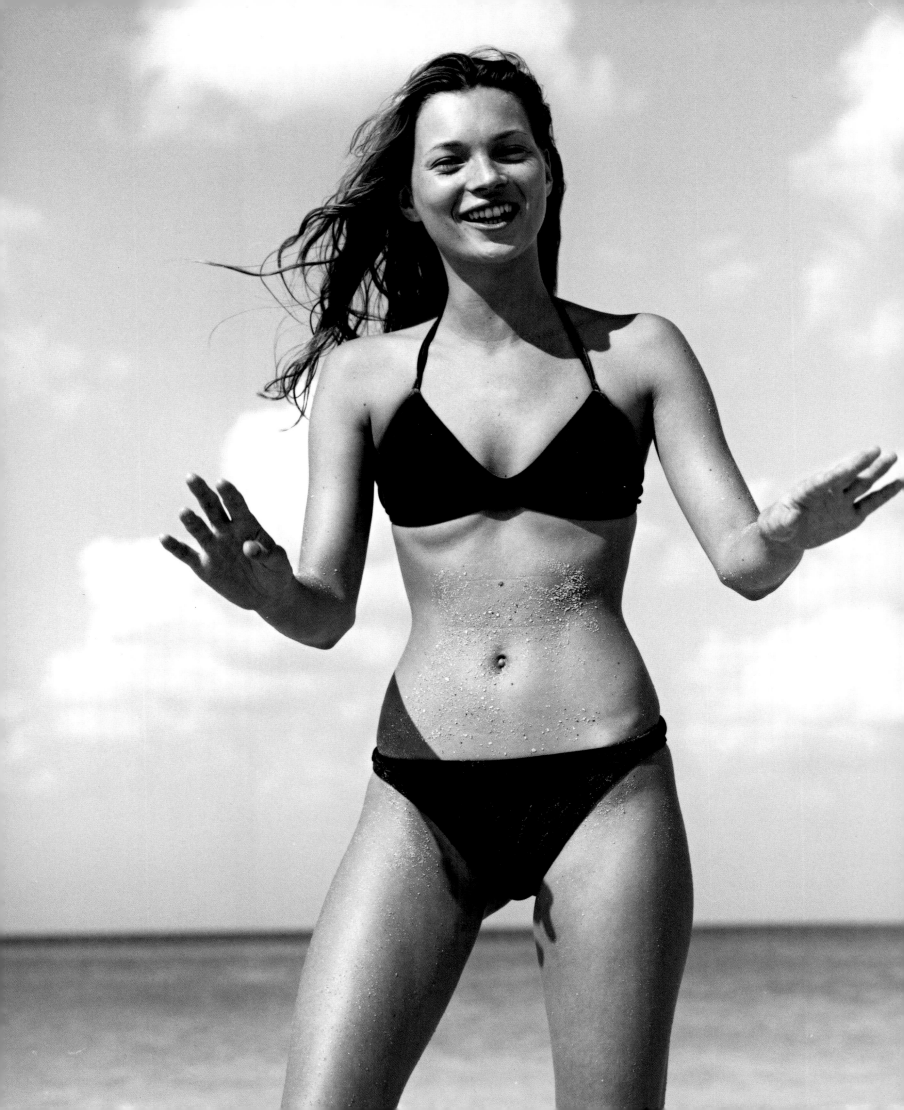

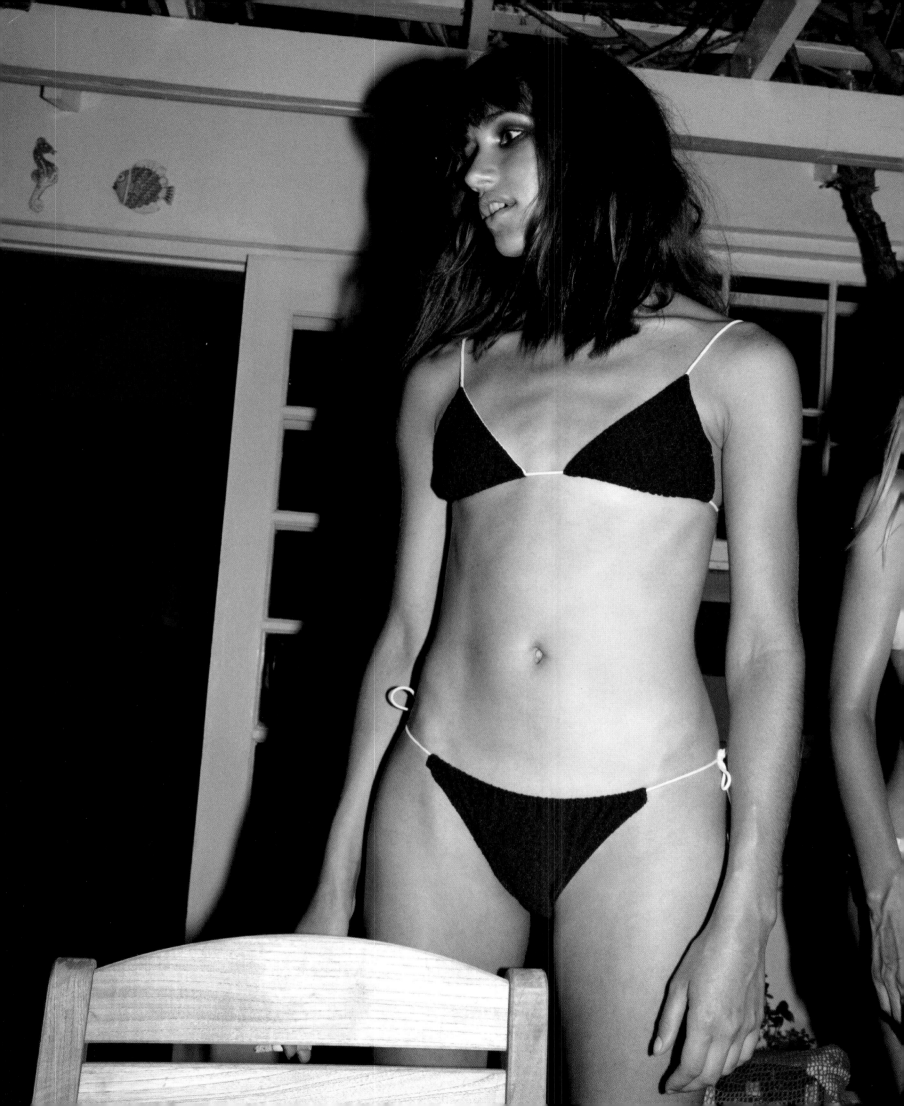

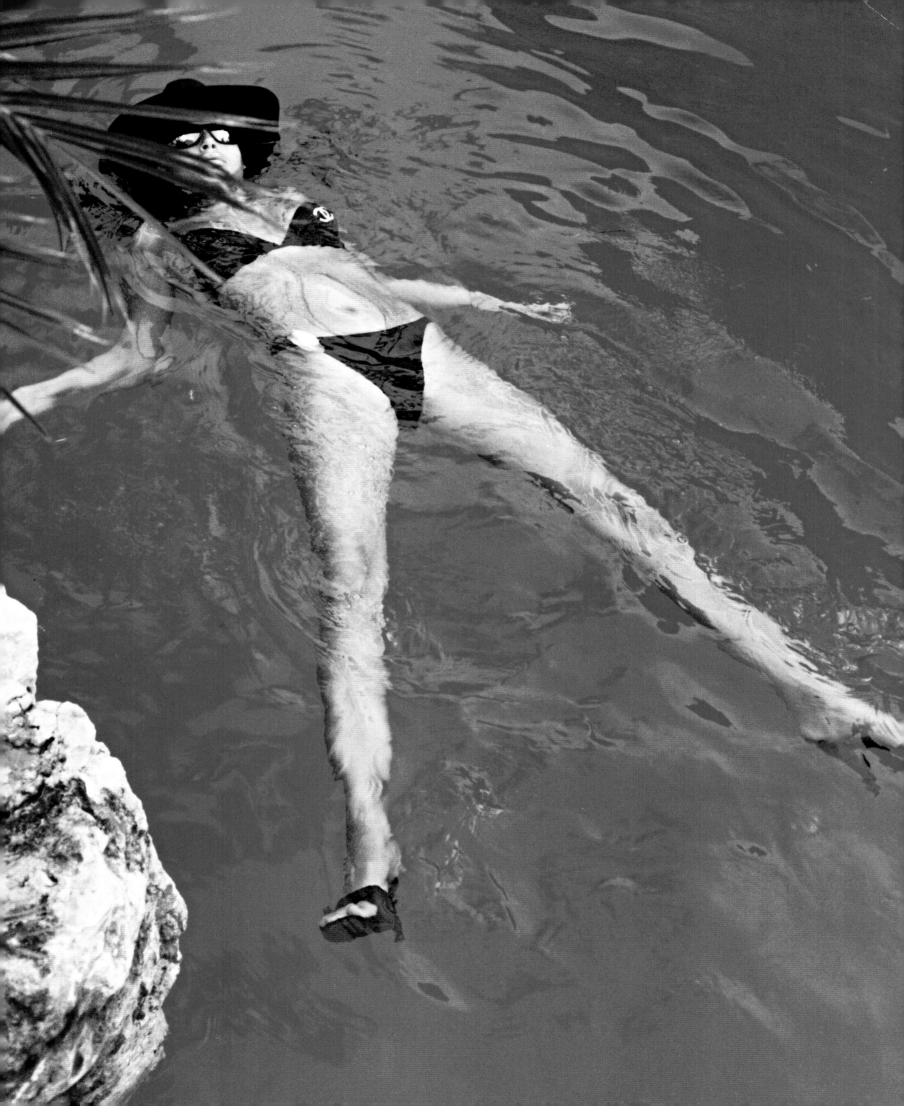

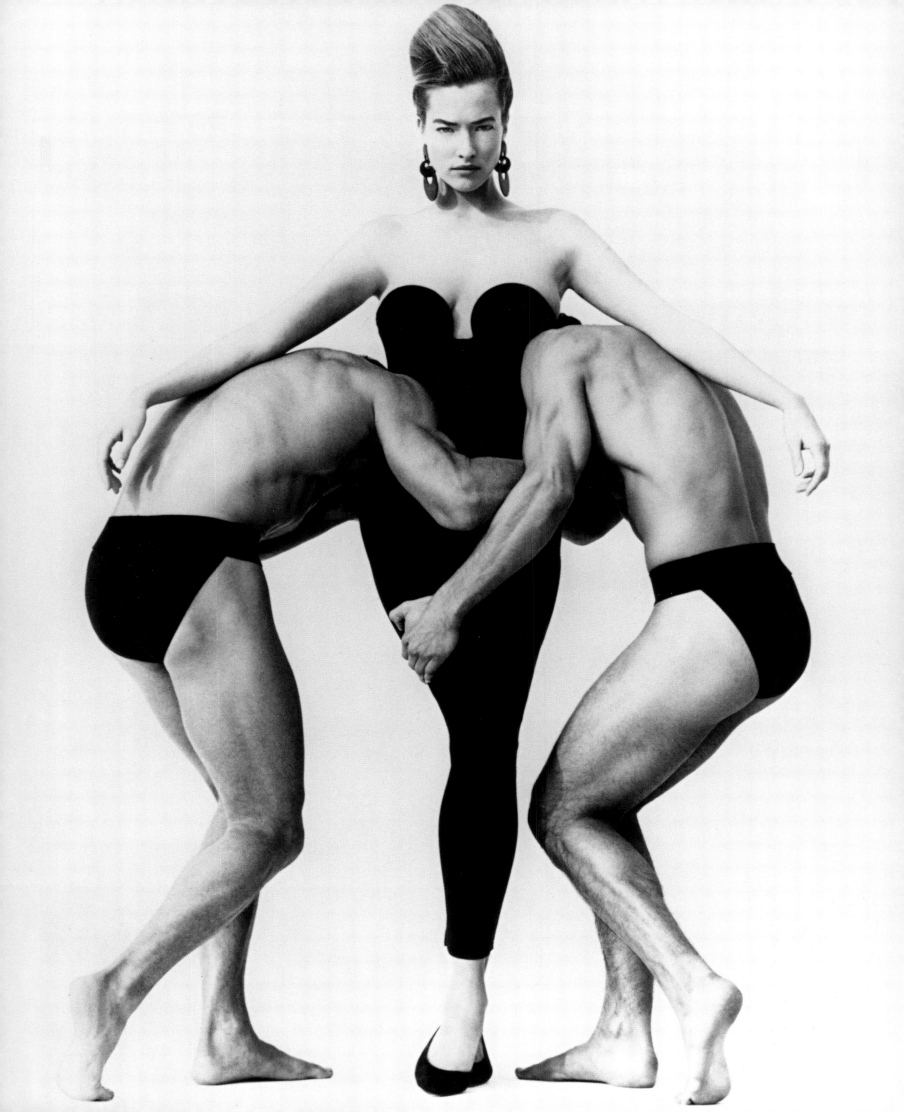

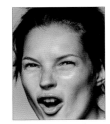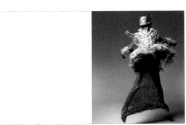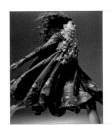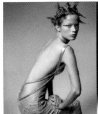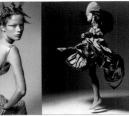

David Sims
Courtesy *Harper's Bazaar*, 1997
Model: Kate Moss

Satoshi Saikusa
Courtesy *Frank*, 1998
Model: Carolyn Murphy

Satoshi Saikusa
Courtesy *Frank*, 1998
Model: Haylynn Cohen

Satoshi Saikusa
Courtesy *Frank*, 1998
Model: Carolyn Murphy

Satoshi Saikusa
Courtesy *Frank*, 1998
Model: Haylynn Cohen

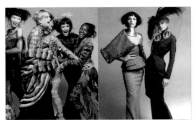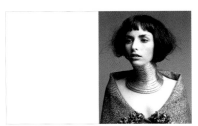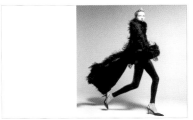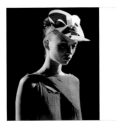

Patrick Demarchelier
Courtesy *Harper's Bazaar*, 1996
Models: Ling, Kylie Bax,
Rhea Durham, Danielle
Cinaich, and Kiara

Patrick Demarchelier
Courtesy *Harper's Bazaar*, 1996
Models: Danielle Cinaich
and Kylie Bax

Patrick Demarchelier
Courtesy *Harper's Bazaar*, 1996
Model: Danielle Cinaich

Patrick Demarchelier
Courtesy *Harper's Bazaar*, 1996
Model: Carolyn Murphy

Mario Sorrenti
Courtesy *Harper's Bazaar*, 1999
Model: Audrey Marnay

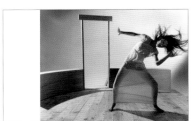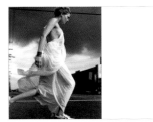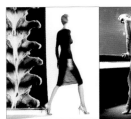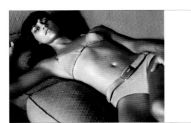

Mario Sorrenti
Courtesy *Harper's Bazaar*, 1999
Model: Audrey Marnay

Steven Klein
Courtesy *Harper's Bazaar*, 1997
Model: Kylie Bax

Steven Klein
Courtesy *Harper's Bazaar*, 1997
Model: Kylie Bax

Steven Klein
Courtesy *Harper's Bazaar*, 1997
Model: Kylie Bax

Steven Klein
Courtesy *Harper's Bazaar*, 1997
Model: Rosemary Ferguson

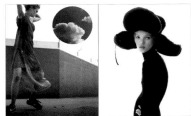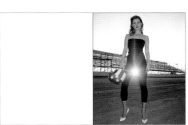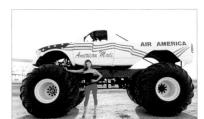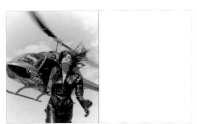

Steven Klein
Courtesy *Harper's Bazaar*, 1997
Model: Kylie Bax

Steven Klein
Courtesy *Harper's Bazaar*, 1998
Model: Kate Moss

Terry Richardson
Courtesy *Harper's Bazaar*, 1997
Model: Kate Moss

Terry Richardson
Courtesy *Harper's Bazaar*, 1997
Model: Kate Moss

Herb Ritts
Courtesy *British Vogue*
The Condé Nast Publications Ltd., 1990
Model: Stephanie Seymour

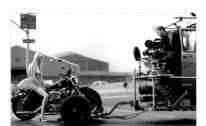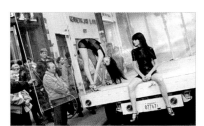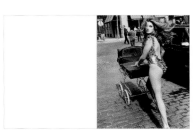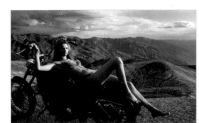

Steven Klein
Courtesy *Harper's Bazaar*, 1997
Model: Amy Wesson

Wayne Maser
Courtesy *Harper's Bazaar*, 1994
Model: Irina Pantaeva

Patrick Demarchelier
Courtesy *British Vogue*
The Condé Nast Publications Ltd., 1990
Model: Cindy Crawford

Patrick Demarchelier
Courtesy *Harper's Bazaar*, 1999
Model: Carmen Kass

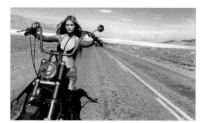
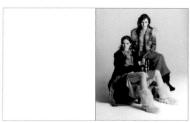
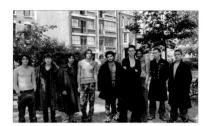
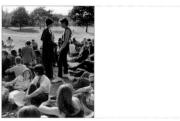

Patrick Demarchelier
Courtesy *Harper's Bazaar*, 1999
Model: Carmen Kass

Patrick Demarchelier
Courtesy *Harper's Bazaar*, 1998
Models: Haylynn Cohen and Danielle Cinaich

Peter Lindbergh
Courtesy *Harper's Bazaar*, 1996
Models: Stella Tenant and Dan MacMillan

Peter Lindbergh
Courtesy of *Harper's Bazaar*, 1996
Model: Stella Tenant

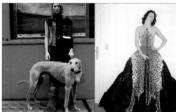
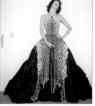
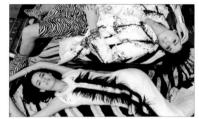
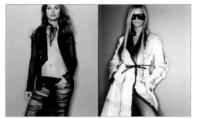
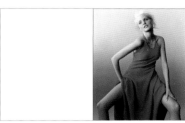

Satoshi Saikusa
Courtesy *Frank*, 1998
Model: Maggie Rizer

Terry Richardson
Courtesy *Frank*, 1997
Model: Carolyn Murphy

Wayne Maser
Courtesy *Harper's Bazaar*, 1999
Models: Lujan Fernandez and Fernanda Tavens

Wayne Maser
Courtesy *Harper's Bazaar*, 1999
Model: Aurelie Claudel

Wayne Maser
Courtesy *Harper's Bazaar*, 1999
Model: Carmen Kass

Mario Testino
Courtesy *Harper's Bazaar*, 1993
Model: Nadja Auermann

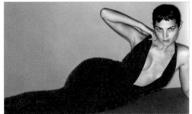
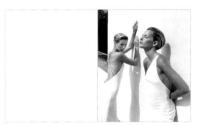
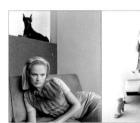
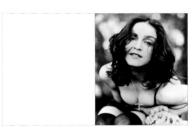

Wayne Maser
Courtesy *Harper's Bazaar*, 1997
Model: Chandra North

Wayne Maser
Courtesy *Harper's Bazaar*, 1996
Models: Carolyn Murphy and Georgina Grenville

Raymond Meier
Courtesy *Harper's Bazaar*, 1998
Model: Carolyn Murphy

Wayne Maser
Courtesy *Harper's Bazaar*, 1996
Model: Annie Morton

Herb Ritts
Courtesy *British Vogue*
The Condé Nast Publications Ltd, 1989
Model: Madonna

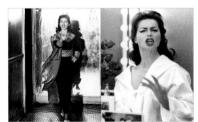
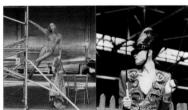

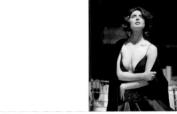
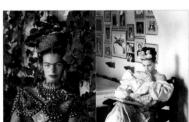

Steven Meisel
Courtesy *Allure*, 1991
Model: Isabella Rossellini

Steven Meisel
Courtesy *Allure*, 1991
Model: Isabella Rossellini

Steven Meisel
Courtesy *British Vogue*
The Condé Nast
Publications Ltd, 1989
Model: Veruschka

Steven Meisel
Courtesy *British Vogue*
The Condé Nast
Publications Ltd, 1989
Model: Tina Chow

Steven Meisel
Courtesy *British Vogue*
The Condé Nast Publications Ltd, 1989
Model: Isabella Rossellini

Steven Meisel
Courtesy *British Vogue*
The Condé Nast
Publications Ltd, 1990
Model: Cordula Reyer

Steven Meisel
Courtesy *British Vogue*
The Condé Nast
Publications Ltd, 1990
Model: Cordula Reyer

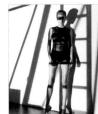
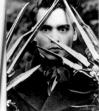
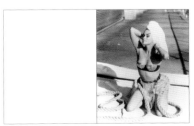
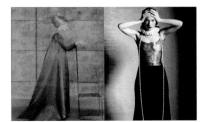
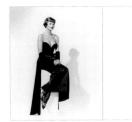

Steven Klein
Courtesy *Harper's Bazaar*, 1996
Model: Kylie Bax

Herb Ritts
Courtesy *British Vogue*
The Condé Nast
Publications Ltd, 1991
Model: Johnny Depp

Steven Meisel
Courtesy *British Vogue*
The Condé Nast Publications Ltd, 1989
Model: Lauren Hutton

Karl Lagerfeld
Courtesy *Harper's Bazaar*, 1995
Model: Kylie Bax

Karl Lagerfeld
Courtesy *Harper's Bazaar*, 1998
Model: Cate Blanchett

Patrick Demarchelier,
Courtesy *British Vogue*
The Condé Nast Publications Ltd, 1991
Model: Linda Evangelista

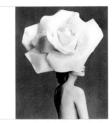
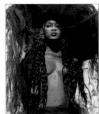
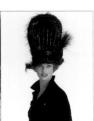
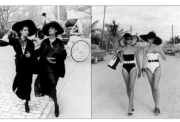
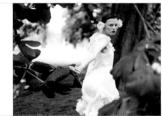
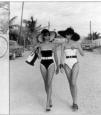
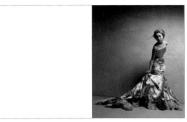

Patrick Demarchelier
Courtesy *British Vogue*
The Condé Nast Publications Ltd, 1992
Model: Christy Turlington

Herb Ritts
Courtesy *British Vogue*
The Condé Nast
Publications Ltd, 1992
Model: Naomi Campbell

Patrick Demarchelier
Courtesy *British Vogue*
The Condé Nast
Publications Ltd, 1991
Model: Linda Evangelista

Patrick Demarchelier
Courtesy *British Vogue*
The Condé Nast
Publications Ltd, 1992
Models: Vanessa Duve
and Gail Elliot

Patrick Demarchelier
Courtesy *British Vogue*
The Condé Nast
Publications Ltd, 1990
Models: Linda Evangelista
and Christy Turlington

Patrick Demarchelier
Courtesy *Harper's Bazaar*, 1999
Model: Devon

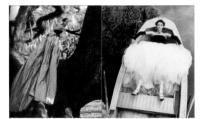
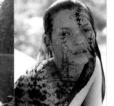
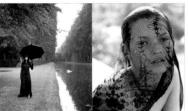
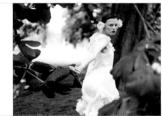
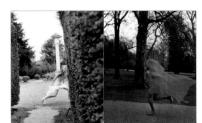

Arthur Elgort
Courtesy *British Vogue*
The Condé Nast
Publications Ltd, 1990
Model: Christy Turlington

Arthur Elgort
Courtesy *British Vogue*
The Condé Nast
Publications Ltd, 1990
Model: Helena Christensen

Satoshi Saikusa
Courtesy *Frank*, 1997
Model: Danielle Cinaich

Patrick Demarchelier
Courtesy *Harper's Bazaar*, 1998
Model: Kate Moss

Mikael Jansson
Courtesy *Frank*, 1998
Model: Karen Elson

Carter Smith
Courtesy *Frank*, 1997
Model: Angela Lindvall

Mikael Jansson
Courtesy *Frank*, 1998
Model: Karen Elson

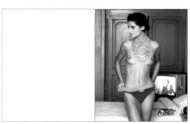
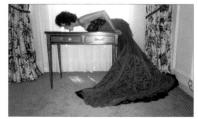
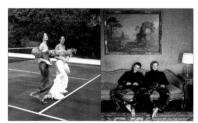
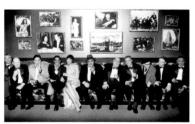

Peter Lindbergh
Courtesy *British Vogue*
The Condé Nast Publications Ltd, 1989
Model: Vanessa Duve

Terry Richardson
Courtesy *Frank*, 1997
Model: Carolyn Murphy

Patrick Demarchelier
Courtesy *Harper's Bazaar*, 1996
Models: Shalom Harlow
and Shiraz

Patrick Demarchelier
Courtesy *Harper's Bazaar*, 1996
Models: Shalom Harlow
and Amber Valletta

Peter Lindbergh
Courtesy *Harper's Bazaar*, 1995
Model: Linda Evangelista

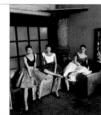
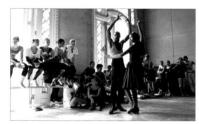
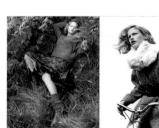
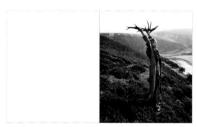

Patrick Demarchelier
Courtesy *Harper's Bazaar*, 1998
Models: Kate Moss and
Cuban Ballet School Students

Patrick Demarchelier
Courtesy *Harper's Bazaar*, 1998
Models: Naomi Campbell and
Cuban Ballet School Students

Patrick Demarchelier
Courtesy *Harper's Bazaar*, 1997
Model: Amber Valletta

Patrick Demarchelier
Courtesy *Harper's Bazaar*, 1995
Model: Amber Valletta

Carter Smith
Courtesy *Harper's Bazaar*, 1998
Model: Carolyn Murphy

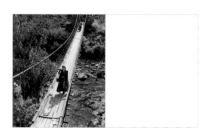
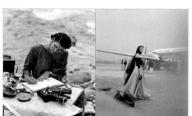

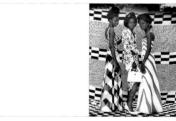
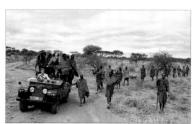

Peter Lindbergh
Courtesy *British Vogue*
The Condé Nast Publications Ltd, 1992
Model: Shana Phipps

Peter Lindbergh
Courtesy *British Vogue*
The Condé Nast
Publications Ltd, 1992
Model: Shana Phipps

Peter Lindbergh
Courtesy *British Vogue*
The Condé Nast
Publications Ltd, 1992
Model: Shana Phipps

Seydou Keita
Courtesy *Harper's Bazaar*, 1998
Models: Local Malian women

Patrick Demarchelier
Courtesy *Harper's Bazaar*, 1995
Model: Peter Jones and Anja Kneller

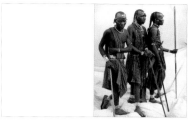
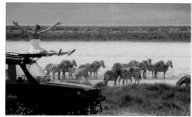
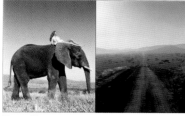
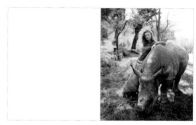

Patrick Demarchelier
Courtesy *Harper's Bazaar*, 1993
Models: Local Masai

Arthur Elgort
Courtesy *British Vogue*
The Condé Nast Publications Ltd, 1992
Model: Christy Turlington

Wayne Maser
Courtesy *Harper's Bazaar*, 1999
Model: Aurelie Claudel

Wayne Maser
Courtesy *Harper's Bazaar*, 1999
Model: Aurelie Claudel

Wayne Maser
Courtesy *Harper's Bazaar*, 1999

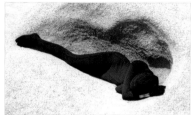
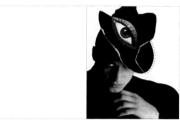
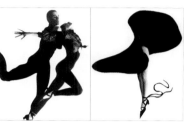
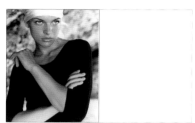
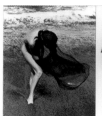
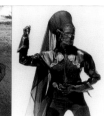

Mario Testino
Courtesy *Harper's Bazaar*, 1995
Model: Milla Jovovich

Tony Viramontes
Courtesy *The Face*, 1986

Tony Viramontes
Courtesy *The Face*, 1986

Tony Viramontes
Courtesy *The Face*, 1986

Herb Ritts
Courtesy *British Vogue*
The Condé Nast
Publications Ltd, 1989
Model: Carré Otis

Herb Ritts
Courtesy *British Vogue*
The Condé Nast
Publications Ltd, 1990
Model: Stephanie Seymour

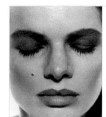
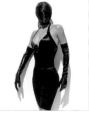
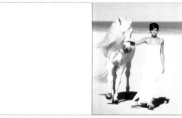
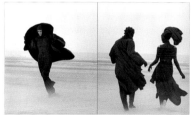

Herb Ritts
Courtesy *British Vogue*
The Condé Nast
Publications Ltd, 1988
Model: Tatjana Patitz

Herb Ritts
Courtesy *British Vogue*
The Condé Nast
Publications Ltd, 1989
Model: Cordula Reyer

Herb Ritts
Courtesy *British Vogue*
The Condé Nast
Publications Ltd, 1991
Model: Helena Christensen

Peter Lindbergh
Courtesy *British Vogue*
The Condé Nast Publications Ltd, 1990
Model: Helena Christensen

Peter Lindbergh
Courtesy *British Vogue*
The Condé Nast Publications Ltd, 1989
Model: Vanessa Duve

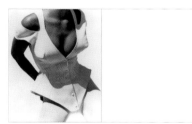
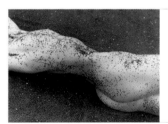

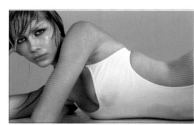

Herb Ritts
Courtesy *British Vogue*
The Condé Nast Publications Ltd, 1991
Model: Helena Christensen

Herb Ritts
Courtesy *British Vogue*
The Condé Nast Publications Ltd, 1989
Model: Carré Otis

Herb Ritts
Courtesy *British Vogue*
The Condé Nast Publications Ltd, 1988
Model: Stephanie Seymour

Richard Burbridge
Courtesy *French Vogue*, 2000
Model: Ana Claudia Michels

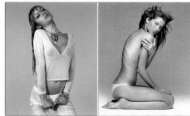
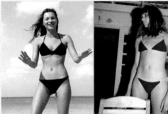
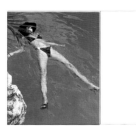
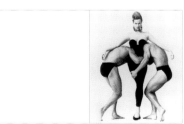

Richard Burbridge
Courtesy *French Vogue*, 2000
Model: Ana Claudia Michels

Patrick Demarchelier
Courtesy *Harper's Bazaar*, 1999
Model: Gisele Bündchen

Patrick Demarchelier
Courtesy *Harper's Bazaar*, 1998
Model: Kate Moss

Steven Klein
Courtesy *Harper's Bazaar*, 1997
Model: Rosemary Ferguson

Wayne Maser
Courtesy *Harper's Bazaar*, 1995
Model: Bridget Hall

Herb Ritts
Courtesy *British Vogue*
The Condé Nast Publications Ltd, 1988
Model: Tatjana Patitz

Acknowledgements

First and foremost, I would like to thank
my late editor-in-chief and dear friend Liz Tilberis
for her support and guidance with my work.

A special thank you to Anna Wintour who started me off.

I would especially like to thank Fabien Baron
for his immaculate design sense.

My deepest gratitude to all the photographers who
collaborated on these shoots and on this book:
Richard Burbridge, Patrick Demarchelier, Arthur Elgort,
Mikael Jansson, Seydou Keita, Steven Klein,
Karl Lagerfeld, Peter Lindbergh, Wayne Maser, Raymond
Meier, Steven Meisel, Terry Richardson, Herb Ritts,
Satoshi Saikusa, David Sims, Carter Smith, Mario Sorrenti,
Mario Testino, and Tony Viramontes.

Thank you to *The Face*, *British Vogue*, *French Vogue*,
Harper's Bazaar, *Allure*, and *Frank*.

A huge thank you to all the talented models and hair and
makeup artists for their invaluable contributions.

I would like to thank Craig Cohen for making this
book happen, Brianna Blasko for her meticulous research,
and my father, Jeff Hoare, for his unfailing support.

Last but not least, I want to thank
all my wonderful assistants who have worked
so hard with me to make these images happen:
Madeline Christie, Eugene Hanmar, Tamara Mellon,
Kate Phelan, Jayne Pickering, Joanna Rodgers,
Cara Shapiro, Mary Alice Stephenson,
and Siobhan Zetumer.

TALKING FASHION

Published in the United States by powerHouse Books,
a division of powerHouse Cultural Entertainment, Inc.
180 Varick Street, Suite 1302, New York, NY 10014-4606
telephone 212 604 9074, fax 212 366 5247
e-mail: talkingfashion@powerHouseBooks.com
web site: www.powerHouseBooks.com

First edition, 2002

Library of Congress Cataloging-in-Publication Data

Hoare, Sarajane.
 Talking fashion by Sarajane Hoare.
 p. cm.
 ISBN 1-57687-115-0
 1. Fashion Photography. I. Title.

TR679 .H63 2001
778.9'974692--dc21

 2001036807

Hardcover ISBN 1-57687-115-0

Separations, printing, and binding by Grafiche Siz, Verona

A complete catalog of powerHouse Books
and Limited Editions is available upon request;
please call, write, or talk to our web site.

10 9 8 7 6 5 4 3 2 1

Printed and bound in Italy

BOOK DESIGN BY FABIEN BARON